John Drake
January 2003

SECESSION

**THE VIENNA SECESSION
FROM TEMPLE OF ART
TO EXHIBITION HALL**

HATJE

"Der Zeit Ihre Kunst – Der Kunst ihre Freiheit"

Inscribed over the entrance of the Wiener SECESSION, this declaration has lost none of its pertinence over a hundred years. In translation, "Every age has the right to its own art and all art has the right to free expression," much of the impact of the original is lost. It may not be possible to give the English translation the strength of the German, but the idea easily transcends the barrier of language.

The motto became a rallying cry for those who valued freedom for artists everywhere.

The establishment of the Coutts Contemporary Art Foundation could easily have been founded with the same motto.

It is because we subscribe to this same thought that we, at Coutts, are particularly pleased to be a part, through this publication, of the Hundredth Anniversary Celebration of the Wiener SECESSION.

Sir Ewen Fergusson
Chairman Coutts Group
Chairman Coutts Contemporary Art Foundation

CONTENTS

PREFACE

Since its founding, the Vienna Secession has functioned as a sensor, reacting to the significant crises of our century, and as a sender, a transmitter of progressive creativity. The restoration of the building in 1986 served not only to secure the physical substance of the Secession, but also, in a careful process of adjustment, to give vital impetus to the Secessionist spirit.

The artists' union of the Secession originated from the need to recover international terrain and expose the art public to the world of the modern. Today, the concern is to appear before an open society with a conception of culture that facilitates the discourse of unhindered artistic development. In this sense, the Secession provides institutional protection for the vulnerable structures of forward-looking art and offers itself as the place for its manifestation.

To extend hospitality to participants in the resonance of culture and to create a space for them has consistently represented an established goal of the Secession, with its erstwhile renunciation of tradition. In light of the hard-won recognition of visual art in this century, the subtle positioning of this self-assertion—in this city especially—acquires particular significance.

Werner Würtinger
President of the Vienna Secession

Acknowledgement

Thanks are due to all who contributed to the success of this project in a variety of ways. Particular gratitude should be expressed to the authors, who wrote new texts or revised and expanded existing ones especially for this book. In view of the flood of scholarly and popular literature on the subject, new approaches and insights were needed to complement the existing literature and encourage additional research. Here the assistance of the Archiv der Wiener Secession was of inestimable value; through the financial support of the Federal Ministry of Education, this archive has at last been systematized and made available for future research. The continual guidance of the publisher also played an essential role in the production of this book. Not least of all, the generous support of the Coutts Bank enabled this project to be realized in celebration of the 100th anniversary of the Vienna Secession.

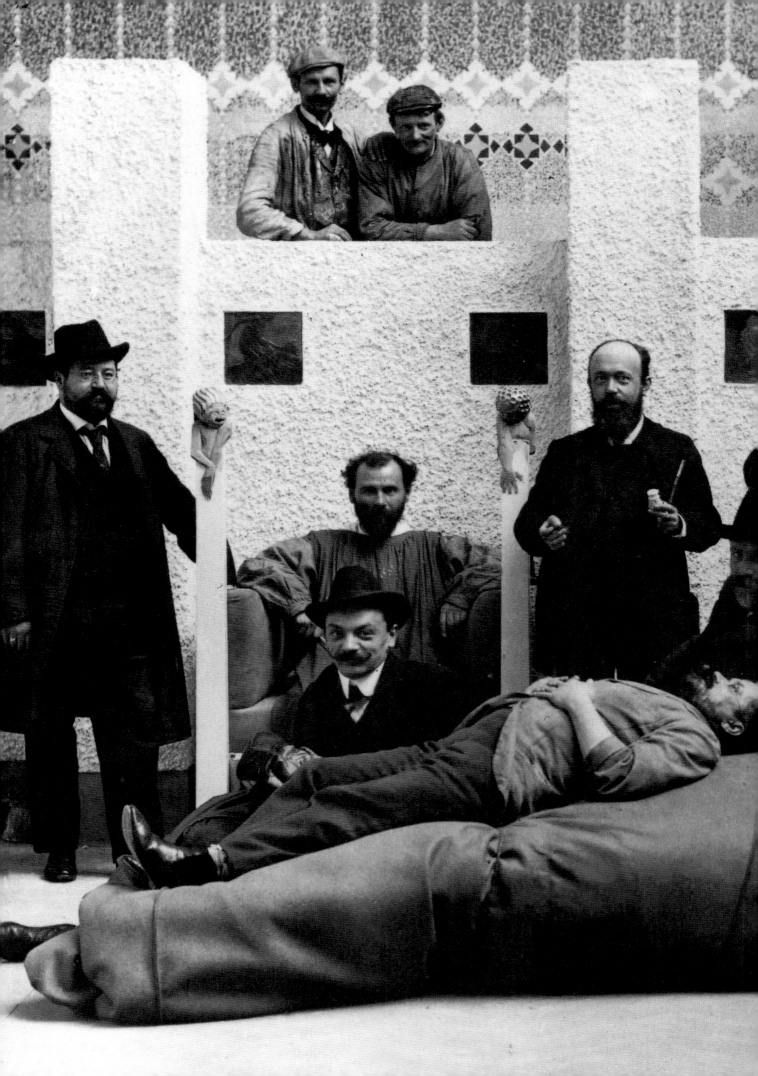

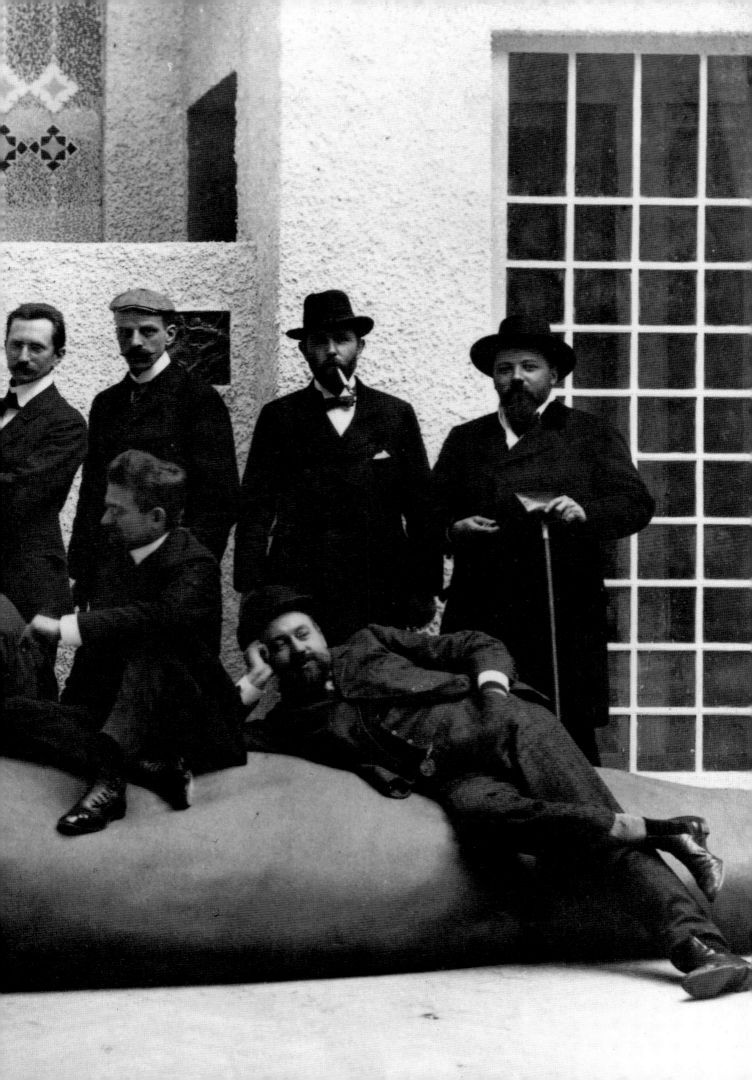

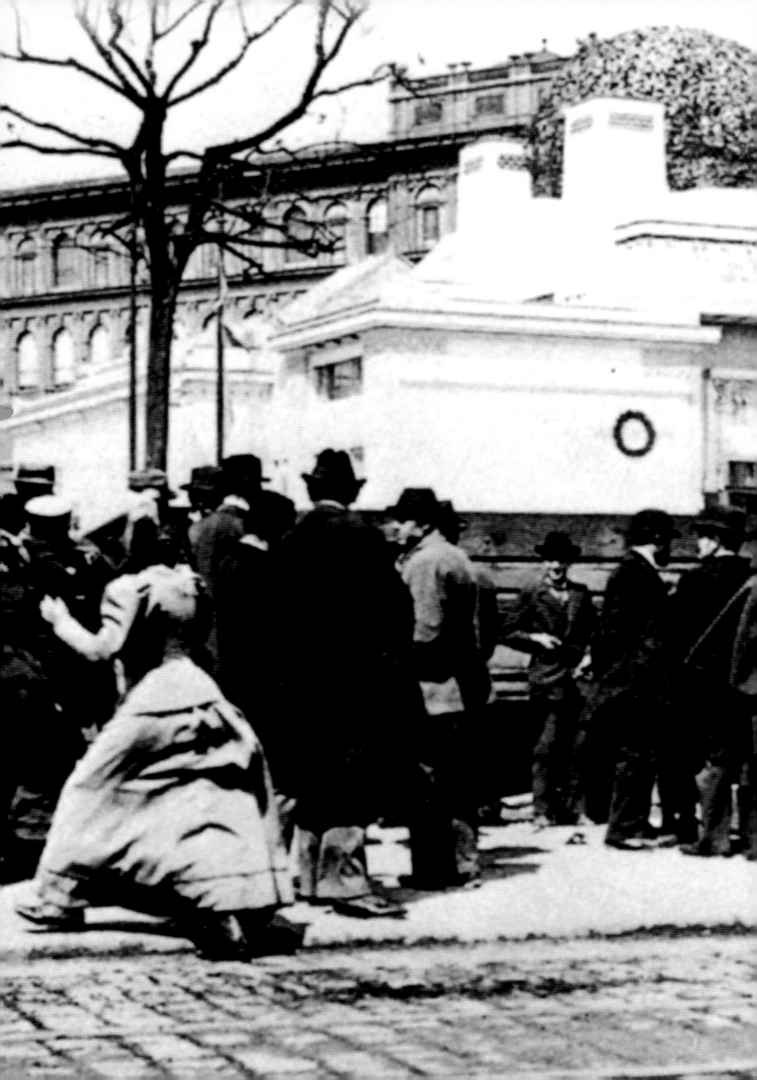

James Shedel

ART AND IDENTITY

THE WIENER SECESSION, 1897–1938

From the moment it came into being, the Secession was fundamentally involved with the issue of identity. The artists who founded it did so in order to establish their personal identities as well as the identity of their art. Gustav Klimt, Josef Hoffmann, Koloman Moser, and the rest of the Secession's founding members shed the rather condescending label of "Jungen" (The Young Ones) for the unique and more exciting title of "Secessionisten." Though it seemed to connote a collectivity, a group of artists who were part of a single school, in reality it was a name that described a diverse group of individuals who were only loosely linked by a style. Certainly, one could point to an art nouveau linearity and a preoccupation with biological motifs as stylistic elements that were common to many of these artists, but it was a philosophy, not a style, that really defined their unity. That philosophy was generally expressed by the motto placed over the entrance to the Secession's home, "To the time its art. To art its freedom." The first clause described the need to be modern, while the second asserted the liberty of the artist to create in whatever manner he saw fit. Creative honesty was the guiding principle from which all else would flow including the identity of the creator and his art. Membership in the Secession justified virtually any artistic identity, but as a formal association of artists it also felt the need for an identity that was not solely defined by art or an artistic philosophy. This was provided by their concern for issues of national identity. Through calling itself the *Vereinigung bildender Künstler Österreichs* the Secession acknowledged itself as being Austrian and in so doing became involved along, with its art, in the vexed and complex issue of defining a nation.

From its founding in 1897 to its enforced hiatus after 1939 the Secession concerned itself with the same general issues of continuity and change that bedeviled the question of what defined an Austrian identity. Whether in the Monarchy or the First Republic, the fate of the Secession and its art were bound up with that of Austria itself. The birth of the Secession was accompanied not only by turmoil in the artistic world, but also by its counterpart in the political. While Klimt and his associates were declaring their artistic individualities by walking out of the Künstlergenossenschaft, Czech and German parliamentarians engaged in a similar exercise at the Reichsrat. Disrupting the Austrian parliament, however, was more than an assertion of cultural independence. Occasioned by Ministerpresident Kazimierz Badeni's attempt to place the Czech and German languages on an equal footing within the imperial bureaucracy for Bohemia, the resultant crisis pitted Czech and German national sensibilities and interests not only against each other, but also in opposition to their ostensibly common Austrian identities. Although the Secession advocated artistic independence, throughout its existence it would either overtly or tacitly recognize the need for unity within the arts. It stood for the creative latitude that made artistic change possible, but also recognized the need for that change to take place within a cultural structure that embodied continuity with what had gone before. The conflict between Czechs and Germans about the seeming triumph of the Czech language over German constituted a major crisis not so much because it paralyzed the legislative branch of the state, as that it challenged the continuity of the supra-national idea of an Austrian identity that was supposed to transcend that of individual nationalities. The virulence of the national animosities between Czech and German that spilled out into the streets of Vienna and Prague marked a change that threatened the continuity of the Monarchy itself. But the

View of the Vienna Secession from the Gemüsemarkt, April 1899
Photo: Historisches Museum der Stadt Wien

Preceding pages: Group photo of members of the Vienna Secession on the occasion of the 14th exhibition, 1902. From left to right: Anton Stark, Gustav Klimt (in armchair), Kolo Moser (in front of Klimt, with hat), Adolf Böhm, Maximilian Lenz (reclining), Ernst Stöhr (with hat), Wilhelm List, Emil Orlik (seated), Maximilian Kurzweil (with cap), Leopold Stolba, Carl Moll (reclining), Rudolf Bacher.
Photo: Bildarchiv der Österreichischen Nationalbibliothek

problem of reconciling a particularist identity based on ethnicity with one based on history was to be the problematic leitmotif that threatened Austria's existence until the *Anschluß*. The Secession with its commitment to reconciling change and continuity became a cultural antidote for the tendencies present in Austrian society that opposed such a reconciliation. For this reason the history of the Secession up to 1938 transcends its place within the history of art to become a factor in the story of Austria's struggle to come to terms with itself.

At first, the role of identity as a motivation for creating the Secession was masked by the formal reasons for the exit of Klimt and his colleagues from the *Künstlergenossenschaft*. When they left the meeting of May 22, 1897 it was due to a combination of personal insults and anger over a discriminatory exhibition policy directed against themselves. Following its constitution as an independent association of artists on July 21, the crucial role played by the issue of identity in the character of the Secession became apparent.[1] As early as 1896 the future members of the Secession had already identified themselves with what they saw as the newer trends in art coming from abroad. The month before their departure from the Künstlergenossenschaft Klimt had notified its governing board that he and his associates were motivated by a desire to come into closer contact with these 'progressive' developments and to break with what they saw as the 'market character' of the *Genossenschaft's* exhibitions.[2] Thus, modernity and purity were to be hallmarks of the new group. When the Secession held its first exhibition in the spring of 1898 in the borrowed premises of the *Gartenbaugesellschaft* (Horticultural Society) it inaugurated a policy of exhibitions as didactic venues for instructing artists and the public alike in what it considered worthwhile in the fine arts. This involved shunning what it felt represented the mere copying of past styles, but not works of art that were genuine products of historical epochs whose presence could be of instructive value. In this spirit, the 1898 exhibition focused on the recent history of modern art as the Secession saw it and, in order to emphasize the artistic sources of what the Secession intended to build on, presented mostly non-Austrian works. As a further sign that this exhibition marked a new beginning for art in Austria, the works were hung and displayed with as much open space around them as was practical. The usual clutter that typified most exhibitions was avoided so that the individual work of art could be appreciated for itself and not simply as an object for sale.[3] The creative freedom of modern art was thus matched by a physical freedom designed to maximize its impact upon the viewer.

The reaction to the Secession's debut was generally positive. Most reviewers praised the quality of the exhibition and its modernist intentions.[4] It drew large crowds including specially arranged visits by workers,[5] but the most important visitation was that of Emperor Franz Joseph on April 6. Although the Emperor had been the initiator of the Ringstraße and a patron of the historicist painter, Hans Makart, he generally kept his distance from direct participation in artistic matters. Franz Joseph's attendance at events such as the opening of the Secession made them official events in the strictest sense of the term.[6] It was normally a bureaucrat who decided which cultural events would be graced by the Emperor, and the Secession was no exception. Because 1898 was the jubilee anniversary of his fiftieth year on the throne, the Emperor was in great demand. By breaking with the Künstlergenossenschaft, the members of the Secession had left the one organization that enjoyed extensive official patronage, including that of Franz Joseph. The Secession may have wanted to emphasize art rather than money, but its members still needed to sell their works in order to survive and a visit from the emperor would help to legitimize them in the eyes of the state and public alike.

The Secession realized the importance of an imperial visit and, accordingly, Klimt, Carl Moll, and the highly respected octogenarian painter, Rudolph von Alt, secured

an audience with the Emperor on March 10 and on that occasion presented him
with a letter of invitation to open the new group's first exhibition. The letter stressed
the Secession's Austrian character by noting that "[…] like-minded German,
Bohemian and Polish artists have allied themselves to the 'Vereinigung bildender
Künstler Österreichs'." The supra-national character of what it meant to be an
Austrian artist was further stressed by an emphasis on how "the rich artistic
talents" of Austria's peoples would be united in international competitions for the
furtherance of her fame.[7] The letter was accepted and then forwarded on to the
Ministerium für Cultus und Unterricht (Ministry for Religion and Education) for
evaluation. Such an evaluation was issued the next day and spoke favorably of
the Secession's artistic aspirations, its likely favorable impact on the art of the
Fatherland (der vaterländischen Kunst), and its need for a successful exhibition.
Although the Emperor was reminded that he owed his presence at the opening of
the Künstlergenossenschaft's jubilee exhibition, he was encouraged to attend the
Secession's exhibition after it opened[8] and dutifully complied.

Franz Joseph's presence at the exhibition assured the Secession of a competitive
status with the Künstlergenossenschaft and the favorable disposition of circles in
government and high society. To be sure, the penetration of art nouveau style was
already evident in the architecture of the pavilions at the Jubilee Exhibition in the
Prater, but this "false Secession" as Hermann Bahr called it,[9] was now to be
overshadowed by the Secession's status as a kind of semi-official source for all
that was to be considered modern. It had already more or less laid claim to that
distinction in the first issue of its journal, Ver Sacrum[10], and this impression was
further strengthened when it opened its own strikingly unorthodox building,
designed by Joseph Olbrich, in the fall of 1898. But in a society and state that was
still dominated by a dynastically based order it was the outward sign of that order's
acceptance that ensured the Secession a niche and an identity. It was on its way to
becoming an institutionalized avant-garde in a society dominated by an old and
powerful institutional structure.

While the future of the Secession would not be without crises, by the end of 1898
it was not only a public success, but had essentially established its identity as
both modern and Austrian. The Secession's first exhibition, despite the fact that it
contained no Secessionist art, had been a psychological triumph that capitalized

on expectations of artistic modernity that had already been generated by the sensational circumstances of the Secession's origins and the speed with which it was able to advertise its modernist credentials in *Ver Sacrum* and elsewhere. Although it would not be until the second exhibition that art by Secessionists would be on display, a perception that the Secession was the representative of modern art in Austria had been established in the official and public imagination. Of course, in 1898 there were and, in subsequent years would always be, practitioners of 'modern' art outside the confines of the Secession, but so strong was the perception of the Secession's virtually exclusive claim to artistic modernity that even the founding of the modernist Hagenbund in 1900 had practically no effect on the group's status.[11] In popular terms, to be 'secessionist' was to be stylish and imitations of a so-called 'Secession style' appeared almost immediately in everything from paintings to bric-a-brac.[12] Controversy, like that provoked by Olbrich's Secession building,[13] only served to enhance the modernist credentials of all who were associated with the Secession. Ultimately, it did not matter that the group's philosophical commitment to creative individualism meant that its modernity was often defined by its rejection of historicism rather than its ability to generate a single overarching style. Naturalism, impressionism, sinuous art nouveau, geometricity, and expressionism were all secessionist styles so long as their practitioners adhered to the principle of creative honesty. Diversity became the essence of modernity and this cosmopolitanism also allowed the Secession to claim its art as European.[14] This same artistic diversity, however, proved equally compatible in asserting the Austrian side of the Secession's character.

Building of Vienna Urban Expansion Commission during Imperial Jubilee Exhibition, 1898.
Photo: Bildarchiv der Österreichischen Nationalbibliothek

In its formal name and in its letter to the Emperor, the Secession had made clear its identification with Austria and a modern 'Austrian' art. Slaying the two-headed dragon of historicism and commercialism was not enough. In order to create a modern art, an art for its time, the Secession felt the need to take its context into consideration. When the Secession's founding members looked at the developments in modern art abroad they saw them with English, French, or Belgian characteristics. Modern art was both international and national. At home they saw only an outworn attachment to an exhausted historicism. Artistic renewal would require an originality that could ultimately only come from the experiences of the artist himself and to the artists of the Secession such experiences would naturally come from their Austrian environment. Other Europeans could point the way, but it was as Austrians that the Secessionists would have to travel the path to artistic modernity. Thus, the first exhibition showed artists and public alike how the signposts to modernity looked, and the second exhibition in December of 1898 showed where they had led. That destination generally pleased the critics and the second exhibition, like the first, was a success.[15] It did not matter that it was the Secession building itself that showed the clearest indications of a distinct style, the art it housed was still a modern 'Austrian' art by virtue of those who had created it.

Joseph Urban, entrance portal of annex to Künstlerhaus at Imperial Jubilee Exhibition, 1898.
Photo: Archiv Sabine Forsthuber

Creating a modern Austrian art, however, had implications beyond creative modernity itself. An Austrian art could never be a national art, because Austria was a historical construct rather than a nation. It was the creation of Habsburg dynasticism and in an age of nation-states saw itself as supra-national. As Franz Joseph's motto, 'viribus unitis' (With United Powers), proclaimed, Austria's strength was based on its diversity and whatever unity it possessed could only be preserved by recognizing that fact. This was a constant in the state's history, and in the course of dealing with change the Habsburg Monarchy was careful to maintain a continuity over time of means that served the ends of unity and the survival of the state. By the time the Secession appeared, those means were embodied in a unique combination of the traditional and the modern that together formed the political culture of the Austrian Rechtsstaat.

The rule of law in Austria was based on two complementary sources of legitimacy. With its origins in Joseph II's adoption of Enlightenment principles, the Habsburg dynasty had come to acknowledge the role of natural law ideas alongside that of divine sanction for their authority. From Joseph II on, the dynasty seized the basic initiative for positive change from above, identifying the state with modernization while at the same time preserving the traditional basis of its authority and institutions, such as the Catholic Church, essential to it. Though not without lapses, this combination allowed it to have change with continuity even if that meant, as in 1867, admitting popular participation in the government. The dynastic state had always been the guarantor of order for all its peoples and under a constitution that was a gift of the Emperor, it was now the guarantor of their individual and national rights.[16] By 1897 Austria, like other advanced European states, had to deal with the problem of social disunity typified by the emergence of social democracy, but added to this was its unique dilemma of maintaining the "Austrian idea" of unity paradoxically derived from diversity in the face of growing national consciousness among its peoples. The Badeni crisis that swirled around the Secession in its formative years challenged the basic assumptions of the Austrian idea and cried out for some means of redressing this dangerous situation.

When the Secession stressed its supra-national Austrian credentials to Franz Joseph in its invitation, it was clearly conscious of the positive effect that it would have on the Emperor and the government, but it would be wrong to attribute that strategy to mere cynicism. The ideas about the relationship between art and society that are discernable in the Secession by the end of 1898 indicate their complementary

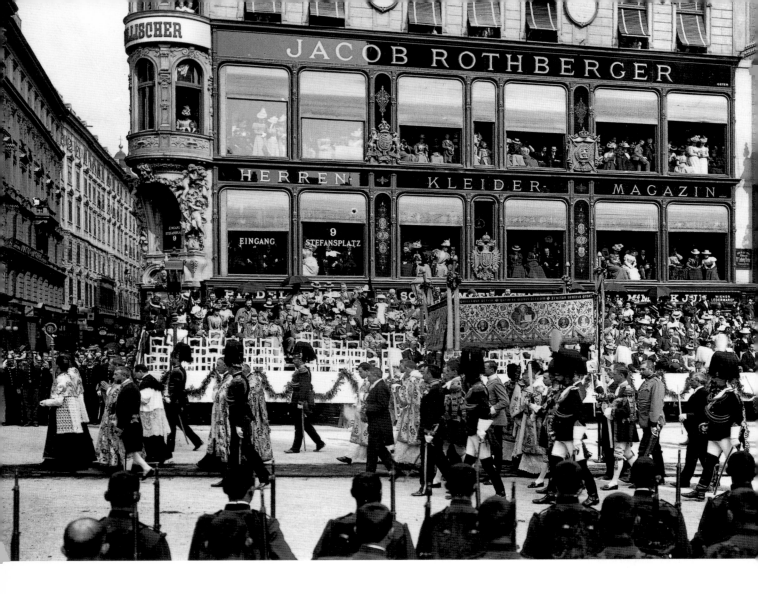

Emperor Franz Joseph I behind
Sanctissimum of Corpus Christi
procession near St. Stephan, 1898.
Photo: Bildarchiv der
Österreichischen Nationalbibliothek

character to the "Austrian idea" and the political culture of the Austrian Rechtsstaat.
As it announced in the first issue of *Ver Sacrum* and its own by-laws made clear,[17]
the Secession saw itself as having an obligation to society at large to make the
public aware of the benefits of art, whatever form they might take. This obligation
united the artist and the public through the work of art in what was known as the
Künstlerschaft. Since the Secession rejected the notion of 'high' and 'low' art (i.e.
fine and applied art) it saw all art as serving the needs of its Künstlerschaft
constituency and the most effective means of uniting the diverse traits and benefits
of art was in the *Gesamtkunstwerk* (the total work of art). Inherent in that concept
was the notion of diversity coming together to form a unity that was greater than
the sum of its parts, a phenomenon that was compatible with both the "Austrian
idea" and the motto of 'viribus unitis.' Because the fully realized Gesamtkunstwerk
required architecture to give it form, however, it also could provide an environment
that embodied the desirable traits of unity and harmony, thereby conveying their
influence through constant exposure to those who inhabited or used it.[18] In the
conditions of post-Badeni Austria the potential benefit of these traits was obvious.
Similarly, the hierarchical character of the Gesamtkunstwerk with architecture and,
by extension, the architect having the final responsibility for its realization bore a
complementary resemblance to the idealized role of the Emperor in assuring the
well-being of Austria; a role that from 1897 on he played very frequently in trying to
overcome the disruptive heritage of the Badeni crisis.[19]

In concrete terms, at the close of 1898 the Secession could only point to its own
building, the organization of its exhibitions, and the works of its sympathizer and

soon to be member, Otto Wagner,[20] as examples of the Gesamtkunstwerk realized. The idea, however, had a resonance that went beyond its physical application. The idea of a totally integrated and ordered world, of which the Gesamtkunstwerk was a reflection, had deep roots in Austria's Habsburg past as an expression of the dynasty's post-Reformation reconstruction and extension of its realm. This phenomenon is most often referred to as Austria's 'baroque' heritage because of its largely seventeenth century origins, but perhaps it should more properly be seen as the *Habsburg* heritage since its characteristics of uniting divine and earthly hierarchy through the cooperation of church and state and a rich palette of cultural devices was not simply an accidental development. Rather, it was the beginning of what became the "Austrian idea." By emphasizing the concept of the Gesamtkunstwerk the Secession was embedding the idea of continuity into the midst of its artistic change. It was adapting a still living tradition to a contemporary situation. Totality could serve the interests of the new art by making its influence omnipresent and, in the process, assist the state and society by its example of physical unity.

The idea of change with continuity was not only expressed by the Gesamtkunstwerk, but was also part of how the Secession saw the process of modernizing art. Being modern was not simply a function of novelty; it was a process of growth. All of the founding members of the Secession had come to their modernist convictions from practicing other styles. Klimt himself had mixed naturalism and historicism in his earlier work and neither he nor his colleagues had

Burial of Rudolf von Alt, 1905, with members of the Vienna Secession on entrance stairs of Secession building. Photo: Bildarchiv der Österreichischen Nationalbibliothek

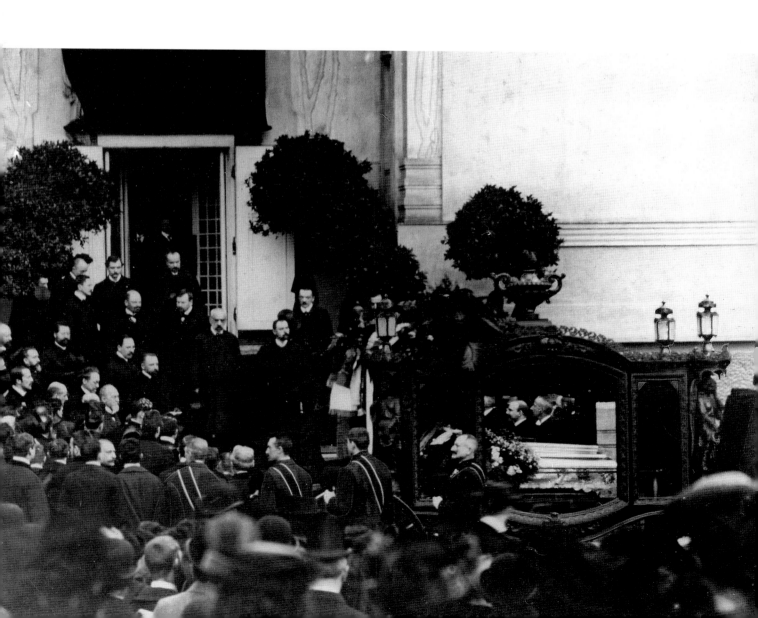

Main hall of Vienna Secession during 16th exhibition (*Impressionism*), 1903. Photo: Bildarchiv der Österreichischen Nationalbibliothek

escaped the classically dominated training of the art schools. Having an art for its time did not mean having one that was rootless. The accompanying notion of artistic freedom was reflected in the Secession's willingness to accept a diversity of styles so long as they were purely motivated. The past could exist side by side with the present in this context and, as the group's first exhibition showed, the present in art was derived from the past, even if it was fairly recent. Indeed, this belief would be displayed in later exhibitions such as those on the influence of Japanese art and the development of impressionism.[21] Already in 1896, Wagner in his, *Moderne Architektur,* had rejected the imitation of history, but not its influence.[22] Similarly, Bahr, who came closest to being the Secession's ideologist, could declare in his book on the Secession, "We say to the artist, 'Take your means from all times, […] express what we feel, express in your own way our life!'"[23] In fact, in architecture

Austrian exhibit at World Exposition in Paris, 1900. Photo: Bildarchiv der Österreichischen Nationalbibliothek

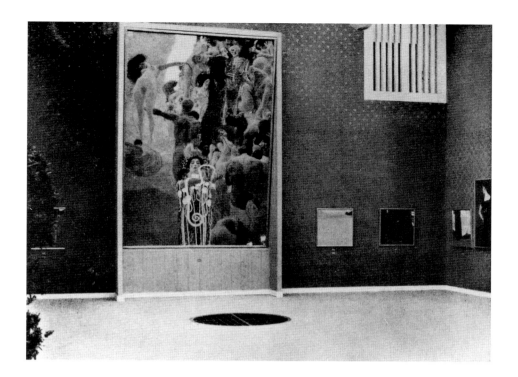

Gustav Klimt's *Medicine* in main hall of 10th exhibition of the Vienna Secession, 1901. Exhibition design by Kolo Moser.
Photo: Archiv der Wiener Secession

and painting, modernism in Austria was to very seldom stray from the classical and the figurative whether it was in the work of the anti-Secessionist Adolf Loos or the Secession-inspired Egon Schiele.[24] A modernism that was so cognizant of its roots was made to order for an Austria whose raison d'être was history.

The reality of the Austrian Rechtsstaat, however, indicated that Austria's existence was not simply a museum piece. The Monarchy's commitment to the rule of law was an example of how change with continuity led to the creation of something vital and positive. What was occurring in the development of Austria's modern art mimicked this evolutionary process and its results. The latitude afforded artists to create as they pleased in the Secession was made possible by the constitutional guarantees of individual rights that were upheld by Franz Joseph himself. That this

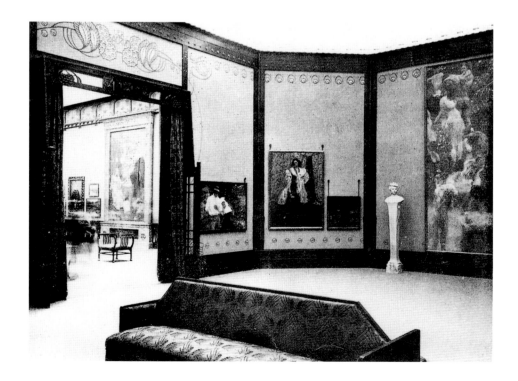

View into hall designed by Josef Hoffmann at World Exposition in Paris, 1900, with Gustav Klimt's *Philosophy* on the right.
Photo: Archiv Sabine Forsthuber

was not lost on Secessionists is illustrated by Wagner's reply to Bertha Zuckerkandl when, in 1900 during the controversy over Klimt's *Fakultätsbilder,* she asked if he was not concerned about losing his teaching position at the Art Academy because of his association with a group as controversial as the Secession. He answered, "That could happen to one under an autocratic regime. But Emperor Franz Joseph—and therefore I am a supporter of the monarchy—holds himself stubbornly and properly to the constitution."[25] In fact, although Klimt's career was to suffer somewhat from the controversy, it never resulted in any general popular or official backlash against artistic modernism in Austria. Unlike in the Germany of Wilhelm II, where at this time modern art was seen by the dynasty as threatening, even the conservatism of the heir to the throne, Archduke Franz Ferdinand, could not prevent the free development of modern art or, as would become apparent, its official encouragement.[26]

If by the end of 1898 and the close of the century the Secession in its art and its world view had taken on the dual identity of being modern and Austrian, how was this identity expressed by it and its members? In the imperial period, at least, it was expressed in many ways, too many, in fact, to be discussed here except by representative examples. The leitmotif of the Secession and its members in this period, however, was expressed by Bahr when he said, "I believe that we shall prepare a new Austria […] I am certain that we are called to give a new form to our old common being [Volkswesen]: to create our Austrian culture."[27] This duty was to be interpreted in a variety of ways.

One of these took the form of involvement with the state. Members of the Secession were no strangers to state involvement with art. Klimt had done decorative paintings for the Burgtheater (Court Theater) and the Kunsthistorisches Museum (Art History Museum), and, while still in the Künstlergenossenschaft, had been commissioned to do the allegorical representations of the philosophical, medical, and jurisprudential faculties (the *Fakultätsbilder*) at the University of Vienna. Similarly, Wagner had designed the imperial reviewing stand for the 1879 jubilee and was a professor at the Academy. Even the young Josef Hoffmann had been commissioned to do the "Viribus Unitis" room at the 1898 Jubilee Exhibition and the binding for the commemorative publication of the same name.[28] The opportunities for further association with the government only increased after the founding of the Secession. Through the art section of the Ministerium für Cultus

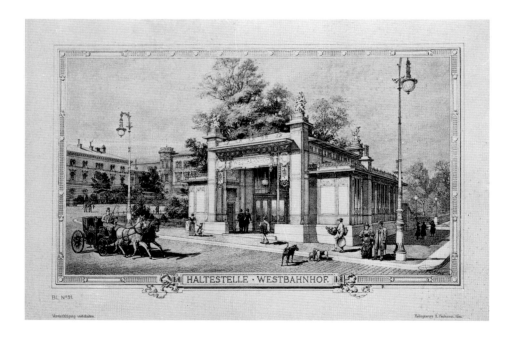

Otto Wagner, *Stadtbahn station Westbahnhof,* 1897.
Photo: Archiv Otto Kapfinger

und Unterricht the government carried out a conscious program of supporting the arts as a means not only of imperial representation, but also as a way of co-opting art and artists that it saw as useful and inclined to further ideas or values that supported the state. The Secession with its multi-national composition, dedication to Austrian culture, and evident loyalty to the existing order was a natural candidate for state support.[29]

One of the first signs of state favor came in relation to Austria's participation in the Paris World's Fair of 1900. In that year half the appointments of the 10 member artistic representation on the official committee for the fair were members of the Secession[30] and after considerable lobbying and protest it was allotted a major share of the exhibition space and a 6,000 florin subvention.[31] In 1899 Wagner and the Secessionist Carl Moll were appointed to the Ministry's new *Kunstrat* (Art Council) which dealt with a wide variety of public issues relating to the arts. There the two men successfully pushed for the creation of an official gallery of modern art. Although it would not be realized under the Monarchy, the Secession donated works for its collection and the state made purchases from Secession exhibitions.[32] Appointments to state art schools were also a sign of official approval. Early on, Secessionists were to be found at the Academy and, in particular at the Kunstgewerbeschule (School of Applied Art). There they became very influential, and in 1899 supplied its director in the person of Felician Freiherr von Myrbach.[33] In 1908 Moser, although by then a Secessionist in spirit rather than by membership, was commissioned to design seven postage stamps on the occasion of Franz Joseph's Sixtieth Jubilee.[34] Thus in matters great and small, the Secession and its members found favor in official circles.

The Secession, however, was not passive in its relationship to the state and freely participated in public controversy. Aside from its support of Klimt over the criticism of his allegorical imagery in the *Fakultätsbilder* (1900–1905), the Secession involved itself in debates over the design of banknotes and the proper restoration of St Stephen's Cathedral.[35] With somewhat less success it also dealt with the city of Vienna. Although it had gained its building plot from the city[36] and Wagner was already building the Stadtbahn when the Secession began, the Christian Socialist ideology of the city government under Karl Lueger and his successors meant that its arts policy tended to be more conservative than that of the state. Joseph Engelhart, one of the Secession's founders, was a member of the party and

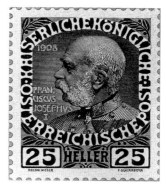

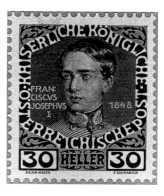

Imperial Jubilee postage stamps, 1908, 25- and 30-penny stamp after a design by Kolo Moser (steel engraving by Ferdinand Schirnböck). Photo: Bildarchiv der Österreichischen Nationalbibliothek

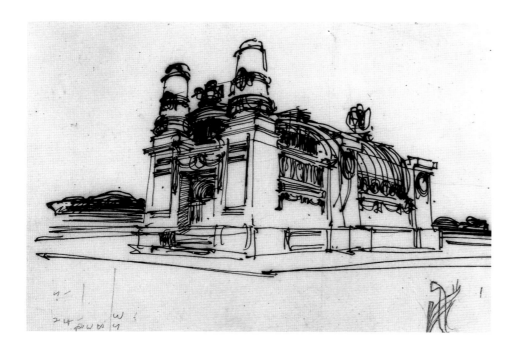

Joseph M. Olbrich, study for *Stadtbahn station*, 1897. Photo: Stiftung Preußischer Kulturbesitz, Staatliche Museen, Kunstbibliothek Berlin

through him the Secession retained a link to the Rathaus (City Hall), but as Wagner's unsuccessful struggle from 1900 to 1912 to build a city museum testified, artistic modernism was not always to the city's taste.[37] Given the Secession's keen interest in creating Gesamtkunstwerk environments, it is ironic that it was never able to put its ideas to the test in its native urban environment. Despite Wagner's praise of city life in his 1911 book, *Die Großstadt* (The City), and his presentation there of a design for a new XXIInd District for Vienna, Secessionist ideas and Viennese city planning found no common ground. It found more consistent favor with the city's main opposition party, the Social Democrats, who, though without municipal commissions to hand out, generally looked with favor on the Secession's art and appreciated its gesture of inviting workers at reduced rates to its first exhibition.[38] While the invitation had been made in the spirit of the Künstlerschaft, rather than from sentiments of socialist solidarity, it probably set a favorable precedent for a future when social democrats would control the awarding of commissions.

At the same time that the Secession was being recognized by official and unofficial political circles as the dominant expression of artistic modernism, that same perception continued among the public, but with success came problems. There was a large demand for Secessionist art, especially in its applied form. This led to the founding in 1903 by Hoffmann and Moser, with the financial backing of Fritz Wärndorfer, of the *Wiener Werkstätte* (Viennese Workshop). By this time the Secession had grown to a much larger group of artists and the group's very diversity provided the basis for division. A conflict with the government over who would be exhibited at the 1904 St. Louis World's Fair seemed to many lesser lights in the membership to have been waged for the benefit of a few artistic stars. With Klimt, Hoffmann, and the other leading figures occupying commanding positions in public popularity they were also in possession of the high ground of economic success. Klimt and other notables, like Hoffmann and Moll, were doing well, and against the backdrop of the Werkstätte's commercial success a proposal by Klimt and Moll that the Secession should buy the Galerie Miethke as a sales outlet led to

Otto Wagner, *project for XXIInd district of Vienna,* 1910.
Photo: Bildarchiv der Österreichischen Nationalbibliothek

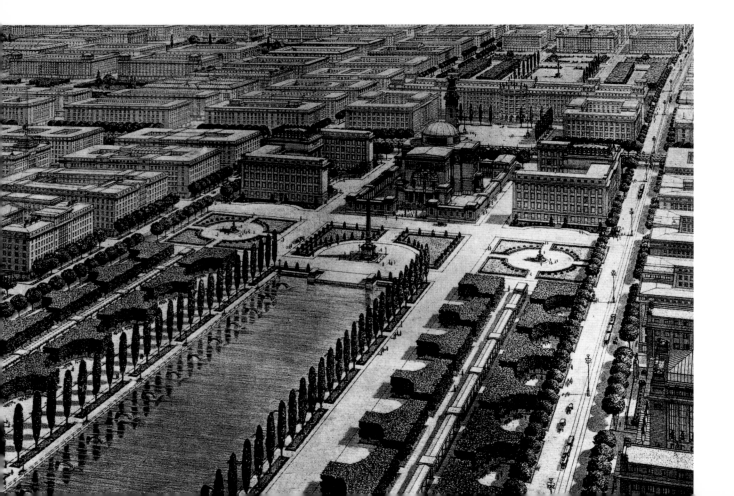

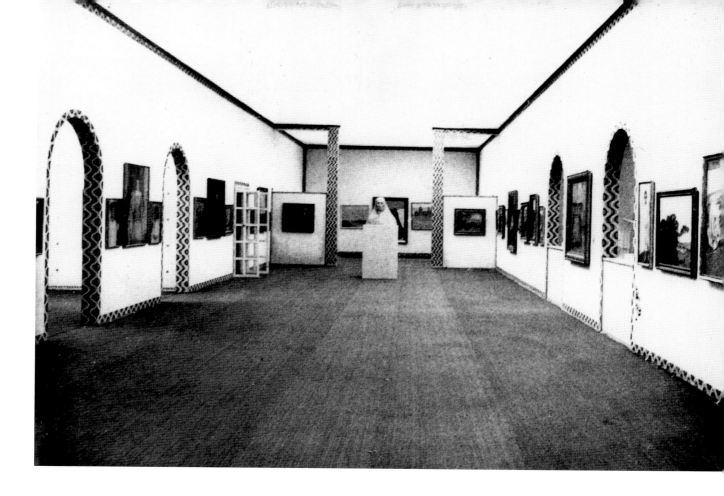

a negative vote and the departure of Klimt, Moll, and most of the Secession's leading figures. Ironically, the split was ostensibly over the same issue of commercializing art that had been leveled against the Künstlergenossenschaft 8 years earlier.[39] Although in philosophical terms the split left the institutional Secession in a position that, according to the original intentions of the group, was morally correct, it now left the association with the stylistically less prominent and less creatively imaginative members. After 1905 there would be two Secessions, one with the name and one with the spirit.

What became known as the *Klimt-Gruppe* (Klimt Group), as well as the formal Secession, continued to adhere to the ideas of 1897, but during the jubilee year of 1908 when both groups mounted special exhibitions in honor of the occasion it was the Klimt-Gruppe's *Kunstschau* (Art Show) with its own buildings, Gesamtkunstwerk format, and willingness to sponsor new artists, such as Schiele and Oskar Kokoschka, that seemed more like the original Secession than the lacklustre show in Olbrich's building. In fact, even the building itself was no longer the same. A renovation that year had resulted in the removal of the Secession's motto from over the entrance and the elimination of all decoration produced by the artists who had left in 1905.[40] Symbolically, at least, the division was consummated, but what did this mean for the two identities the Secession had come to represent?

Artistically, the Secession's modernist identity was now divided and therefore no longer an exclusive one. The split in 1905 ultimately accomplished what the Secession had always claimed as one of its goals, the dissemination of a modern Austrian art. Division in the ranks of the Secession meant that the public's attention would no longer be so myopically focused on what happened in Olbrich's building on the Karlsplatz. With the appearance of the Klimt-Gruppe, the diversity of the Secession's modernism was extended beyond its formal boundaries, and the Kunstschau's embrace of new artists like Schiele and Kokoschka, who also

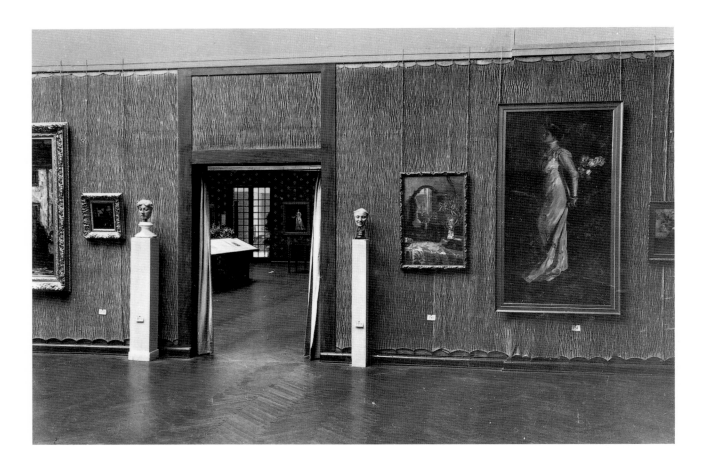

Left rear space of 37th exhibition of the Vienna Secession, *Die Kunst der Frau*, 1910.
Photo: Bildarchiv der Österreichischen Nationalbibliothek

represented the new modern style of expressionism, demonstrated that the Secession as a movement based on a set of ideas had succeeded in nurturing a freer and, therefore, more creative atmosphere for Austrian art. The members of both Secessions could claim the credit for that success. In the future, however, both representatives of the Secession would rest on their laurels. The Klimt-Gruppe ceased to mount major exhibitions after the Kunstschau closed in 1909, but the institutional Secession continued after 1905 its regular schedule of 2 to 3 exhibitions a year. Although few of them were artistically exciting, the exhibitions remained didactic, international, and even encouraging of neglected talents which included women, as well as younger male artists.[41]

In terms of its Austrian identity, both groups remained committed to the Secession's original intent. They had helped to bring into being a modern 'Austrian' art and there was no real sign that they had forsaken the ideas that made the Secession so compatible with the "Austrian idea". In 1905 the Klimt-Gruppe still talked about their dedication to furthering the 'influence' of art over the 'expressions of modern life,' and at the opening of the Kunstschau Klimt asked for more public commissions as a means toward the goal of contact between artist and public[42]. In the Secession itself, the exhibitions, though showing some signs of a German bias, continued to present the work of non-Austro-Germans and this ethnic diversity was also still represented in its membership.[43] It was a respectable part of the Austrian cultural establishment and , as such, was consulted and listened to by the authorities,[44] but its very success at connecting modern art to an Austrian identity and winning acceptance from the public had, by the last years before the war, diminished its influence; and the same could be said for the Klimt-Gruppe. Both artists and the state felt the need for a new organization to further the development and impact of modern Austrian art.

This new institutional form was the *Österreichischer Werkbund* (Austrian Crafts League). Since 1907 Josef Hoffmann and the Wiener Werkstätte had been involved

with the German Werkbund movement and by 1912 the Austrian state had begun to take an interest in its approach to applied art and its 'sachlich' (essentialist) character as a means of enhancing the further development of Austrian production in this area. Accordingly, with official blessing and a membership that included Hoffmann, Klimt, Wagner, and Hugo von Hofmannsthal as well as government agencies and major industrial concerns and associations, the Österreichischer Werkbund was founded in Vienna with great ceremony on April 30, 1913. Hofrat Dr. Adolf Vetter, the bureaucrat in charge of furthering craft production, spoke of the Werkbund idea as a means of pushing Austria beyond the stylistic achievements of the Secession and even saw it as leading to a 'Staatskunst' (state art) that would somehow unite the disparate elements of tradition, liberalism, and 'völkisch' elements.[45] On the other hand, Adolf Freiherr Bachofen von Echt, declared that the new organization would "encompass the entire realm with all its nations" even though he could also envision the seemingly contradictory founding of separate but associated Bohemian and Polish Werkbund organizations.[46] There was, in fact nothing very clear about this new undertaking except that it would be modern and

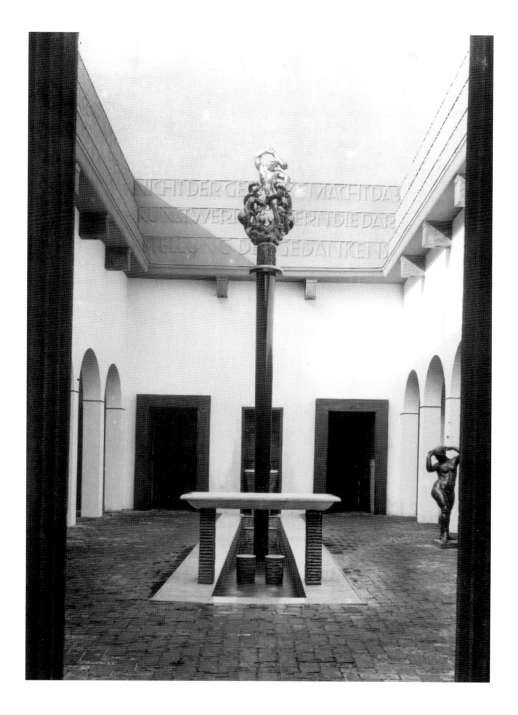

Werkbund exhibition, Cologne, 1914, Austrian pavilion, view of courtyard, designed by Oskar Strnad (probably with Josef Hoffmann).
Photo: Bildarchiv der Österreichischen Nationalbibliothek

Austrian, concepts that were clearly a continuation of Secessionist principles. The presence at its birth of Hoffmann, Klimt and other Secessionists suggested that despite its 'sachlich' intent it would not stray too far from the Viennese version of a more decorative applied art. In fact, as subsequent events were to show, the new group's concentration on architecture and crafts would be strongly influenced by Hoffmann's presence. Its 'Austrian' character, however, reflected an understanding of what it meant on the eve of World War I that was more problematic than it had been even in 1897.

Since the Badeni crisis, the Emperor and the state apparatus had increasingly taken the political initiative as the Reichsrat became less capable of resolving the obstructionism caused by the conflict between Czechs and Germans. In addition to invoking Article 14 to continue the business of state during these crises, the imperial government also attempted political reform from above, such as the introduction of universal manhood suffrage at the behest of Franz Joseph. When that failed to permanently resolve national tensions, from 1905 to 1914 the state engaged in encouraging a series of piecemeal *Ausgleiche* (compromises) between the nationalities of Moravia, the Bukovina, and Galicia while continuing to try to push for a similar success in Bohemia. These compromises meant that the Austrian half of the Empire was taking on a defacto federalist character, but paradoxically this process was being made possible by the increase of power at the center, i.e. the Emperor and his government, due to the decline of parliament. It is not surprising that the uncertainty of this transitional process was being reflected in the confused artistic visions behind the Werkbund. Generally, as the imperial government became the final bulwark of an orderly Rechtsstaat and exercised its authority appropriately, classicism and a return to Biedermeier forms emerged from Austria's diversity of styles as historically complementary models for a more monarchically centered society.[47] When war broke out in 1914 the two identities that the Secession had tried to secure through its art were showing signs of flux and by war's end the Secession and its heritage would face the daunting task of trying to salvage and preserve them.

The beginning of the war found the formal Secession holding its spring exhibition which was focused on the work of the Spanish painter Claudio Castellucho and the

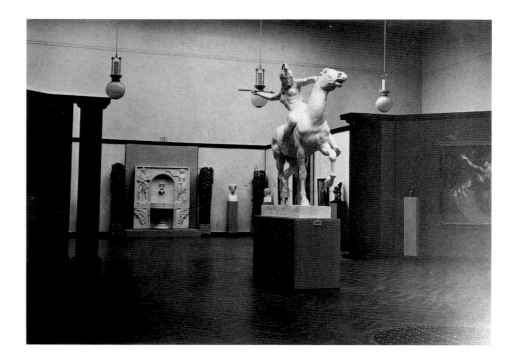

47th exhibition of the Vienna Secession, 1914, main hall with *Amazon* by Franz von Stuck. Photo: Archiv der Wiener Secession

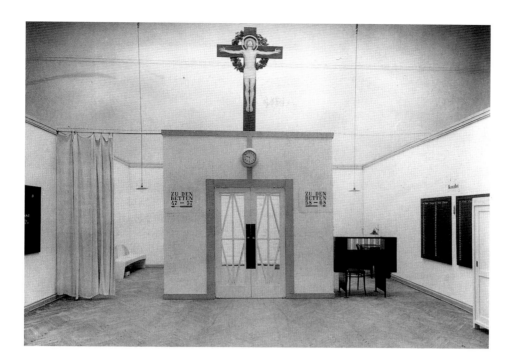

life-size model for a statue of a mounted *Amazon* by Franz von Stuck. This mediocre show closed shortly after the fighting began, and the Secession's building became a reserve Red Cross hospital for lightly wounded soldiers until 1917.[48] The Secession was able to express the patriotic side of its Austrian identity by not only giving over its home to the war effort, but also by organizing, along with the Künstlergenossenschaft and the Hagenbund, the *Kriegshilfscomitee bildender Künstler* (Artists' War Help Committee) as part of the *Kriegsbüro* (War Bureau) of the Ministerium des Innern (Ministry of the Interior). This organization was meant to encourage a degree of artistic quality in the visual propaganda being generated for the war. The committee was empowered to hold competitions and award commissions. This latter activity became a means of helping shore up the deteriorating economic conditions of artists caused by the disappearance of the peacetime market, a situation which would remain a problem even after the end of the war. By 1916 the committee had succeeded in producing 153 pieces of high quality war art.[49] As was to be expected, the Secession's membership also participated in the production of war art and included the likes of Maximilian Lenz, Rudolf Jettmar,[50] and Engelhart, whose patriotically motivated sketches of the high treason proceedings against the Young Czech political leader, Karl Kramář, would form a prominent part of the Secession's first wartime exhibition in the fall of 1917[51]. Of those who had left in 1905, Alfred Roller lent his talents to the war[52] while Hoffmann, like many other architects, designed monuments and graves for the war dead[53]. Otto Wagner, among other projects, worked on a *Friedenskirche* (Peace Church) for the post-war era, and showed his patriotism by refusing to buy food on the black market with the tragic consequence of fatally weakening his resistance to disease.[54]

Projects for a post-war Austria, however, were not only to be found on the drawing boards of architects. The Secession was also concerned with this issue and in November of 1917 its Secretary, Rudolf Lechner, proposed the creation of a *Künstlerkammer* (Artists Chamber) to represent the interests of artists and the arts in a peacetime Austria. In his view, the various artists' associations, including that of architects, should band together as an overarching lobbying group in order to present the government with a united front capable of decisively influencing it in their favor. Although he assumed that an imperial Austria would still exist after the war, Lechner also realized that times were likely to be difficult and, therefore, artists

needed to be as strongly represented as possible if their interests were to be protected. Unfortunately, his proposal seems to have foundered on the opposition of the architects, but Lechner's idea would find a more favorable hearing after 1918 when post-war conditions proved to be far more disastrous for the arts than he had imagined.[55]

Lechner's plan showed that the Secession, even in the midst of the war, was still aware of its responsibilities to Austrian art and in its last major exhibition before the collapse of the Monarchy, it also reasserted its identity as a group dedicated to modern art. The 69th exhibition opened in March of 1918 and scored a success as Schiele's only major show before his death in November of that year. Exhibiting with him, however, were other young artists such as Anton Faistauer, Alfred Paris Gütersloh, and Alfred Kubin, all of whom had grown up in the shadow of the Secession and now represented the coming generation of modernists in Austria.[56] Unfortunately, the encouraging signs of the Secession's renewed activity were not matched by the events happening around it. By November of 1918, the creative core of those who had left in 1905, Klimt, Wagner, and Moser, were dead. Only Hoffmann survived as a still major figure from the pre-war days and, although he would not effectively rejoin the Secession until 1945, the devastation of the war years brought a defacto close to any real sense of there being a divided Secession. But if the war can be credited with restoring the Secession to a kind of unity, it proved fatal to that of the Habsburg Monarchy. Military defeat and territorial dissolution led Franz Joseph's successor, Karl I, to remove himself from the government on November 11 and on the following day Austria became a republic.

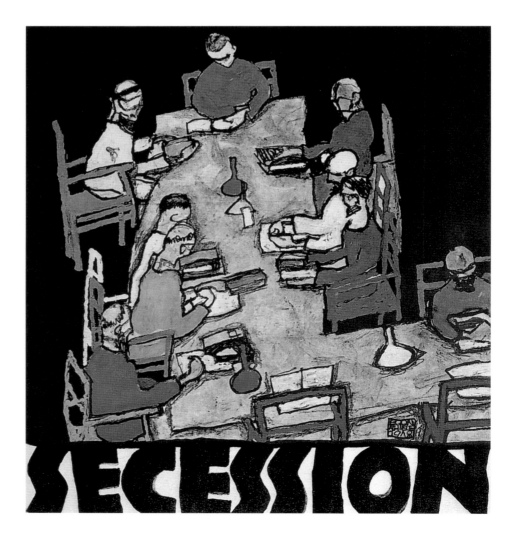

Poster for 69th exhibition by Egon Schiele, 1918.
Photo: Archiv der Wiener Secession

53rd exhibition, Josef Engelhart, 1919.
Photo: Bildarchiv der Österreichischen Nationalbibliothek

The birth of the first Austrian republic was not a happy one. Not only was it generated by the effects of military and political catastrophe, but its survival beyond birth was an unintended accident that would leave it malformed for the rest of its existence. The intention of the socialist Karl Renner and the Christian Social leadership that went along with the initiative of the social democrats, was to unite Austria to Germany and its ethnic kindred. Indeed, the name of the new republic was, initially, *Deutschösterreich* (German Austria). It was felt that without its imperial hinterland a separate Austria made no sense and was neither politically nor economically viable. Although there was only token dissension to this analysis at home, abroad the victorious Allies were not willing to see Austria become a kind of territorial consolation prize for a Germany they had just defeated. Accordingly, Austria was forbidden to join the new German republic and this stipulation was written into the peace treaty. The result was that by 1919 Austria was forced to accept life against its will and to find the means both to survive and to justify the validity of that survival. Culture, and hence the Secession, would become a significant element in that effort, but only as the weak counterpoint to an ultimately self-destructive politics.

The political life of the new republic was characterized by the leitmotif of an ongoing identity crisis that, in turn, was dominated by the ideological conflicts of its two main parties, the Christian Socials and the Social Democrats. They represented the mainstream parties of the right and left, respectively, and each stood for fundamental positions that were diametrically opposed to one another. Thus the right was Catholic, tended to favor being "Austrian," accepted capitalism, was generally provincial in its composition, and had monarchist leanings; while the left was aggressively secular, wanted union with Germany (until 1933), believed in Marxist economics, was overwhelmingly urban, and stood solidly for republicanism. For most of the period up to 1934 the two parties were led by men who embodied these dichotomies: Ignaz Seipel, a Catholic priest, and Otto Bauer, a Marxist

theoretician. Seipel was the Republic's most significant Bundeskanzler (Federal Chancellor) and his party the one most often in control of the government, but Bauer influenced only his party and his party controlled Vienna and not a great deal more. The stage was set for conflict and as the bloody events of July 1927[57] showed, it could occur in the street as easily as in parliament. Austria's ideological division made it difficult to find common ground between the two sides, and the situation was only exacerbated by the disjuncture between the political culture of the First Republic and that of the Habsburg Monarchy.

The post-1918 Austrian Rechtsstaat was a political legacy from its imperial predecessor, but the new constitution of 1920 could embody only a portion of that legacy and represented political modernity without the support of political tradition. Austria's transition from a monarchy to a republic had been sudden and the result of circumstances caused largely by military defeat. Neither political evolution nor genuine revolution had led to the founding of the Republic and when it was prevented from subsuming itself into the new German state the problematic nature of its origins, although obvious, were expediently ignored. The demands of the Allies, the interests of the Empire's successor states, and the realities of Austria's domestic politics dictated that she continue on a path to a republicanism that could find only a partial precedent for its existence. Given the monarchical origins of the Austrian Rechtsstaat and the important role played in its creation and legitimation by the dynasty and traditional institutions associated with it, the post-1867 era of constitutionalism was a weak foundation on which to construct the Republic, especially since it was primarily the Habsburg state that had kept that foundation in place after 1897. Following the events of November 1918 there was no traditional order to fall back on or to act as an umbrella under which disparate social and political interests could compete and still rely on the stability of a political structure that was defacto 'guaranteed' by an authority claiming the permanence of history. For all its problems, the Habsburg Monarchy provided the possibility of change with continuity, while the Republic seemed only capable of change with discontinuity.

The competing ideological claims of the Christian Socials and the Social Democrats could not be reconciled by a republican Rechtsstaat that depended on these same parties for a consensus in favor of its existence. Throughout the Republic's life, including its *Ständestaat* (Corporate State) phase, such a consensus was conditional and dependent on the immediate international and domestic contexts as well as the relative strengths of the competing political interests. Civil society in the post-1918 period lacked a viable unifying principle and an overarching source of authority to support it as had been the case with the "Austrian idea" and the Habsburg dynasty. Democracy, federalism, and even the increased powers of the president after 1929[58] were unable to coalesce into a powerful enough legitimating force capable of overcoming ideological division and establishing a consensus for a new popularly based "Austrian idea". Instead, in the pre-1934 Republic, before the collapse of parliamentary government had led to civil war, persistent ideological division exacerbated economic hard times and produced a perception that the past was a more appropriate model for the future than was the present and Austrian culture in this period, including the Secession, appeared to represent the potential of this more positive heritage.

Before the war the popular perception of culture was that of a largely unpolitical phenomenon practiced by academicians and artists. Although it could and did clearly serve nationalist and ideological interests, as in the cases of Czech political agitation and a Social Democratic "workers' culture", there was agreement across the broad spectrum of imperial Austrian society on the verities of classical Western culture; and even German cultural achievements, including those of Austro-Germans, enjoyed grudging admiration among the Monarchy's non-German

peoples. The Social Democrats, as well, despite the Marxist labeling of culture as a bourgeois creation, relied heavily on the classics in their formation of the 'new men.'[59] Only folklorists and the 'völkisch' fringe deviated significantly from this pattern, while popular or 'mass' culture occupied a clearly subordinate and lesser position in the cultural hierarchy.[60] The scholarly characterization of culture as something that developed over time as a kind of organic process added the weight of history to its legitimation as something that transcended the squabbles of everyday life. Given this intellectual bias and the importance placed on history in the raison d'être of the Habsburg Monarchy, it was little wonder that the Secession had promoted modern art as change based on continuity. Moreover, the Secession in pushing its Austrian, Habsburgtreu (Habsburg-true) credentials had further underlined its transcendent vision of art as a diverse yet unifying phenomenon. In the uncertain and disappointing atmosphere of the First Republic culture and, by extension, the Secession, stood for the continuation of a positive tradition from Austria's better past that had an appeal across party lines.

This perception of culture as standing for something higher and better than conditions in the First Republic was acknowledged, ironically, by the desire of the competing parties to lay claim to it. The continuation and enlargement of Hofmannsthal's Salzburg festival with its 'baroque' (Habsburg) message of unity found patronage from the conservative, Catholic camp[61], while Social Democracy's ongoing difficulty in creating a socialist culture without the use of bourgeois 'classics' showed its adherence to the traditional Austrian definition of culture as above the mass, i.e. an 'elite' culture that came from the imperial era.[62] Though in the case of Social Democracy it was unintentional, the continuity in cultural matters between the Republic and the Monarchy often carried with it a nostalgia for the Empire.[63] Indeed, the so-called 'revolution' of 1918 left practically no trace in Austrian cultural circles[64] which further added to their image as something linked to the 'good old days' of an 'überparteilich' (above-party) Austria.

The lack of political radicalism in cultural circles following the 'revolution' was particularly noticeable among artists. Unlike Germany, where the fall of the monarchies had led to the appearance of politically left-oriented avant-garde associations like the *Novembergruppe* (November Group) and the *Arbeitsrat für bildende Kunst* (Work Council for Fine Art), in Austria such organizations were few and short-lived and made no lasting political impression. In fact, most such groupings seem to have been of young artists simply trying to promote themselves and their art in the difficult post-war circumstances.[65] This lack of radical feeling or enthusiasm for the Republic and the workers movement seems to have also been typical of the Secession which emerged from the collapse of the Monarchy without the bulk of its corresponding members, with an awareness that it would probably lose financial patronage, and anger at what it perceived as inadequate protection of Austria's cultural patrimony by the new Republic.[66] In the arts, the advent of republicanism was not a cause for celebration. Inflation, the rise of Philistine speculators, the impoverishment of the cultured bourgeoisie, and a greatly reduced state budget meant that artists faced a desperate situation.[67]

It was clear to the Secession and the other artists' associations that the passing of the Monarchy was bringing hard times for Austria and its artists, and it was necessary that they work together in order to mitigate the unfavorable conditions. Rudolf Lechner's 1917 proposal by the Secession for an umbrella organization that could protect the post-war interests of artists and art, generally, was revived in 1919 as a more ambitious project to create an *Amt für Schöne Kunst* (Office for Fine Art) within the old Ministerium für Cultus und Unterricht. Although his wide-ranging vision of a bureaucratically guaranteed artistic establishment was not taken up, it does seem to have been part of the efforts that finally led to the founding of

the *Ständige Delegation* (Standing Delegation) composed of the Secession, Künstlergenossenschaft, and Hagenbund. The Delegation was similar in spirit, if not size, to Lechner's original idea of a *Künstlerkammer* that could offer some degree of protection, independence, and representation for the arts.[68] Additionally, the pressure of necessity pushed the three associations plus the old Kunstschau group to achieve a level of cooperation among themselves in the 1920's and 1930's that was unheard of before 1918.[69] Although these efforts were aimed at creating a favorable atmosphere for art overall, they still reflected the pre-war view of the state as the natural source of support for institutions which, like itself, had an interest in establishing stability and order in their own spheres.

Unfortunately, this expectation was never fully realized even under the more representationally oriented Ständestaat. The federalized structure of the Republic and Austria's drastically reduced economic base left the central government with far fewer resources than had been the case under the Monarchy. The lack of any clear concept of an Austrian identity before 1934 also left the state with less motivation to use art as a propaganda tool. It was more concerned with turning its attention to educational issues where the main ideological battle between right and left was being fought.[70] All governments up to 1938 were interested in Austria being perceived as a leading *Kulturstaat* (Cultural State) in order to attract tourists and recapture some of its pre-war glory, but in practice this meant putting resources into maintaining the many cultural institutions inherited from the Monarchy and, above all else, in promoting Austria and Vienna as the premier homes of traditional high culture and of classical music, in particular.[71] Artists, like other cultural figures and their organizations, continued to receive some financial support and were consulted by the new Ministerium für Unterricht (Ministry of Education) on appropriate matters, but the state now shared its role of patron with the city of Vienna which became a source of commissions second only to the government. Like the state, it consulted the artistic establishment on a regular basis and also handed out subventions, but unlike the state it carried out an extensive long-term construction project in the form of municipally financed workers housing that required the services of architects and artists on a large scale. The *Kommunaler Wohnbau* (Municipal Housing Projects) were examples of the Gesamtkunstwerk in service of socialism and aimed at creating environments conducive to a socialist world view while also relieving a desperate shortage of affordable housing. Members of the Secession and figures as diverse in their artistic views as the architects Hoffmann, Loos, and Josef Frank found work on these projects and were employed by the socialist administration without regard to politics.[72] In general, the political division between the state and its capital did not stop them from patronizing the same artistic establishment. Both sides gained the practical use of the available talent and the benefits of associating themselves with the 'untainted' values of culture.

The Secession's participation in occupying the middle ground of an idealized 'überparteilich' culture was also reflected in its purely artistic activities. The principle of diversity remained a constant in the Secession up until the eve of the Anschluß. Its post-1918 exhibitions continued to show both what was new and what was old in Austrian art, but the artistic cosmopolitanism of its pre-war days was considerably diminished in the more parochial atmosphere of the Republic. Under the Monarchy the Secession stood as the multi-national and European representative of art in a society where those traits were seen as complementary to the state's raison d'être. Now, as part of a society traumatized by the collapse of the Monarchy and in a state without a clear reason for existing, multi-nationalism was of no importance and Europe was a place where Austria carried on a precarious existence. Under these circumstances, interest in artistic innovation generated less public interest than previously and the Secession's commitment to

Above: Main central hall of 95th exhibition, *Meisterwerke der englischen Malerei aus drei Jahrhunderten,* 1927.
Photo: Archiv der Wiener Secession

Below: Unpacking the *Paterson Children* by Sir Henry Raeburn for the 95th exhibition, *Meisterwerke der englischen Malerei aus drei Jahrhunderten,* 1927.
Photo: Bildarchiv der Österreichischen Nationalbibliothek

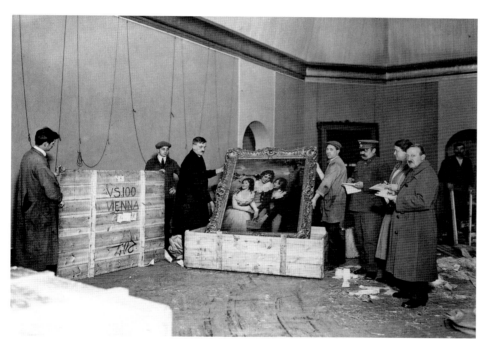

change with continuity tended to favor the latter element just as Austrian society tended to favor the past over the present. Thus, one of the first exhibitions held under the republic was the 1919 retrospective show devoted to a founding member of the Secession, Josef Engelhart.[73] Such retrospective exhibitions, including one devoted to Klimt in 1928, became a standard part of the Secession's repertoire and were among its most popular and critically successful shows.[74]

In 1923 the Secession became associated with the *Gesellschaft der Museumsfreunde* (Society of Friends of the Museum) and in that year joined with them in mounting an historical exhibition of Austrian art entitled *Von Füger bis Klimt* (From Füger to Klimt). It was a success and in virtually every year thereafter the Secession included an art historical show, usually from the nineteenth century or the fin de siècle. There were, however, some notable foreign shows of this genre such as that devoted to nineteenth century French art in 1925 and the 1927

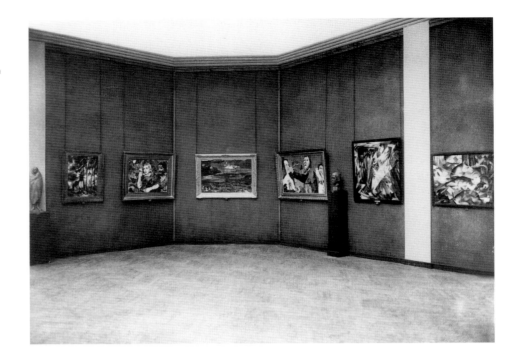

Meisterwerke der Englischen Malerie aus drei Jahrhunderten (Masterworks of English Painting from Three Centuries) which drew a record crowd of 60,000 to view a national school of art that was virtually unknown in Austria.[75] Such exhibitions, including the retrospectives, usually made money for their exhibitors, slaked the public's thirst for positive associations with the past, and continued the Secession's original commitment to educate the public about art.[76] The subject matter of these exhibitions also retained the principle of artistic diversity, but the real test of how faithful the Secession was to this commitment has to be based on its shows of contemporary art.

The dominant new styles in Austria after the war were expressionism, its variations, and some cubism. Dada, abstraction and other more avant-garde styles were barely known. Indeed, one historian has claimed that the Austrian art world was so turned in on itself that "[…] scarcely any foreign art journals or catalogues were purchase […]."[77] While this may be an exaggeration, it serves to point out that Austria was no longer in the forefront of artistic innovation. Even in expressionism Austria's most famous living practitioner of the style, Kokoschka, spent most of the period from 1918 to 1938 abroad as an ex-patriot alienated by the cultural and political conservatism of his countrymen.[78] Vienna itself had become less of a magnet for new talent and lost ground to the provinces as the Austrian source of creative innovation.

Although the Secession counted expressionists, such as Oskar Laske, among its members in the 1920's, many of its best representatives of the newer stylistic trends, among them Gütersloh and Robin Andersen, came to it after 1930 following the dissolution of the Kunstschau.[79] The Secession's efforts to connect with the new trends, however, dated from the earlier Schiele dominated exhibition of 1918 under the presidency of Richard Harlfinger who continued until the end of his term in 1919 to try to bring new art into the Secession. Although the Secession would exhibit the contemporary work of many new Austrian artists, including, as it had done before the war, that of women,[80] the only really significant exhibition of modern art held in its building was not its own. The 1924 *Internationale Kunstaustellung* (International Art Exhibition) was organized by the socialist based *Gesellschaft zur Förderung moderner Kunst* (Society for the Promotion of Modern

Art). It exhibited artists such as Marc Chagall, Wassily Kandinsky, and Pablo Picasso, and met with a mixed reaction, especially from the right.[81] Neither the Secession nor any other arts organization in Austria would attempt to mount another exhibition like it.

The Secession wanted to be modern and its pluralistic character moved it in that direction, but its commitment to a tradition of continuity and the generally conservative cultural atmosphere in Austria seems to have influenced it away from making any radical break with its own stylistic past. Modernism in the art shown at the Secession would remain heavily figurative and readily understandable to most viewers. The *Neue Sachlichkeit* (New Essentialism) of the 1920's and early 1930's found an echo in Austria and the Secession, but only because it could be adapted to existing traditions.[82] An association of artists that could mount two major exhibitions devoted to contemporary religious art, in 1925 and 1933, was not likely to be the source of any truly disturbing artistic innovations. Indeed, for most of the inter-war years the Secession could be characterized as based on concepts of "[…] enlightened academicism and moderate liberalism […]" in an institution that seemed as if it had become "[…] the guarantor of artistic quality[…]."[83]

By the onset of the Great Depression and the political crises of the early 1930's the Secession stood firmly in the artistic middle. While there were few groups that could match its institutional prestige, there were those that could surpass its involvement with modern art. In the 1920's the Hagenbund and the Kunstschau displaced the Secession as the leading associations interested in artistic change and as the

Viennese Werkbundsiedlung, at right front houses by Josef Hoffmann, behind it with plate houses by André Lurçat, at center the short side of houses by Adolf Loos and Heinrich Kulka, 1932.
Photo: Archiv Adolf Krischanitz

sources of exhibitions where it could be seen.[84] In the areas of applied art and architecture, however, the Werkbund took over completely from the Secession. In contrast to the Secession's original championing of crafts and modern architecture, especially in relation to the Gesamtkunstwerk concept, after 1918 it counted as no more than a fringe group in these areas. Its ideas were still influential in the Wiener Werkstätte until its demise in 1932, but it was clearly the Werkbund that inherited the Secession's commitment to innovation in form and function that had characterized its earlier 'heroic' phase.

The Werkbund had, of course, been founded expressly as a source for innovative design with the blessing of the Secession's leading figures, including Hoffmann, and after the war it was the scene of major debates about the direction of Austrian design. At the core of these debates was the issue of how much continuity there should be with the design ethic of the pre-war era. Hoffmann, who in the inter-war years became the 'grand old man' of Austrian design and its most influential figure at home and abroad, accepted the need for an evolving modernism, but opposed what he saw as radical breaks with the Secessionist traditions of creative genius and handwork. Twice over these issues Hoffmann led walkouts that resulted in the founding of rival organizations: the first in 1920 and the second in 1933. The 1920 break was healed in 1926 and the Werkbund went on to produce Austria's most famous architectural exhibition of the period. The 1932 *Werkbundsiedlung* (The Werkbund housing development) consisted of 70 modest single family homes designed by 63 architects erected on the then outskirts of Vienna. In addition to houses by Hoffmann, Loos, and other Austrians, there were also structures by André Lurçat and Gerrit Rietveld. It was the architectural equivalent of the 1924 modern art exhibition and, like it, was a less than stunning success. Despite the strong Gesamtkunstwerk implications of the Siedlung's largely *International style* designs, Hoffmann felt that the Werkbund itself was moving too far in the direction of industrial design and too far from the principles of handwork. He blamed the mildly leftist architect, Josef Frank, and his circle, and in 1933 precipitated a permanent break and the founding of the more artistically and politically conservative *Neuer Werkbund Österreichs* (New Craft League of Austria). The achievements that had made the Werkbund significant as well as the controversies that led to its final division owed a debt to ideas associated with the Secession, but it is a telling commentary on the Secession's relative position vis-a-vis artistic change that these events occurred elsewhere and with the participation of a *former* member.[85]

Although the Secession was able, at least, to maintain the unity of its own diverse membership, the Werkbund's division between an artistic right and left mirrored the reality of what was occurring in Austria politically. The onset of the Depression after 1929 worsened the material condition of most of the population and heightened the existing divisiveness of Austrian politics with the result that the general atmosphere, even in the arts, started to deteriorate. In 1932 the worsening economic situation moved the then president of the Secession, Othmar Schimkowitz, on behalf of the other major artists associations, to address an open letter to the state. Citing the mostly poor financial results of exhibitions since the war and the efforts to support modern and regional Austrian art in the face of an indifferent and art-historically oriented public, Schimkowitz underlined the urgent need for state support.[86] In the Secession's particular case it was already receiving annual subventions from both the state and the city of Vienna[87], but the economic crisis now moved the Secession to negotiate a more favorable contract with the Gesellschaft der Museumsfreunde and to mount more popularly oriented exhibitions like its 1933, *Leben der Frau* (Woman's Life).[88] This meant a defacto decline in its commitment to exhibit serious contemporary art. Still, the economic situation for art remained precarious.

Added to financial woes, were overt signs of ant-Semitism in the arts. Discrimination against Jews in Austrian society was hardly a rarity, but it seldom came so openly to the surface among artists as it did with the Secession and Werkbund during the last years of Austrian democracy. In 1932 the Secession was openly accused in the journal, *Die Stunde* (The Hour), of excluding the Jewish members of the defunct Kunstschau, while, nevertheless, accepting their gentile colleagues. Although unproven at the time, it seems borne out by the Secession's known lack of Jews in its membership.[89] A year later, during the conflict in the Werkbund, in a statement obviously aimed at their Jewish and socialist opponent, Josef Frank, the Hoffmann group claimed that the Werkbund had undergone a "Verjudung" (Jewishization). After the split, the Neuer Werkbund Österreichs, headed by the architect and staunch Catholic, Clemens Holzmeister, contained no Jewish or leftist members.[90] While these examples of anti-Semitism were far from what was being advocated by Austro-Nazis and others on the extreme right, their appearance in the years 1932–33 indicated that no aspect of Austrian life, not even culture, could stay completely above the growing political crisis.

When in 1933 the right moved against the remainder of Austrian democracy and Bundeskanzler Engelbert Dollfuß, with the support of the Christian Social party, declared on September 11 that Austria was to become a Ständestaat, the Secession was showing the exhibition on contemporary Christian art. Subsidized by the state and designed by the pro-Dollfuß Holzmeister, the exhibition was organized to coincide with the German Katholikentag (Catholic Conference) being held in Vienna .The declaration of the Ständestaat with its description as a Christian state had clearly been made during the Katholikentag to gain church support. Inadvertently, the Secession's exhibition had helped create an atmosphere useful to the birth of the new order.[91] What had been accidental, however, soon became intentional and in March 1934, one month after the brief civil war and suppression of the Social Democrats, the Secession, as part of the Ständige Delegation, joined the ruling Fatherland Front.[92]

The new regime intended to end Austria's identity crisis. Even Dollfuß' murder by Nazis during a coup attempt in July of 1934 had no effect on the regime's pursuit of its goal; the new Bundeskanzler, Kurt von Schuschnigg, was as dedicated to

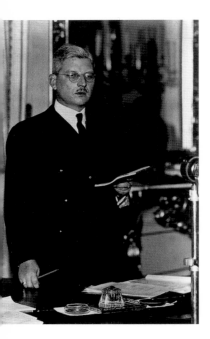

Kurt von Schuschnigg (1897–1977) at
the reading of his Christmas message
to the Austrian people, 1935.
Photo: Bildarchiv der Österreichischen
Nationalbibliothek

pursuing it as his predecessor. The leadership of the Ständestaat aimed at creating a so-called 'neue Zeit' (new era) for Austria in which all divisions and issues would be solved by a united people purged of competing parties and class conflict.[93] Although the regime claimed to be looking to the future, it planned to get there with a great deal of help from the past. For it to succeed, the Ständestaat needed to recapture the stability and unity of the Monarchy and it sought to do this by reintroducing the legitimating element of tradition into both the political culture of the Republic and the consciousness of individual Austrians.

The authoritarian, corporate, Catholic, and German character of the new order and its linkage to a modified constitutional system found its inspiration from the imperial period. The often dual offices of Bundeskanzler and Bundesführer of the Fatherland Front with their enormous political power were analogous to the position of the emperor and his authority; the corporate organization of society revived the pre-war social hierarchy in the guise of a technically classless order; the restored official position of the Catholic Church went back to the days of the Concordat; while designation of Austria as German capitalized on the post-1918 reality and the historical ethnic basis of the Monarchy. Finally, by retaining a constitutional structure for the Ständestaat that reproduced much of the 1920 constitution, including a list of personal rights and freedoms, the regime was identifying itself with the pre-republican Rechtsstaat that had been based on modern as well as traditional sources of legitimacy. Indeed, even the new constitution's concept of sovereignty attempted to combine the new and the old by declaring that law came from God, but was received by the *people*.[94] To add spice to this political ragout, the regime also took on some of the trappings of Italian Fascism, but its heavy reliance on the institutions and traditions of a pre-totalitarian past belied its admiration for Mussolini's Italy. Like its politics, the identity of the new Austria was to be an updated and modified version of what it had been in the Monarchy. God, country, hierarchy, and history defined what was Austrian and culture, including art, was a useful means of pointing that out.

This was not an easy task for culture to accomplish. Although the regime wanted to be seen as reintroducing the principle of change with continuity, it was such an arbitrary combination of past and present that the Ständestaat was really neither fish nor fowl. It was a *novum.* How was culture to relate to such a creation? One way, as Schuschnigg himself often pointed out, was to emphasize Austria's 1 000 year old mission as the protector and disseminator of Western and German culture in the east; yet another was to point to a connection with the recent cultural glories of the Monarchy; or still another approach was to praise the role of a God linked "Volksgemeinschaft" (People's Community) as a source of Austrian culture.[95] With such a range of possibilities, the Ständestaat's attempt to impose some direction and order on Austrian culture was self-defeating. Neither the authoritarian Kulturamt (Cultural Office) of the Fatherland Front nor the attempt at integrating cultural representatives into the government itself by setting up a Bundeskulturrat (Federal Cultural Council) and appointing Holzmeister to the Staatsrat (Council of State)[96] did more than insure that cultural confusion would be the order of the day. The only unified result of all these different viewpoints was to assert their common conservative outlook as the official character of Austrian culture. Even in the assertion of that principle there was less than complete consistency, the arts included.

While the conservative character of Ständestaat policy was not entirely alien to existing tendencies in Austrian art, the idea of following any sort of single policy was. The mixture of new and old art in exhibitions was threatened by the regime's desire for uniformity, and in 1935 the Secession, along with the other two associations of the Ständige Delegation, directed a resolution to the government denouncing "[…] the now usual dictatorship in questions of art […]" and the danger

Clemens Holzmeister, Seipel–Dollfuß-
Gedächtniskirche, 1933–34,
Vienna, 15th district.
Photo: Margherita Spiluttini

of their limiting effect on artistic development.[97] In fact, though exhibitions devoted
to contemporary artists generally received little encouragement from the state, they
were normally not forbidden and continued to draw their usual small crowds.[98] The
state itself was also inconsistent and could often show a positive attitude toward
modern art. Thus, the painter Herbert Boeckl, a figurative expressionist, was the
first winner of the new *Großer österreichische Staatspreis* (Great Austrian State
Prize) for art and was very successful until the Anschluß, while in 1937 Ludwig
Jungnickel won it for a rather abstract study of poloplayers.[99] Similarly, Austria's
participation in most foreign exhibitions such as the 1934 *Austria in London* and the
1937 Paris World Exhibition included moderns such as Kokoschka, Andersen, and
Max Oppenheimer.[100] Still, if one surveyed the domestic scene, it was clear that
conservative and ideologically supportive art was preferred.

The most powerful figure in the Austrian art world during the Ständestaat was
Clemens Holzmeister, an architect who worked in a kind of "sachlich" classicism

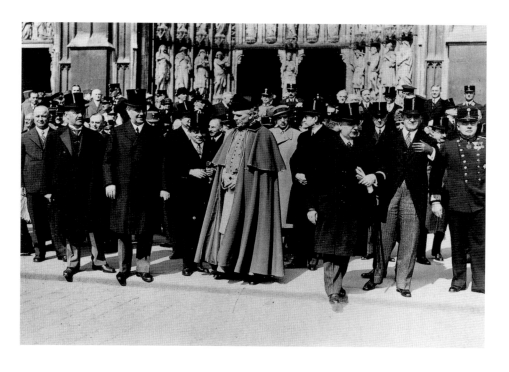

Before the portal of the Votivkirche in
Vienna, at memorial mass for police
killed in the February conflicts, 1934.
From left to right: Josef Kresse, Karl
Buresch, Richard Schmitz, Engelbert
Dollfuß, Theodor Innitzer, Karl Freiherr
von Karwinsky-Karwin, Wilhelm
Miklas, Emil Freiherr von Fey, Eugen
Seydel.
Photo: Bildarchiv der Österreichischen
Nationalbibliothek

and embodied the regime's 'modernist' conservatism. He held virtually every cultural office of any importance[101] and in 1932–34 was entrusted with the construction of the *Seipel–Dollfuß Gedächtniskirche* (Seipel–Dollfuß Memorial Church) which, with its Kanzlergruft (Chancellors Crypt), became a kind of Ständestaat imitation of the imperial Kapuzinerkirche (Capuchin Church). Religious structures had always represented a prominent part of his practice, but from 1934 to 1938 Holzmeister seems to have turned his hand to whatever representational building the regime supported, including the home of the ideologically friendly Salzburg Festival. Although Holzmeister saw himself as an indirect descendent of the architectural wing of the Secession, his structures broke no new stylistic ground and in their carefully conceived forms reflected the image of confident solidity sought by the regime. Their classicism also fulfilled the new order's need to connect with the past which, however, was more demonstrably served by its support of monuments to Franz Joseph[102] and the encouragement of historically oriented art exhibitions. In the latter instance, the Secession obliged with the 1934 *Von Front zu Front* (From Front to Front) show of photographs depicting the imperial army in World War I and in 1935 it mounted the nostalgic *Bildende Kunst der francisco-josephinischen Epoche* (Art in the Age of Franz Joseph).

In its little more than four years of existence the Ständestaat carried out what, in retrospect, was a frenetic program of cultural activity aimed at promoting its somewhat confused vision of Austria, but for all its efforts it failed to secure that vision even in the arts. Just as it was unable to prevent Nazism from becoming a political 'fifth column,' so too the regime could not prevent its infiltration of the arts. Unfortunately, the Secession became one of the main sources of that infiltration. In 1935 it elected as its president the architect and Nazi, Alexander Popp. Since at that time it would have been politically dangerous to be identified with Nazism, Popp must have been discreet about his sympathies, and it is not clear if the other members of the Secession knew about his politics. What is known, however, is that he was only one part of a circle of Nazi oriented members that included the painter, Wilhelm Dachauer, and the sculptor, Wilhelm Frass.[103] Within a year of his election, Popp had managed to sabotage plans by Carl Moll to hold a retrospective of Kokoschka's work at the Secession and, while it was ultimately held at another venue in 1937, Popp's success was an ominous sign of how Nazi hostility to an artist the party had labeled as 'degenerate' could succeed in an association once known for its openness and idealism.[104] Following Austria's rapprochement with Nazi Germany in 1936, it became less difficult to be a Nazi in the Ständestaat and

in the following year Popp succeeded in using the Secession as the site for the constitutive meeting of the Nazi-inspired *Bund deutscher Maler Österreichs* (League of German Painters of Austria).[105] The Secession had already shown Fascist art from Italy in 1935/36,[106] but the icing on the cake for its Nazi members came in the same year as the founding of the Bund; this was the exhibition, *Deutsche Baukunst und Deutsche Plastik am Reichssportfeld in Berlin* (German Architecture – German Sculpture at the Reich's Sport Field in Berlin). Supported by the German ambassador, Franz von Papen, it was meant to celebrate the improved relations between Germany and Austria. Ironically, with 15,000 visitors, it was one of the most successful exhibitions held at the Secession during the Ständestaat.[107] A year later there would be another Nazi triumph on a much grander scale.

The collapse of Schuschnigg and the Fatherland Front regime under pressure from Hitler in March of 1938 not only ended the independence of Austria but of its artists as well. In the period 1938–1939, all Austrian art associations were either dissolved or absorbed into Nazi approved organizations, and their 'undesirable' members were driven into exile or suppressed by the regime. Despite the Secession's "good record" under Popp and a name change that actually dropped the word "Secession," its bid to maintain the independence of the association failed. In 1939 it was forced to return from whence it came by fusing with the Künstlergenossenschaft, the now dominant artists association in the new Ostmark. Although there were several who grumbled over this act of "Gleichschaltung" (Coordination), only one member, Ferdinand Kitt, openly dissented from the officially unanimous vote in favor of it. The demise of the Secession was also assisted by one who had helped to give it birth. Josef Hoffmann, who had rejoined in 1938, quickly made his peace with the new order and was designated as one of the three trustees charged with the Secession's liquidation. It was a slow process, but was finally completed in 1941. In the meantime, Olbrich's building had been relegated to the status of an adjunct gallery for the Künstlergenossenschaft.[108]

With the demise of the Ständestaat and the Secession, Austria and Austrian art seemed to have finally achieved closure in their search for a permanent identity. They were now German. But what did that really mean? Incorporation into the Third Reich supposedly fulfilled Austria's German 'destiny' by reuniting a people that had

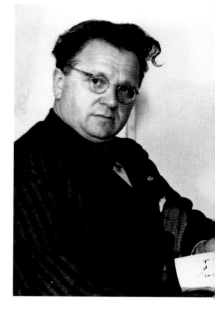

Alexander Popp (1891–1947), press photo on the occasion of his election as president of the Vienna Secession. Photo: Bildarchiv der Österreichischen Nationalbibliothek

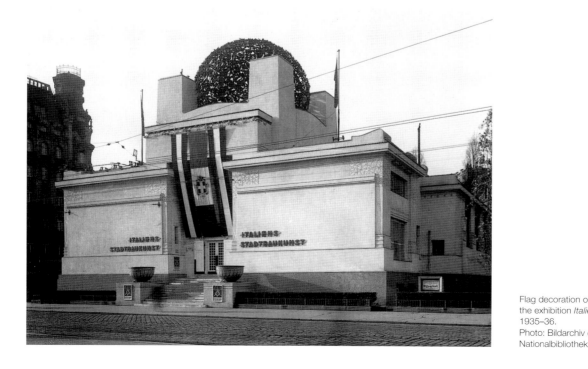

Flag decoration on the occasion of the exhibition *Italiens Stadtbaukunst,* 1935–36. Photo: Bildarchiv der Österreichischen Nationalbibliothek

been unjustly split apart by a whim of history. In the Nazi Weltanschauung (World View) race was the true stuff of history and anything that contradicted this racial truth was irrelevant or pernicious. For Austrians, this meant that much of their past, especially the multi-ethnicity of the Empire, was dismissed as, at best, an unfortunate episode of corrupt dynastic politics. During the Nazi period, references to the traditions of the Habsburg Monarchy were made largely as superficial gestures to appease local sensibilities. To achieve the peace and order of being German meant that Austrians had essentially to deny much of their real past in order to rediscover a 'true' one. But, as is well known, the Nazi version of the past was a gross distortion if not a complete fabrication. There could ultimately be no secure identity based on such a false understanding of history in a country where an awareness of continuity had been so important for its people and its culture.

Under the Monarchy the historical, cosmopolitan character of the "Austrian idea" had provided a formal identity that was linked to the legitimating combination of tradition and political modernism that formed the basis of the Austrian Rechtsstaat. Within this structure state and society could accommodate change with continuity and that process of accommodation had been mirrored in the Secession's approach to creating a modern Austrian art. When the Monarchy collapsed so did the identity that had depended on it. The Republic's attempt during its democratic phase to create a new Austria based on a Rechtsstaat *without* tradition was as doomed as the effort during the Ständestaat period to do so *with* it. Up to 1933/34 official Austria had detached itself from tradition to such an extent that when it attempted a 'reconnection' up to 1938 the wires had become hopelessly crossed. During all these disruptions it was culture alone that seemed to offer Austrians a sense of self and, at least in art, an ongoing process of change with continuity. Aside from whatever specific contributions the Secession made to the development of modern art and to its Austrian variety, for most of the period 1897 to 1938 its main contribution was its ability to serve as a kind of 'good example' in a time of confusion by holding on to its own identity and the principles that informed it. That, as an institution, it finally betrayed its modernity, its principles, and its Austrian character, first in preparation for the Anschluß and then for a chance of survival after it, while a serious failing, must be judged in the context of almost an entire nation that was willing to do the same for the sake of physical and psychological security.

Now that there is once again an artistically modern, principled, and historically aware Secession in the Second Republic, its revived existence testifies to Austria's hard won post-war awareness that a healthy present requires an honest acceptance of the past. For art, as well as for a nation, history and identity are inseparable.

Notes

1 For a full discussion of the circumstances surrounding the founding of the Secession see Wolfgang Hilger, Geschichte der "Vereinigung bildender Künstler Österreichs" Secession 1897–1918; in: Vereinigung bildender Künstler Wiener Secession (ed.), Die Wiener Secession. Die Vereinigung bildender Künstler 1897–1985, Vol. II (Wien 1986); and James Shedel, Art and Society, The New Art movement in Vienna 1897–1914 (Palo Alto 1981)
2 Quoted in Robert Waissenberger, Die Wiener Secession: Eine Dokumentation (Wien/München 1971), 36
3 For a full discussion of the first exhibition see Shedel (as in n. 1), 67–79
4 Ibid., 70–75
5 Ibid., 77–78f
6 For a complete discussion of how the imperial art bureaucracy functioned see Jeroen Bastiaan van Heerde, Staat und Kunst. Staatliche Kunstförderung 1895 bis 1918 (Wien/Köln/Weimar 1993)
7 Invitation to Franz Joseph from the Secession, 11 March 1898, Allgemeines Verwaltungsarchiv (hereafter cited as A.V.), Ministerium für Cultus und Unterricht (hereafter cited as M.C.U.), 1898, Präsidial Nr. 927
8 Evaluation of Secession invitation to Franz Joseph, A.V., M.C.U., 1898, Präsidial Nr. 848
9 Hermann Bahr, Secession (Wien 1900), 38
10 See Ver Sacrum (hereafter referred to as V.S.), Vol. I (Januar 1898), especially "Weshalb wir eine Zeitschrift herausgeben"
11 See Robert Waissenberger, Die Geschichte des "Hagenbundes" and Hans Bisanz, Der "Hagenbund" – Versuch einer Monographie; in: Der Hagenbund, 40. Sonderausstellung des Historischen Museums der Stadt Wien (Wien: 1975)
12 Neue Freie Presse (18 Dezember 1898), 7–8

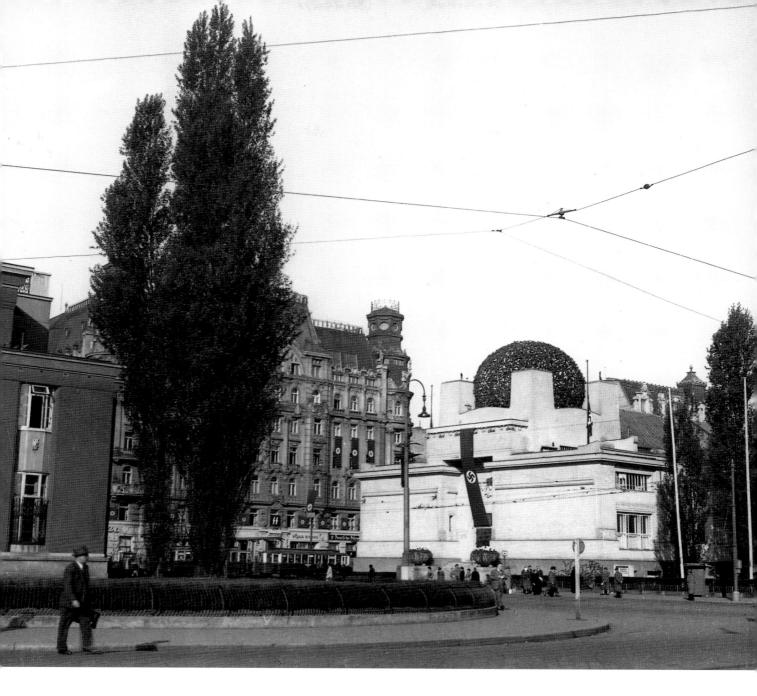

Flag decoration of important
buildings as propaganda for the
"Volksabstimmung" (referendum) of
April 10, 1938.
Photo: Bildarchiv der Österreichischen
Nationalbibliothek

13 Shedel (as in n. 1), 80–85

14 The Secession's interest in being seen as part of a European artistic movement and its members art as an
 expression of that movement was central to their departure from the Künstlergenossenschaft and was evident in
 its statutes, large number of corresponding members from abroad, and their exhibitions. After 1918 the desire to
 be European persisted, but not always the reality.

15 Shedel (as in n. 1), 80

16 For a full discussion of the character of the Rechtsstaat in the Habsburg Monarchy see Shedel, Fin de Siècle or
 Jahrhundertwende: The Question of an Austrian Sonderweg; forthcoming in: idem, Rethinking Fin-de-Siècle
 Vienna (Providence: Berghahn Books, 1998)

17 V.S., p. 6 and Jahresbericht der Secession, Vol. I (1899), 19

18 Shedel (as in n. 1), 29–43

19 Because of the ongoing obstruction of parliament by Czech and German deputies, the Emperor was frequently
 obliged to invoke Article 14 of the constitution. It allowed the imperial government to carry on the business of
 state when parliament was not functioning; all actions being subject to subsequent parliamentary approval. See
 Gernot D. Hasiba, Das Notverordnungsrecht in Österreich (1848–1914). Notwendigkeit und Mißbrauch eines
 Staatserhaltenden Instrumentes (Wien 1985)

20 Otto Wagner remained a member of the Künstlergenossenschaft for two more years after the founding of the
 Secession in hopes of a reconsiliation. He finally left on October 11, 1899.

21 Shedel (as in n. 1), 88

22 The issue of the relationship between the past and the present is interlaced throughout his arguments; see Otto
 Wagner, Moderne Architektur (Wien 1896)

23 Bahr (as in n. 9), 42

24 The architect Adolf Loos, though a self-proclaimed modernist and critic of the Secession, was an admirer of Otto
 Wagner and heavily influenced by classicism in the geometricity and forms of classical architecture. His building
 on the Michaelerplatz is a case in point. Egon Schiele was directly influenced by Klimt in his early art and was
 helped in his carrier by the older artist.

25 Quoted in van Heerde (as in n. 6), 271, Note 47

26 For a discussion of Wilhelm II's hostility to modern art see Peter Paret, The Berlin Secession, Modernism and Its Enemies in Imperial Germany (Cambridge 1980); on Franz Ferdinand's attitude see van Heerde, ibid., 271–272

27 Bahr (as in n. 9), 257–258

28 Eduard F. Sekler: Josef Hoffmann, The Architectural Work. Princeton 1985, S. 253

29. For a brief overview of state policy toward the arts see van Heerde (as in n.6), 33–42

30 V.S., Heft 4 (15 Februar 1900), 64

31 V.S., Heft 11 (1 Juni 1900), 177

32 Ibid., 178

33 Peter Vergo, Art in Vienna 1898–1918, Klimt, Kokoschka, Schiele and their Contemporaries (London 1975), 129–130

34 Werner J. Schweiger, Aufbruch und Erfüllung. Gebrauchsgraphik der Wiener Moderne 1897–1918 (Wien/München 1988), 21–22f

35 On the banknote controversy see V.S., Heft 1 (1 Jänner 1901), 26 and concerning the resauration of St Stephen's see Der Arbeitsschuss der Vereinigung bildender Künstler Österreichs (Secession), Die Wiener Secession und Seine Excellenz Freiherr von Helfert (Wien: Ostern 1902)

36 Protokolle der öffentlichen Sitzungen des Gemeinderates der k.k. Reichshaupt- und Residenzstadt Wien 1897, 512–513

37 See Peter Haiko, Otto Wagner und das Kaiser Franz Josef-Stadtmuseum. Das Scheitern der Moderne in Wien (Wien 1988)

38 Shedel (as in n. 1), 77–78

39 Ibid., 139–143

40 Otto Kapfinger; Adolf Krischanitz, Die Wiener Secession. Das Haus: Entstehung, Geschichte, Erneuerung, Vol. I (Wien 1986), 71

41 Concerning the exhibiting of women and younger artists see Hilger (as in n. 1), 56–57, 61–62f

42 DText of speech quoted in Christian M. Nebehay, Gustav Klimt – Dokumentation (Wien 1969), 394

43 Although in the years after 1905 the Secession seemed to be somewhat more German oriented and occasionally even 'völkisch' in some of its art, it still exhibited the work of Croations, Poles and other non-Germans, as well as that of foreigners; see Hilger (as in n. 1), 51–62

44 Note the boast of the Secession's President, Franz Hohenberger, on the occasion of the XXXth exhibition in 1908; see Hilger (as in n. 1), 53

45 Astrid Gmeiner; Gottfried Pirhofer, Der Österreichische Werkbund (Salzburg/Wien 1985), 12

46 Ibid., 16

47 See James Shedel, Variationen zum Thema Ornament. Kunst und das Problem des Wandels im Österreich der Jahrhundertwende; in: Alfred Pfabigan (ed.) Ornament und Askese im Zeitgeist des Wien der Jahrhundertwende (Wien 1985).

48 Hilger (as in n. 1), 62

49 Schweiger (as in n. 34), 101

50 Ibid., 102, 105

51 Hilger (as in n. 1), 62

52 Schweiger (as in n. 34), 105

53 Unlike many architects, Hoffmann, was fortunate enough to receive a major industrial commission during the war for a chemical plant in Bavaria; see Sekler (as in n. 28), 163–164, 372–375

54 Heinz Geretsegger; Max Peintner, Otto Wagner 1841–1918, The Expanding City, The Beginning of Modern Architecture (London 1970), 18

55 See speech by Rudolf Lechner on proposed Künstlerkammer, 20. November 1917; Formal printed proposal for the Künstlerkammer, November 1917; and letter from Hugo Darnaut, Präsident, Genossenschaft der bildenden Künstler Wiens, to Rudolf Lechener, 6. März 1918; in Archiv der Secession (hereafter referred to as A.S.)

56 Hilger (as in n. 1), 56

57 The acquital on July 14, 1927 of 3 right-wing militiamen for the murders of 2 members of the socialist miltia resulted the next day in massive rioting, the burning of the Justizpalast (Palace of Justice), and 89 dead with over 1600 wounded from clashes between the police and rioters. See Walter Kleindel, Urkund dessen...Dokumente zur Geschichte Österreichs von 996 bis 1955 (Wien 1984), 312–318

58 The constitutionof 1920 made Austria a federal republic with significant areas of authority going to the federal states. In 1929 the constitution was altered to strengthen the central government and increase powers of the president. See Kleindel ibid., 307–311

59 See Helmut Gruber, Red Vienna, Experiment in Working Class Culture 1919–1934 (New York/Oxford 1991)

60 'Culture' in Austria generally meant high culture. Popular culture, aside from peasant and provincial culture, was strongly influenced by elite models as in the case of operetta's relationship to opera. Modern mass culture only statrted to come into its own in the 1920's with the beginnings of radio and the large scale dissemination of motion pictures, especially from the United States. The state, Christian Socials, and Social Democrats all looked upon the development of this new popular culture with either suspicion or overt hostility. See, for instance, the discussion in Siegfried Mattl, Kulturpolitik; in: Emmerich Tálos, Herbert Dachs, Ernst Hanisch, Anton Staudinger (ed.), Handbuch des politischen Systems Österreichs. Erste Republik 1918–1933 (Wien 1995), especially 627, 630

61 Ernst Hanisch, Der lange Schatten des Staates. Österreichische Gesellschaftsgeschichte im 20. Jahrhundert (Wien 1994), 329

62 See Gruber (as in n. 59), especially Chpts. 2, 4, and 5

63 Hanisch (as in n. 61), 328–331

64 Ibid., 324

65 Irene Nierhaus, Das Zwiegesicht. Facetten der Kunst und Politik der Vereinigung bildender Künstler – Wiener Secession 1914–1945; in: Secession, Vol. II , p.77; and for a contemporary view of the situation see A.F. Seligmann, "Bildende Kunst" in Dr. Wilhelm Exner, 10 Jahre Wiederaufbau. Die Staatliche, Kulturelle, und Wirtschaftliche Entwicklung der Republik Österreich 1918–1928 (Wien, November 1928), 167

66 Nierhaus (as in n. 65), 77–78f

67 Seligmann (as in n. 65), 164–169

68 Organisationsentwurf für das 'Amt für Schöne Kunst;' in: A.S.; and Nierhaus (as in n. 65), 89

69 Nierhaus (as in n. 65), 74–75

70 Hanisch (as in n. 63), 326–327

71 Mattl (as in n. 60), 627, 630

72 Even an architect with such Catholic and conservative credentials as Clemens Holzmeister, in the period 1923–1925, received 3 commissions from the city, including that for his prize-winning design for the crematorium at the Zentralfriedhof (Central Cemetary), Clemens Holzmeister, *Architect in der Zeitenwende. Clemens Holzmeister. Selbstbiographie. Werkverzeichnis* (Salzburg, Stuttgart, Zürich: Verlag des Bergland-Buch, 1976), pp. 32–33; for a general discussion of the significance of the Gemeindewohnungen projects see Gruber.

73 Nierhaus (as in n. 65), 78

74 Ibid., 83, and Seligmann (as in n. 65), 166

75 The historical exhibitions sponsored by the Museumsfreunde and those mounted from abroad or with the help of carl moll were financial godsends fro the Secession; see Nierhaus,.83, and Seligmann,166 (both as in n. 65)

76 Jahresbericht, 19

77 Michaela Pappernigg, Absperrung und Einsperrung. Einfluß der internationalen Moderne in Österreich 1918–1938; in: Jan Tabor (ed.), Kunst und Diktatur. Architektur, Bildhauerei und Malerei in Österreich, Deutschland, Italien und der Sowjetunion 1922–1956, Vol. I (Baden 1994), 110

78 See James Shedel, A Question of Identity: Kokoschka, Austria and the Meaning of the Anschluß; in: Donald G. Daviau (ed.), Austrian Writers and the Anschluß, Understanding the Past and Overcoming the Past (Riverside 1991)

79 Nierhaus (as in n. 65), 89

80 Ibid., 76–77

81 Ibid., 102–104

82 Pappernigg (as in n. 77), 111

83 Nierhaus (as in n. 65), 69

84 Monika Mayer, Freiwillige Verschmelzung. Künstlervereinigungen in Wien 1933–1945; in: Kunst und Diktatur (as in n. 77), 288, 290

85 See Gmeiner/Pirhofer (as in n. 45), 51–59, 141, 177, N.1, and 179–189

86 See Gmeiner/Pirhofer (as in n. 65), 89

87 Mayer (as in n. 84), 289

88 Nierhaus (as in n. 65), 89–90

89 Mayer (as in n. 84), 290–291

90 Gmeiner & Pirhofer (as in n. 45), 184

91 See Nierhaus (as in n. 65), 106 and Mayer (as in n. 84), 289

92 Mayer (as in n. 84), 288

93 Engelbert Dollfuß, Trabrennplatz-Rede; in: Kleindel (as in n. 57), 331–337

94 See the preamble to the constitution of 1934; in: ibid., 349

95 On the various ways Austrian culture could be construed under the Ständestaat see Anton Tautscher, Schuschnigg Spricht. Das politische Gedankengut eines Österreichers (Graz/Wien1935), 24, 27; Josef Froschauer, Der neue Bundesstaat Österreich. Von der Beendigung des Weltkrieges bis zur Verfassung 1934 (Wien 1934), 14; and Johannes Hollnsteiner, Mutterboden der Kultur; in: Monatsschrift für Kultur und Politik, Heft 1 (Jänner 1937), 6

96 See Mattl (as in n. 60), 621 and Helmut Wohnout, Regierungsdiktatur oder Ständeparlament? Gesetzesgebung im autoritären Österreich (Wien/Köln/Graz 1993), 204, 309

97 Mayer (as in n. 84), 288

98 The Secession showed the works of modern artists, for instance, in 1935,but to relatively small crowds; one such exhibition in the spring drew only 1,357 visitors; see Nierhaus (as in n. 65), 90

99 Ursula Prokop, Ein ungemein schwieriger Balanceakt. Der Große österreichische Staatspreis 1934–1937; in: Kunst und Diktatur (as in n. 77), 278–279

100 Monica Mayer, Gesunde Gefühlsregungen. Das Wiener Ausstellungswesen 1933–1945; in: Kunst und Diktatur (as in n. 77), 297–298

101 Helmut Wohnout, Im Zeichen des Ständeideals. Bedingungen staatlicher Kulturpolitik im autoritären Österreich 1933–1938; in: Kunst und Diktatur (as in n. 77), 139–140

102 See Holzmeister (as in n. 72), 15–16, 24, and 27; also Barbara Feller, Sichtbarmachung der Vergangenheit. Kunst-am-Bau und neue Monumente in Österreich 1930–1938; in: Kunst und Diktatur (as in n. 77), 282.

103 Although the stenographic record of the meeting at which Popp was elected president still exists in the archive of the Secession, it is written in a now untranslateable form of shorthand; see also Nierhaus (as in n. 65), 91

104 Mayer (as in n. 100), 295–296

105 Mayer (as in n. 84), 292

106 Nierhaus (as in n. 65), 90

107 Mayer (as in n. 100), 296

108 For the Secession's nazification and the role of Josef Hoffmann see Nierhaus (as in n. 65), 93; Mayer (as in n. 84), 293; and Sekler (as in n. 28), 219

VIII. AUSSTELLUNG
DER VEREINIGUNG
BILDENDER KÜNST-
LER ÖSTERREICHS
SECESSION.

DIE VEREINIGUNG
WIRD IHRE GÄSTE
☿ SAMSTAG DEN ☿
3. NOVEMBER 1900
ZWISCHEN 11 UND
5 UHR EMPFANGEN
UND GIBT SICH
DIE EHRE, HIERMIT
IHRE EINLADUNG
ZU ÜBERREICHEN.

DIE VEREINIGUNG
BEEHRT SICH DIE
EINLADUNG ZUR
VORBESICHTIGUNG
DER AUSSTELLUNG
ZU ÜBERREICHEN.

Herrn
Maler k. k. Professor
Koloman Moser

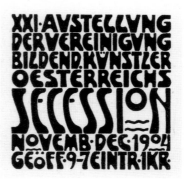

DONNERSTAG, DEN
10. NOVEMBER 1904,
VON 11 BIS 5 UHR.
UNÜBERTRAGBAR.

Invitations of the Vereinigung
bildender Künstler Österreichs
Secession

Above: 8th exhibition, 1900
Below: 21st exhibition, 1904.
Design: Friedrich König
Photos: Archiv der Wiener Secession

Left: 9th exhibition, 1901
Right: 13th exhibition, 1902

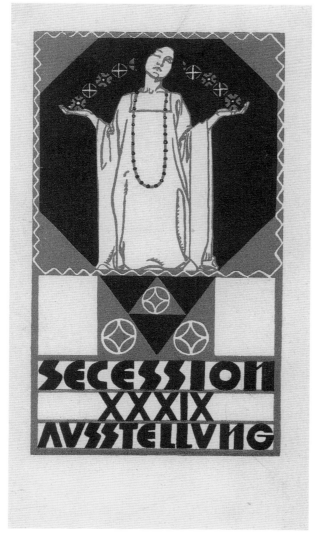

SECESSION XXXIX AVSSTELLVNG

Above: 11th exhibition, 1901
Left: 39th exhibition, 1911

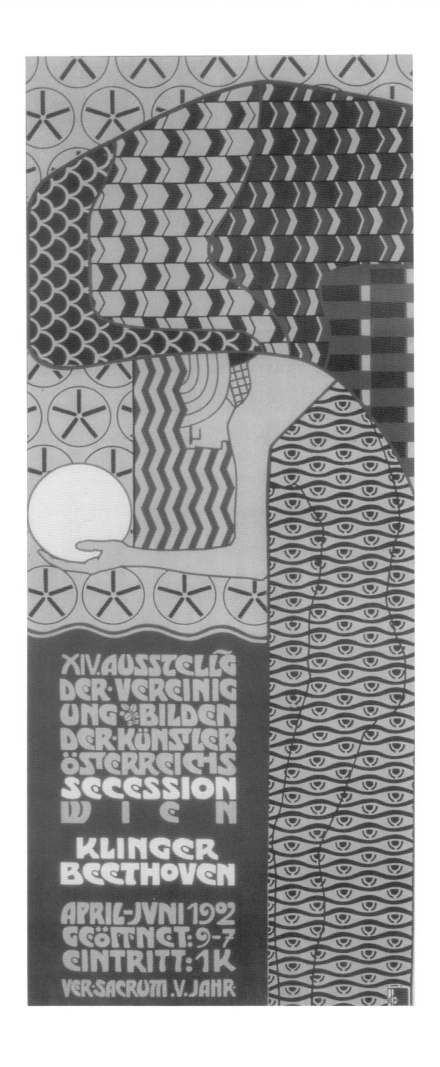

50

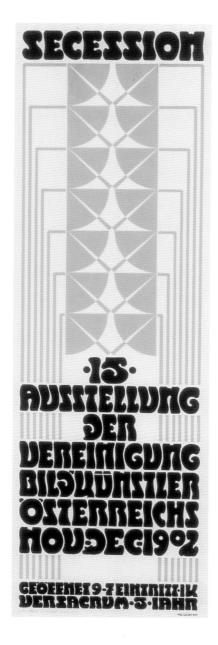

Posters of the Vereinigung bildender
Künstler Österreichs Secession
(pp. 50–57)

Left to right:
15th exhibition, 1902.
Design: Adolf Böhm.
16th exhibition, 1903.
Design: Alfred Roller.
17th exhibition, 1903.
Design: Maximilian Kurzweil
Photos: Historisches Museum der
Stadt Wien

Left page: 14th exhibition, 1902.
Design: Alfred Roller.
Photo: Historisches Museum der
Stadt Wien

26th exhibition, 1906.
Design: Ferdinand Andri
Photo: Historisches Museum der
Stadt Wien

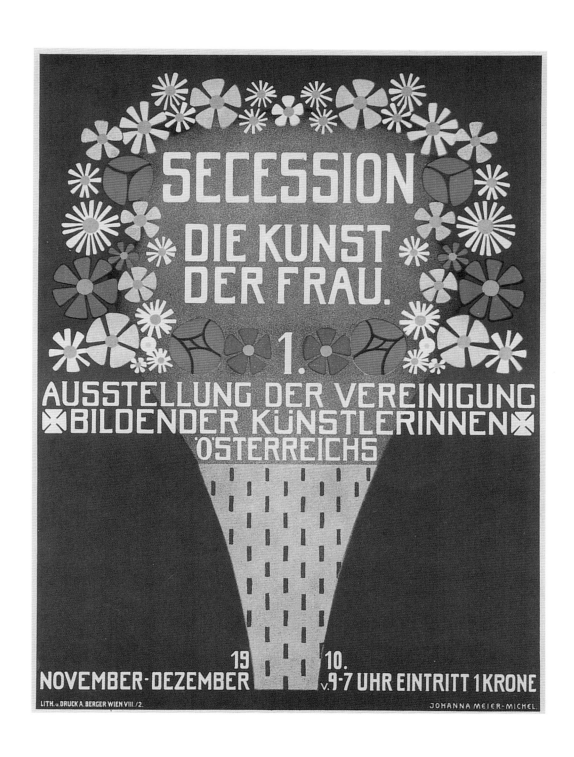

37th exhibition, *Die Kunst der Frau,*
1910.
Design: Johanna Meier-Michel.
Photo: Historisches Museum der
Stadt Wien

40th exhibition, *Plakat-Ausstellung*
(poster exhibition), 1912.
Design: Ernst Eck.
Photo: Historisches Museum der
Stadt Wien

54

40th exhibition, *Plakat-Ausstellung*
(poster exhibition), 1912.
Design: Richard Harlfinger.
Photo: Historisches Museum der
Stadt Wien

44th exhibition, 1913.
Design: Franz Wacik.
Photo: Historisches Museum der
Stadt Wien

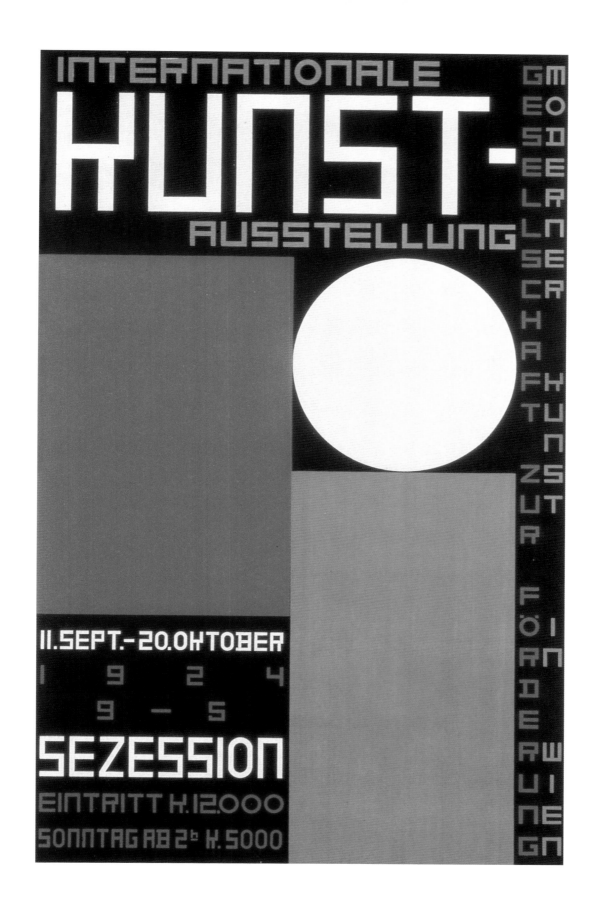

79th exhibition, *Internationale Kunstausstellung*, 1924.
Design: Friedrich Kiesler.
Photo: Verlagsarchiv Dr. Christian
Brandstätter

Gottfried Fliedl

THE SECESSION AS SACRED CENTER

CORNERSTONE AND LAURELS

The laying of the cornerstone for the Secession building on the afternoon of April 28, 1898, involved more than just the customary immuring of a building document and the laying of the first stone, in this case symbolically entwined with laurel. Rather, it had the character of a "congenial fellowship", an "intimate domestic celebration," as Ludwig Hevesi, eyewitness and sympathizer of the artists' group, assures us; it was, he concedes, "no merely technical act," but an almost religious ritual, in which the members of the Secession together with donors and friends ceremonially confirmed their solidarity: "After the reading [of the founding document], those present approached one by one, Honorary President Alt first of all, and placed their signatures on the parchment. They then proceeded to the block of stone; each one struck it three times with the hammer and uttered a good aphorism. All heads were bared and the solemn voices could be heard from afar in the quiet air. [...] The laurel wreath was then plucked to pieces and everyone stuck a sprig of it into his buttonhole; a green twig will even be sent to friends far away."[1] Nor was the photographic documentation of the event neglected.

Gilded laurel leaf.
Photo: Margherita Spiluttini

The laurel that adorned the small, profane cult gathering on that day and lent expression to its apostolic-ecumenical sense of mission becomes, on the finished building, the spherical crown of a laurel tree. As such, it is the principal bearer of a concentrated, many-layered symbolism, whose multivocality and ambivalence was to elicit both apologetic and polemical glosses in the criticism of the day. The 'coronation' of the building with the branches of a laurel tree—formally and symbolically oscillating between bower, sphere, treetop, grove, dome, and baldachin—may be read as both a manifestation of monumental-architectural pathos and as the programmatic emblem of the Secession and its 'mission.'

In antiquity, garlands woven of plants originated in the cult of sacrifice; the crown of laurel, moreover, was used to distinguish victors in contest, generals, and artists. Here, however, the consecration with the laurel wreath was not merely that of art in general. The artists clearly intended the pathos to refer to themselves, associating it with the idea of fame, if not redemption: in Gustav Klimt's *Beethoven Frieze,* the laurel wreath is promised to the *Well-Armed Strong Man* at the beginning of his path of initiation and salvation. The offense taken at the narcissism of this self-styling and self-consecration, moreover, has not been confined to the artists' contemporaries.

But the architectural symbolism of the Secession building has a temporal meaning as well. The leafy sphere flanked by four pylons evokes the image of a roof of foliage supported by four tree trunks and thus points beyond the architectural-theoretical and historical topos of the 'primeval hut' to an origin in and of itself, just as the periodic ritual construction of primeval or leaf huts in various religions[2] points to the renewal and renewability of time—a theme implicitly announced in the motto of the Secession over the entrance to the building.

The symbolism of the gilded laurel dome thus points to the idea of a myth of origin,[3] a conception that marked the self-image of the Secession as well. It viewed itself as a movement of renewal, bringing about a new blossoming of art and architecture. The symbolism of the Secession building represents this claim as the temporal relation between the modern and the ancient (the archaic, not the classicizing), an antiquity that itself was considered a kind of primeval modern.

Left page: View into interior of dome of Vienna Secession.
Photo: Margherita Spiluttini

Gustav Klimt, Ex Libris of the Vereinigung bildender Künstler Österreichs Secession with Pallas Athena by Gustav Klimt, 1898. Photo: Archiv der Wiener Secession

But the narcissistic, melodramatic aspects of the ceremonial and architectural symbolism of the Secession should not mislead us. The comparison of the museum with the temple, extending into everyday speech (often in a disparaging way), should be taken seriously as a symptom that sheds light on the museum in general and the Secession in particular. The laying of the cornerstone is not only a ceremonial act marking the construction of a new building; here it reveals itself most emphatically as the establishment of an origin, the definition of a symbolic place, the creation of a sacred district in the midst of the city.

Sacred, consecrating, and victorious, the evergreen laurel plant is closely associated with the myth of Apollo.[4] In the Secession building, it points far beyond the function as exhibition space for art to an undertaking of civilizational and historical proportions: "In addition to the external meaning of victory, dignity, and purity, in this myth [of Apollo] the laurel is associated with a foundational event: with the overcoming of the older, female principle by a younger, male principle […], with the appropriating and transcending of maternal, chthonic knowledge by the enlightened god of light […]."[5]

Since its earliest beginnings, architecture has developed a topographical model for illustrating and interpreting the division between the sexes, a model in which the two spheres are placed into a relationship that can be interpreted spatially and temporally and at the same time hierarchically. The metaphor of a power relationship is visible already in prehistoric cave and cult structures, often partially or entirely underground; here, the feminine—as already theorized in Hesiod's *Theogony*—is repressed as chaotic, alarming, and threatening, but at the same time is hailed as the source promising reconciliation.[6]

The division of the feminine into alarming and threatening aspects on the one hand and protective, 'maternal' ones on the other recurs in one of the principal works of the Secession, Klimt's *Beethoven Frieze*. In addition, it is developed in the interior and above all on the exterior of the Secession building in a variety of decorative accessories (for whose interpretation I refer the reader to the work of Otto Kapfinger). Here it appears as a deeply ambivalent tension between the rationalizing and the instinctive, the Apollonian and the Dionysian—aspects associated with the message of the 'archaic' (re-)birth of art and the cultic, ritualized encounter with it.

In this respect the Secession building is not an anomaly. The bourgeois idea of the museum had turned it into a prominent symbolic space, and since then museum architecture has frequently employed a quasi-structural, strangely unvarying basic vocabulary: nature/architecture, interior/exterior, light/dark, above/below, open/closed, formed/unformed. But the civilizational state of tension and its irresolution is presented not only by this means, but also through the creation of a kind of rite of passage, a pilgrimage through the conscious and the unconscious.[7]

Thus in the Secession our attention is drawn above all to the treatment of the transition between the two spheres. The Secession's descriptions of itself, its ideas about the function of art and the artists' community allow us to focus our consideration on the order of the relationship between profane urban space and the 'sacred' space of art. The social model of the function of the arts as 'sacred' to and therefore radically withdrawn from society, yet for that very reason effectual within it, gives rise to the corresponding styling of the building as a 'cultic structure' in which the allusion to temple and shrine comes into play—and not merely for the architect Joseph Maria Olbrich himself, who makes reference to the antique temple of Segesta.

Among the most widespread architectural topoi for the shaping of the transition from the profane to the sacred are portals and stairs. In the Secession building, the stairs lead sharply upwards, drawing visitor and viewer out of the sphere of urban space.

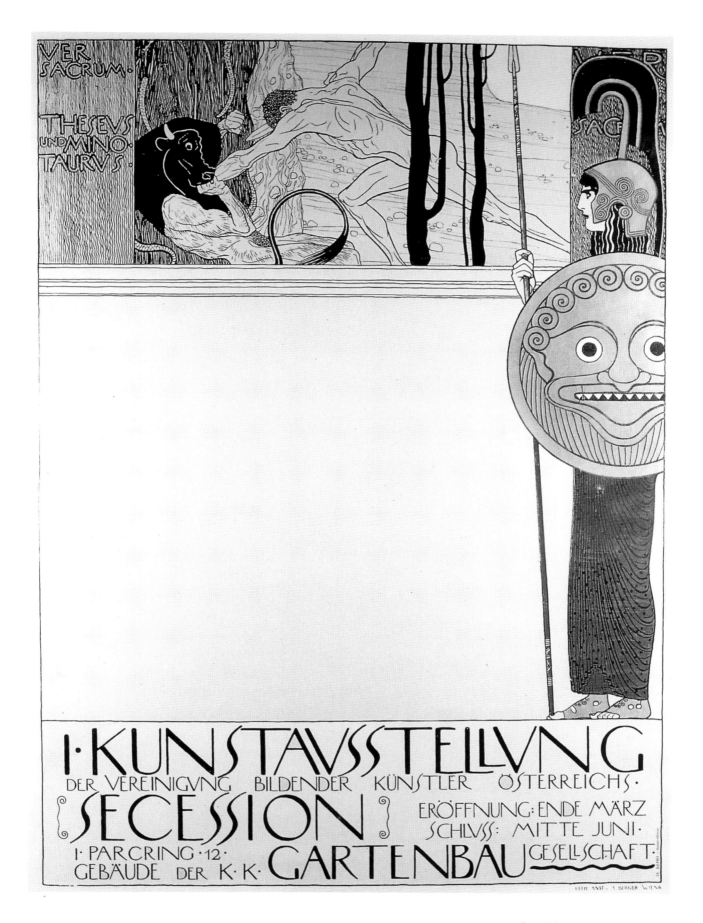

Gustav Klimt, poster for 1st exhibition
of the Vereinigung bildender Künstler
Österreichs Secession in the building
of the Imperial and Royal Horticultural
Society, 1898.
Photo: Margherita Spiluttini

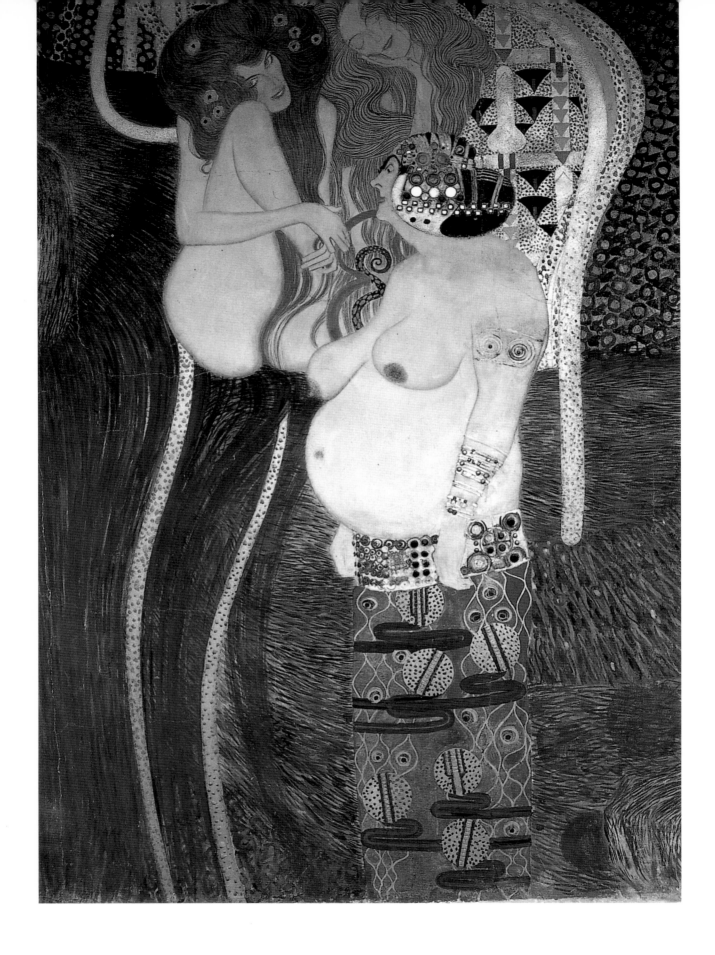

Unchastity, Lasciviousness,
Intemperance, detail from *Beethoven*
Frieze by Gustav Klimt, 1902
(restored frieze).
Photo: Matthias Herrmann

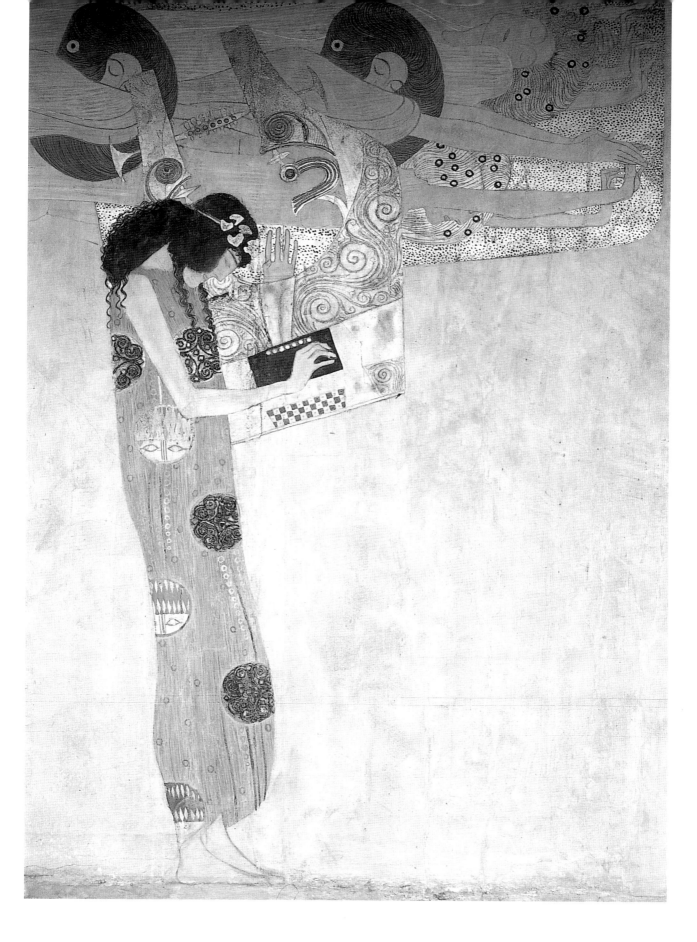

The Longing for Happiness is Assuaged by Poetry. The Longings and Desires of Humanity Fly Past, detail from *Beethoven Frieze* by Gustav Klimt, 1902 (restored frieze). Photo: Matthias Herrmann

At the same time, they emphasize the narrowness of the entrance, decorated with apotropaic-archaic signs as a meaningfully marked threshold between exterior and interior. The passage is a kind of initiation, transforming the exhibition visitor and art enthusiast as "neophyte" in his physical and mental being and making him a kind of symbolic sacrifice by requiring the stripping off of present existence. Thus Hermann Bahr, for example, speaks of the entry space as a "forecourt," which, "under the laurels," "serves for the purification of souls."[8] And once again, we recall Klimt's *Beethoven Frieze* as another model of such a rite of passage.

The forms which the iconology of museum architecture reserved for the heightened, ceremonial representation of this process of transcendence were the central, domed space, open at the top and illuminated through an 'eye' (or opaion, an aperture), and a carefully planned approach, often partially 'underground,' intensifying the experience as it passed through different spheres and levels.[9] The adoption of the ancient Roman Pantheon as the ideal type and model was not confined to classicistic architecture at the beginning of the development of the modern, bourgeois museum and its architecture. Both the Pantheon's form and its function—as a temple to all the gods, church of all the saints, burial site, locus of the artist cult (since Raphael's interment), and transformation into a profane, national heröon in the tradition of the Catholic Christian martyrium—were essential and served to inspire symbolic allusion.[10]

SECESSIO PLEBIS AND VER SACRUM

The artists' community that had constituted itself in calculated opposition to the "fathers' generation" of artists (in what Schorske describes as an "Oedipal revolt") drew their programmatic slogans from a mythological rather than an aesthetic repertoire. Both *Secession*—the name of the alliance of artists—and *Ver Sacrum*—the name of its art magazine, its journalistic mouthpiece—refer back to mythic and political events in antiquity. In this way, incidentally, the terms also served to clearly distance the new movement from the historicist appeal to the arts of the Renaissance or the Middle Ages that had long dominated the 19th century and to throw off the developmental-historical corset of the stylistic epochs.

The Roman *ver sacrum* is a cult of sacrifice intended to help overcome catastrophic threats to the community through the sacrifice of animals and plants engendered in the spring following the threatening occurrence. The one such event known from history rather than myth is the *ver sacrum* proclaimed after the defeat at the lake of Trasimenus. The other manner of sacrifice associated with the *ver sacrum*, known only from obscure tradition, is the banishment of the youth born in that spring, associated with the founding of a new city and therewith a new community and a new people. Similarly, city foundings in antiquity are always connected with sacrificial rites.[11] Both forms of sacrifice were probably substitutes for human sacrifice formerly practiced.

The choice of the name *Ver Sacrum* for the mouthpiece of the Secession (the magazine was founded in 1898) reveals the aim of restoring a 'voluntary' self-sacrifice—now styled as a 'consecration of the youth,' practiced in times of danger—in the service of a new beginning, a renewal. With the choice of this half-mythical, half-political idea, the Secession quite openly propagated a religious, cultic renewal not only of art, but also of society. Even in this sublimated form, fully divested of the memory of the bloody sacrifice, the *ver sacrum* retains a connection to its original sacrificial significance; now, however, it refers above all to the banishment of the youth—vowed in times of need but carried out years later—and thus to the founding of new peoples and cities.

It is this community-creating function of the cult of the *Sacred Spring*—a function guaranteed through sacrifice and division—to which the Secession makes

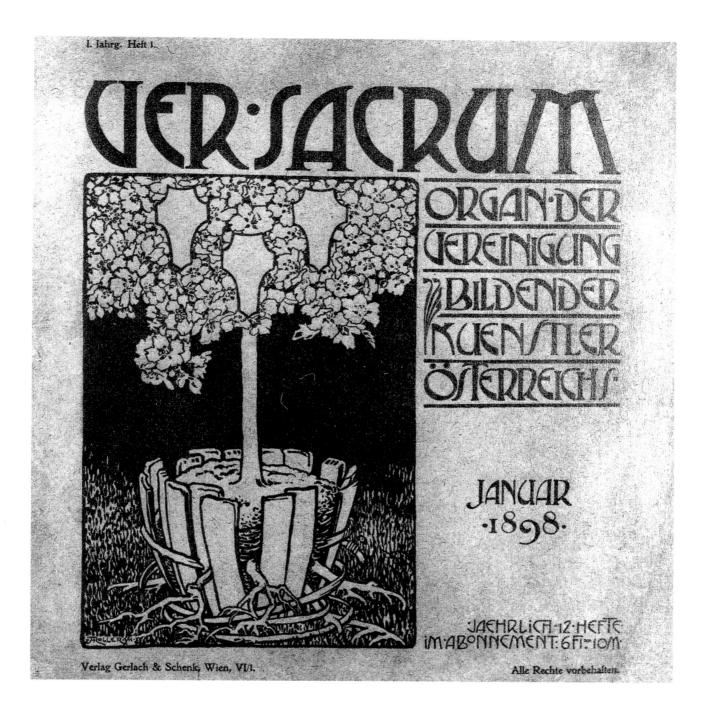

I. Jahrg. Heft 1.

VER·SACRUM

ORGAN·DER
VEREINIGUNG
BILDENDER
KUENSTLER
ÖSTERREICHS·

JANUAR
·1898·

JAEHRLICH 12 HEFTE
IM ABONNEMENT: 6 FL = 10 M

Verlag Gerlach & Schenk, Wien, VI/1. Alle Rechte vorbehalten.

Ver Sacrum, organ of the Vereinigung bildender Künstler Österreichs, vol. 1, no. 1, January 1898, title page design by Alfred Roller. Photo: Archiv der Wiener Secession

reference. In so doing, it transforms itself into the sacrifice, the sacrifice of the individual artist and of an entire new generation of young artists, who thus enter the service of society. The Secession here appears not merely in the role of the renewer of art, but with an emphatic social-communal purpose, that of the *renovatio* of society founded on voluntary sacrifice. The choice of this particular leitmotif brings to light not only a concept of aesthetic modernity as a vitalistic regeneration, capable of recurring again and again—as also manifested in the work of the president of the Secession, Gustav Klimt—but also a concept of the social-political role of art.

The programmatic statement by Max Burckhard in the first issue of *Ver Sacrum* leaves no doubt as to the intended reference to the ancient sacrificial ritual. But what is original both in his explanations and in the self-understanding of the artists' group is the allusion to a second historical-political event, one which originally had nothing at all to do with the *ver sacrum:* the *secessio plebis.* The Vienna Secession, itself originating in a demonstrative 'withdrawal' from an older union of artists, exalts this act as well through the allusion to events from antiquity: "In ancient Rome,

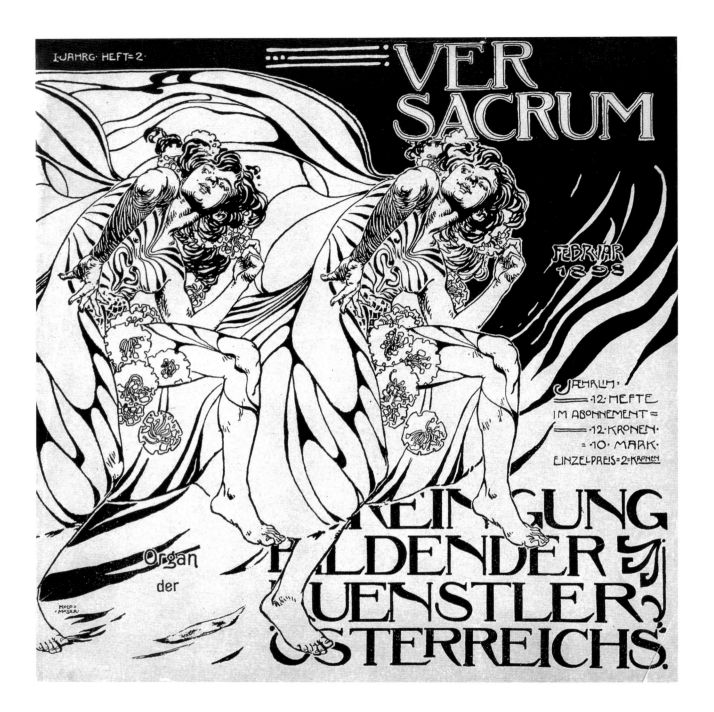

VER SACRUM

FEBRVAR 1898

JAHRLICH· ·12·HEFTE IM ABONNEMENT= ·12·KRONEN· =·10·MARK· EINZELPREIS=2·KRONEN

Organ der

VEREINIGUNG BILDENDER KUENSTLER ÖSTERREICHS·

Ver Sacrum, organ of the Vereinigung bildender Künstler Österreichs, vol. 1, no. 2, February 1898, title page design by Kolo Moser. Photo: Archiv der Wiener Secession

when the tensions continually provoked by economic oppositions had reached a certain climax, one part of the people would ascend the Mons Sacer, the Aventine or the Janiculum, with the threat that if its demands were not met, it would there, in view of the old mother city and the venerable city fathers, found a second Rome right before their eyes […]., this was called the Secessio plebis […]. But when great danger threatened the fatherland, then the entire people would consecrate to the gods every living thing the next spring would bring forth, as a sacred spring offering—VER SACRUM, and when those born in the sacred spring were grown, then the youthful host, itself a sacred spring, would depart from their old home into a foreign land to form a new community through its own power and with its own ends."[12]

This feuilleton-like description, of course, constitutes yet another revision of the antique practices. It deprives the antique *secessio plebis* of the stinger of social conflict, the power struggle among the social classes, and allows the Secession to conceive of itself as an opposition in revolt, but one that remains within the community, for whose ultimate benefit the revolt takes place.

The invocation of sacrifice, revolt, and founding myth—and as we have heard, the founding was of no more or no less than a "second Rome"—could hardly be more overt. In light of this self-styling, it seems permissible for us now to focus on the allusion to antique cult practices and to view the "intimate domestic celebration" of the cornerstone-laying as the emphatic founding of a 'symbolic space,' or *templum,* an act which exerted its effect on art and society.

The 'creation' of a *templum* was the fundamental act of (Roman) city founding. Beginning with divination by the flight of birds, the augur used speech and gesture (though never bare hands) to mark the 'space,' a circle as a kind of representation of the heavens, which was then divided by crossed lines (which, however, did not designate the points of the compass and completed to form a 'diagram,' the *templum.* This 'virtual' activity of the augur, the *contemplatio,* provided the frame of reference for physical places as well, for cities or military camps, though here it was called not *templum,* but *templum minus.* The etymological roots of *templum* are to be sought first of all, with reference to the activity of the augur, in the word *tueri,* to look or to stare, and secondly, with reference to the demarcation of a piece of land, in the Greek word *temenos* or sacred district, from *temno,* to cut or wound.[13] Another reading includes the conception of cutting through in the sense of traversing (as of paths through a center).[14]

The reference to the heart of Roman city-founding rituals is not intended to expose the founding act of the Secession as an imitation, but rather to point to structural commonalities in the creation and definition of spaces that order and structure the hierarchy of social and cultural relationships—in short, symbolic spaces.[15]

THE NAISSANCE AND SACRALITY OF ART

Although with the name 'Secession' the Viennese artists' group had already made use of a term invested with dissident overtones, it nonetheless emphasized the distance separating them from other artists' groups with their fundamentalist claims. In the first issue of *Ver Sacrum* in January 1898, for example, Hermann Bahr wrote: "At that time I learned to understand the duty of our young painters in Vienna, that their 'Secessio' must be very different from that of Munich or Paris. In Munich and Paris, the purpose of the Secession was to place a 'new' art next to the 'old' art […] for us it is different. We are not fighting for or against tradition; indeed, we don't have one. The struggle is not between the old art […] and a new [art] […], but about art itself […] about the right to engage in artistic creation."[16]

In the self-image of the Secession, the concept of modernity designates not a specific, unique historical period—another, new step in the historical development of the arts—but rather the consciousness of a generation that brings forth beauty suitable to its time. Max Burckhard's introduction to the first issue of *Ver Sacrum,* mentioned earlier, attributes modernity to the Secession in exactly this sense—in language once again charged with the metaphor of sacrifice: "Because it [the artist's alliance] […] has seen a danger not to its own personal interests, but to the sacred things of art, and because it was and is willing, in dedicated enthusiasm, to take on any sacrifice for this cause, and because it wants nothing but the attainment of its own ends through its own power, it has placed itself under the sign of VER SACRUM: the spirit of youth that pervades the spring has brought them together, the spirit of youth through which the present always becomes the 'modern' […]."[17]

Allusion to the 'presentness' of the idea of modernity is also the intention behind the motto mounted over the entrance to the Secession's exhibition building: "To the time its art, to art its freedom." Correspondingly, Koloman Moser's stained glass window on the interior of the building at the transition between the entrance area and the exhibition space proclaims an aphorism formulated by Hermann Bahr:

Hermann Bahr, photograph by
Madame d'Ora.
Photo: Archiv der Wiener Secession

"May the artist show his world, the beauty that was born with him, which never yet was nor will be again."

Since its origin, the idea of modernity had been a relational concept, conceived only in relation to the past and the future as a kind of transition. Here, however, once again in connection with the idea of sacrifice, it becomes a concept intended to disrupt the time-continuum, including that of the historicist stylistic epochs as the corset of current artistic production. The founding myth, the image of the new beginning, is revealed as the masking of a social act; and it is only this act which, through the sacrificial figure of the artist (common enough in the nineteenth century, but now, around 1900, intensified into a collective sacrificial fantasy), makes art possible in the first place.

This concept of art is more constructive than representative, a fact which has consequences for the function of the space in which it is to be displayed. While the bourgeois museum, such as the national museum, presumably could still serve the 'master narrative' of an evolving collective self, by 1900 this kind of representation of collective identity had clearly become obsolete, both in general and with reference to the representation of art. At issue here is not merely the distinction between the museum and the exhibition, i.e. between permanent collection and temporary display, but the crisis of the museum itself. The Secession building as an exhibition hall is in fact relieved of the customary obligation of the art museum, i.e. to select, evaluate, and assemble a canon with ostensibly universal, timeless validity.

With respect to the practicalities and technicalities of exhibiting, as well, there is a rejection of (art) history: in a space that for its period is highly modern, functional, and in a certain sense radically empty, art can be presented and contextualized anew, over and over again. The eminent opposition between the carefully designed, symbolically charged exterior structure and entrance hall on the one hand and the functional, ascetic exhibition area on the other—with lighting as uniform as possible for the sake of the artworks and a variable spatial structure with no permanent walls—was immediately noted as one of the most remarkable characteristics of the Secession building. The building reveals itself in the interior as a staging ground,[18] a 'theater' with constantly changing performances, in the same sense that the museum is occasionally discussed today: not as a place of certain knowledge and a stable relation to existing reality, but one where knowledge and the modes of representation are continually being 'staged,' 'constructed,' and 'invented' anew by the viewer, curator, designer, architect, etc.

Since there is no longer any stable, binding social or aesthetic context for the representation and perception of art, it is the task of each individual exhibition to create and define this context anew—hence the conception of the Secession exhibition as a kind of *Gesamtkunstwerk,* a 'total' experience.

The presence of a guiding idea was intended not only to counteract the isolation of the work of art and the disintegration of individual art forms, but also, according to Ernst Stöhr's analysis of the Beethoven Exhibition, to create nothing more or less than "temple art," art "that places no stigma on the fleetingness of existence."[19]

As the self-presentation of the Secessionists at the cornerstone-laying ceremony already shows, the sacralization of art as cult goes hand in hand with the sacralization of the artist: in the terminology of the Secession, he is *expressis verbis* a "priest." Not least for this reason did the Beethoven Exhibition—with the cult of the artist at the center and Klimt's frieze praising the artist's redemptive work—represent a high point in the activity of the Secession. "If ever there were an example of collective narcissism, this was it: artists (of the Secession) glorified an artist (Klinger), who in his turn glorified a hero of art (Beethoven)."[20] The Beethoven image of this period epitomized the messianic conception of art and of the artist—

the artist who, misunderstood by his time, assumes martyrial and savior-like qualities; one thinks of Hermann Bahr's characterization of Klimt as a hero working against the flow of his time.[21]

The decor of the building reveals the contradictory nature of a concept that on the one hand disrupts the time continuum in order to allow a primeval, natural, and instinctive modernity to come into its own, but on the other intends to use this very means to weave art and life together again for the sake of social reform. The sculptural and decorative ornamentation of the Secession refers repeatedly to the motifs of renewal and transformation (as in the motif of the snake), but also to the opposition between the Dionysian (the frieze of the dancing maidens) and the Apollonian. It "[…] can be said that the exterior form of the Secession temple is equipped with symbolic signs that repeatedly overlap and intensify one another, signs that unequivocally express the period's revolutionary 'will to art,' the propagation of an anti-conventional, anti-historicist 'art enthusiasm' drawing from the depths of the subjective, the 'initiation' of the 'VER SACRUM' and purification and strengthening in a return to the origin as the beginning of a better future."[22]

The dense intermingling of ornament and asceticism, of the instinctive removal of boundaries and a rationalizing extreme of design was mirrored already in the first

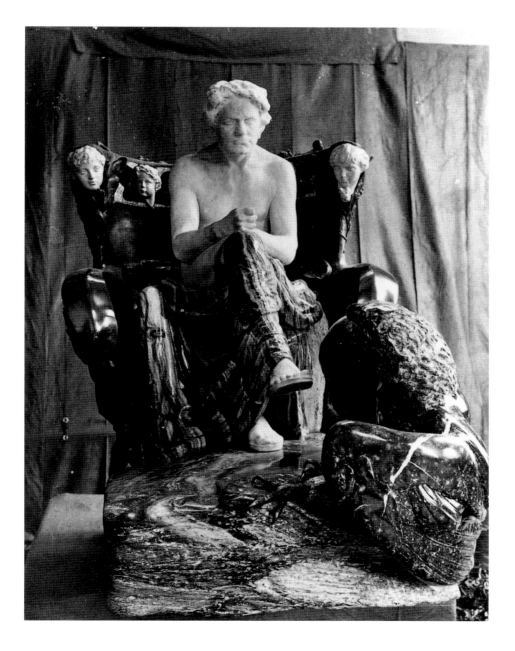

Max Klinger, *Beethoven sculpture.*
Photo: Bildarchiv der Österreichischen Nationalbibliothek

69

Dance of the Wreath-Bearing Maidens, detail from fresco by Kolo Moser on rear facade of Vienna Secession.
Photo: Stiftung Preußischer Kulturbesitz, Staatliche Museen, Kunstbibliothek Berlin

series of reviews, critiques, glosses, and polemics. Ironic distancing, aggressive mockery, hymnodic praise, and apologetic prove to be different sides of the same coin.

I don't think, however, that we can attribute to Olbrich an active, analytical posture any more than—as Carl Schorske suggested—Gustav Klimt should be associated with Freud, since in Schorske's opinion both had a "passion for archaic culture and archaeological excavation" and used "ancient symbols as a metaphorical bridge to excavate the life of instinct, especially the erotic." Such interpretations imply that the Secession made use of the unconscious with enlightened, analytical intent.

But while Freud read the archaeological layers and the remains buried in them as symptoms, the writing of an 'other' that, when decoded, would break the

unconscious, pathogenous effective spell of the past, neither Klimt nor the Secession—nor for that matter the symbolism of the Secession building—can be accused of such an 'enlightened' approach to the unconscious. Despite, or perhaps because of, the appeal to a seemingly wild, undomesticated, archaic antiquity, the artists and their symbolism—and thus also the symbolism of their 'place'—remains bound up with the production of a new, more modern condition, in which the old civilizing conflicts recur, but remain unsolved.

CENTER AND PASSAGE

In discussion of the museum in general, the idea of the temple soon suggests itself, sometimes as affirmation and mystification of the institution, sometimes as critique, as in the rationalizing and pedagogical slogans of the 1970s which contrasted the supposedly outmoded 'temple of the Muses' with a 'place for learning.'

The Well-Armed Strong Man, detail from Beethoven Frieze by Gustav Klimt, 1902 (restored frieze). Photo: Matthias Herrmann

The affinity of the Secession building with a temple was an established fact not only for the architect Olbrich himself, but also for the first critics of the building.[23] The building is apostrophized as a "mysterious cult place," a "temple of art," a "temple that vindicates itself in the golden globe of world rulership." The association with tomb and mausoleum, however, appeared as well, along with many others, some much more profane. "The walls," as Olbrich himself writes, "are to be white and gleaming, sacred and chaste. Serious dignity of the kind that overwhelmed and moved me as I stood alone in Segesta before the unfinished shrine."

The idea of the temple, which as we have seen is by definition a 'sacred place,' points here to both the transcendent and the sublimating aspects of the experience of art, as well as to sacrifice. Significant for the iconography of the museum in general, but also for that of the Secession building, is the architectural design of both aspects, the intersection, as it were, of passage and the place of sacrifice.

The entry space erected over a cruciform ground plan and the basilical exhibition space, equipped with a quadratic and therefore centralizing middle, can be understood as a sequential spatial continuum that makes possible the passage through the 'sanctifying experience" of art. The entrance area is most often described as a transitional space between the city and the space of art, as a space of purification and initiation, the passage between the two spheres. With reference to the Secession building, the metaphor of purification means that the subject must abandon, give up, sublimate—in other words sacrifice—his individual aspirations in order to be able to participate in the communion of the art experience, though not only in this, as we will see.

In this respect, the description of the exhibition building written by the journalistic herald and comrade-in-arms of the Secession, Hermann Bahr, is instructive. Bahr's early description analyzes the sequence of spaces as a path: he calls the entry space a "propylaeum" and "forecourt," taking the identification of museum and cult building for granted. One can indeed make the association with antique temples or even Christian churches, where such forecourts were customary as preparatory spaces. Bahr clothes the function of this entrance, too, in a 'religious' metaphor, calling it a space where the visitor is to be "purified from the mundane and attuned to the eternal," where he may "lay off the cares and whims of the common world and prepare himself for devotion, as it were, in the quiet cloisters of the soul."[24]

Bahr divides the exhibition area, in turn, into two different stages, resulting in a total of three phases of experience, although the 'dome,' too, while in no actual communication with the interior, comes into play as a purely symbolic but nonetheless significant element: "Under the laurel [is the] forecourt for the purification of spirits, then [the space] for the works, and finally the architecture for meditation and reflection, the chapel."[25]

The extent to which the entry space is conceived as a 'transitional space,' still belonging to the exterior rather than to the building itself, becomes clear in Bahr's surprising description of the exhibition space, of which he says: "Then we enter the building *proper.*"

The passage from the exterior to the interior of the building, from the square in front, up the stairs, through the anteroom, and finally into the space prepared for the experience of art, is clearly understood as a carefully, architecturally staged ritual, but one whose end has not yet been attained with the entering into and remaining in the exhibition space: "Lastly, we come to a space with architecture as serious and ceremonial as that of the forecourt. While the latter served for preparation, this is intended for subsequent reflection. Before we return to daily life, we may linger pensively a while in the feelings of art, ponder them, calm ourselves. We want to store up their resonance here within ourselves. Then we may go."[26]

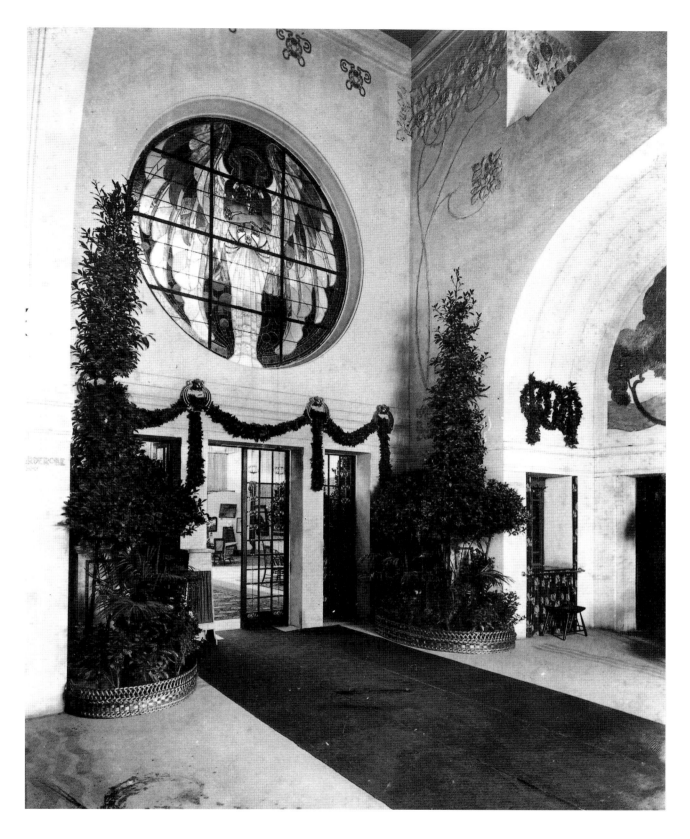

Bahr's description makes clear that the passage is meant to do more than just present the experience of art as a kind of three-step initiation. The styling of the exhibition house as cult space has to do with the situation of the building within its urban context, a situation which is fantasized as isolation, the architectural equivalent of the 'exclusion' of the sacred from society: "As one approaches from the Karlskirche, sets foot on the square and sees the building, its crown gleaming in the sun, it appears as a shining island with its white and gold in the green, a blessed island in the tumult of the city, an escape from mundane cares into eternal art."[27]

Foyer of Vienna Secession before remodeling by Josef Hoffmann in 1902.
Photo: Bildarchiv der Österreichischen Nationalbibliothek

The metaphor of the (museum) island is not new; it was already common in the nineteenth century, where the integration of the museum building into the urban structure reflected the prominent role of art and therefore of the art museum as the haven of the ideal in the midst of prosaic reality.[28] Around 1900, the metaphor was radicalized into a literal insularity, an architectural illustration of the ambiguity of the social function of art. This is the case, for example, in a design for the Kunsthalle in Hamburg created not long after the Secession, where the museum building is located on an isle in the Alster, giving rise to the additional association with the islands of the dead.[29]

The topography of the museum as a 'sacred place,' shaping the social function of art at both the individual and the collective level, finds its correspondence in the aesthetic theory of the Secession. Rudolph Lothar, for example, states:[30] "Here [in the exhibition] is created a place where one can retreat far from the noise of daily life into conversation about art and pictures. The new art demands not silent viewers, but utterance, speech and rejoinder. It draws its impulses from the conflict of opinion."

Art criticism had developed during the Enlightenment from the discussion, debate, and spoken argumentation of the bourgeois public sphere in which essentially anyone could utter his opinion freely without regard for social rank and profession, and within which norms for the evaluation of art were to develop discursively. A remnant of this discursivity still lives in Lothar's "conflict of opinion," but only within the intimate sphere of the exhibition, which at the same time appears strangely distanced from the rest of life, separated from it both communicatively and spatially. Art and life exist in a paradoxical relationship; the former should and can have an effect on the latter only when it is separated and sealed off from it. The mundane

View of beginning of Wienzeile before installation of permanent Naschmarkt halls, ca. 1903/4.
Photo: Archiv Otto Kapfinger

Wien. Magdalenenstrasse. Secession.

world—including the life of work and employment, with all its miseries and cares—is present only in aesthetic-escapist refraction: "And when we escape from the life outside by inviting ourselves to be the guests of art, only then do we truly approach it. But by another route [...]. The highest calling of art is not to be pleasure or enjoyment, but to teach it. In this sense, art is the glorious schoolmistress of man."[31]

Vignette of Vienna Secession

The notion of art as educating, humanizing, and instructing, a conception in which the development of the bourgeois museum is grounded, here loses its significance. For the goal is no longer the understanding of the work of art, the critical concern for the significance of its meaning within a historicizing context established through presentation. Rather, what is important is the subjective pleasure of the viewer spending time as a 'guest' in the exhibition: "It [the art] educates in the ability to enjoy; it teaches the senses to discover the treasures of happiness. For pleasure is happiness."[32]

COLLECTION AND COMPOSURE

In search of comparable spatial structures, Otto Kapfinger has interpreted the building of the Secession as, among other things, a kind of condensed paraphrase of the "receptive, signifying space" created by Gottfried Semper in the Kunsthistorisches Museum in Vienna, though it occurs there in a much more elaborate and spatially more differentiated form.

There, too, the iconographical program, the sanctifying, domed center, the theatrical presentation of the entrance, and finally the access to the collection itself constitute a carefully staged and intensified 'passage' that prepares the visitor for the experience of art. In this way the museum makes use of a topos and structure that was established at the latest with Karl Friedrich Schinkel's paradigmatic museum building for the royal collections at the Lustgarten in Berlin (opened 1830), the model for many later museums. Here, in Schinkel's structure, the access to the collection is explicitly defined as a passage. The visitor is first led through the Corinthian portico at the front of the two-storey building; decorated with ambitious cosmological and anthropological iconography, the portico functions as a 'hinge' between the space of the city and that of the museum. The visitor then proceeds into the central, Pantheon-like domed space extending up through both floors of the museum.

This central space is a space for 'collecting' in a double sense. Statues of gods once stood there, and today, after considerable war damage, they stand there again in a reconstructed condition approaching that of the original. But the space is more than a place for exhibiting important works of art obligated to the classicistic canon of art; it is also a space for collecting oneself. Thus two different aspects come into play here: the order of things and the identity of the visitor. Schinkel himself, deviating from his otherwise sober, bureaucratic language, explained this central space as a place in which the visitor is "elevated": "In the end, even a mighty building such as the one this museum is destined to become cannot dispense with a worthy center, the shrine that preserves that which is most precious. This is the place first entered when coming in from the outer hall, and here the view of a beautiful and sublime space must make one receptive and set the mood for the pleasure and recognition of that which is preserved within the rest of the building."[33]

This central space of collection and composure is intersected by a spatio-temporal structure that can be read both horizontally and vertically. The sequence and superposition of ancient and modern art (the sculpture collection on the ground floor, with painting above) paradigmatically illustrates the temporal-stylistic development of art and the normative artistic ideal of the time, constituting a

compromise between the classicistic canon and the historicist relativizing of this ideal.

After passing through the collections, the visitor's tour of cultural history led out onto a platform on the upper story with a view of the city and the royal palace. Before the purifying passage through the ideal realm of art concluded with the descent back through the portico, down a staircase likewise open to city and palace, the fresco decoration of this upper staircase once again offered a contextualizing re-reading in which the cultural history of art and of the subject was placed within a civilizational, sacrificially interpreted frame: "self-sacrifice for others during natural catastrophes" and "self-sacrifice for others in defense against human savagery," as Schinkel himself described the themes.[34]

In the Kunsthistorisches Museum in Vienna, the central dome structure no longer functions as exhibition space. Instead, the dome motif unfolds in a superimposed doubling before the monumental staircase, whose pictorial decoration also glorifies the patronage of the ruling house. The whole scenario, occupying considerable spatial volume, provides a highly charged initiation into the museum visit.

In the Secession—to continue the comparison with the Kunsthistorisches Museum—the highly charged choreography of entry and preparation essentially makes use of the same structural elements. Here, however, there is no communication between the dome and the interior space: "The purely symbolic function of the dome is intensified still more through its dissolution from the interior space: the access to this arbor is completely 'esoteric' and is possible only through the difficult ascent by ladders and platforms within the narrow, dark shaft of a pylon."[35]

The liberation of the circular, domed center from a practical in favor of a symbolic function is not unusual. Naturally, the appropriation of this obvious leitmotif of monumental museum architecture, featuring domed or even nearly spherical, 'centralizing' spaces, always gives rise to a tension between the practical and the symbolic dimension, between 'collecting' in its material significance (the assembling and preserving of things) and 'composure' in its intellectual dimension (the experience of the things).

In the history of museum architecture, the design of the 'center' spans a whole range of possibilities: the highly charged symbolic form can be combined with the utilitarian function of display, or the center as void can be emphasized with objects accentuating its symbolic function. Intended for Schinkel's rotunda were first of all antique sarcophagus-like chests, then a mighty granite basin; in the end, the center remained empty.

An example of the comparable creation of aura for the center in the Secession exhibitions is the placement of Max Klinger's *Beethoven monument* on a platform surrounded by a circular, distancing barrier.

This dichotomy between the 'utilitarian' exhibition space on the one hand—the space intended to house works of art—and the space of symbolic significance and 'composure' on the other—where visitors are initiated and prepared, enabled to 'collect themselves'—can be resolved in a radical way. Such resolution appears in spaces like the dome of the Secession, or even its 'architrave' resembling a chest or sarcophagus, spaces whose unenterability seems completely irreconcilable with the museum's practical function and which therefore draw attention to the symbolic function of the museum in general. Two phantasmagorias situated at opposite ends of the development of the idea of the museum can be named as examples of this phenomenon. One is Etienne Louis Boullée's 1783 design for a *museum* (not intended to be realized), whose spaces serve no collecting function at all and whose central domed space—Pantheon-like,

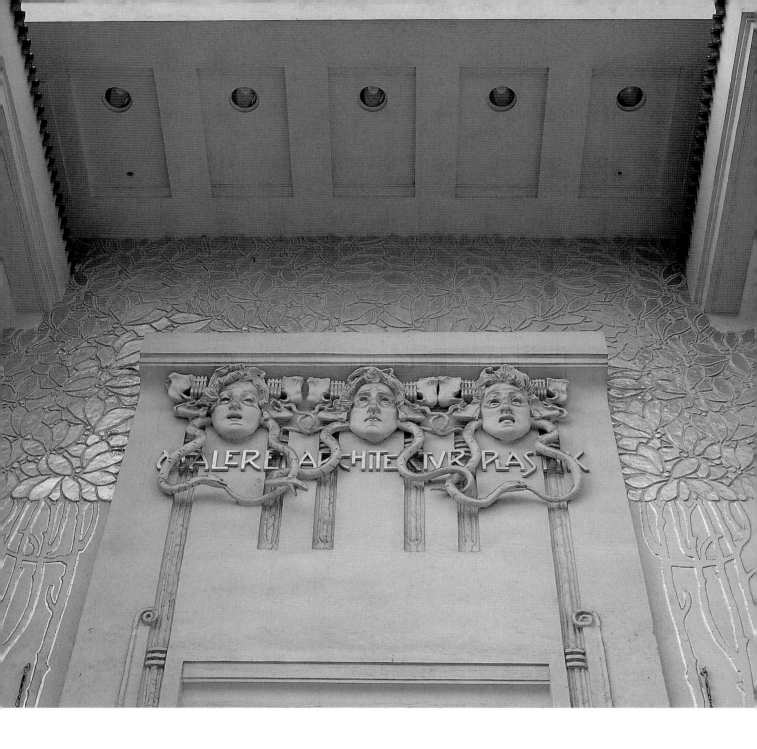

View of portal niche.
Photo: Margherita Spiluttini

illuminated from above through an oculus, and accessible via staircases leading past blazing altars for sacrifice and burnt offerings—is entirely empty. The other is Daniel Libeskind's *Jüdisches Museum* under construction in Berlin, which evades the narrative representation of Jewish history and the extermination of the Jews through, among other things, the design of unenterable and in part invisible empty spaces, voids.

For all the differences between these two designs, what they share is a rejection of concrete representation. In their radical abstraction, they point to an inescapable non-representability, one that can never be overcome by even the greatest and most well-organized of collections. The abstraction of symbolic space, probably also of concern to Olbrich in his design for the 'dome,' has more than just an aesthetic dimension, as Louis Kahn makes clear when he speaks of the Pantheon, the space paradigmatic for the type of the centrally-focused museum building. As is well known, the Pantheon can be inscribed in a circle; for Kahn, its perfection is disturbed by only one circumstance: the fact that it has a door.[36]

A deepened understanding of the symbolic function of central museum spaces and thus of the museum in general can be gained from a very strange, almost forgotten text which appeared in 1936 and is clearly obligated to the National Socialist ideology of sacrifice. Its author, Hubert Schrade, was concerned with updating the Romantic metaphor of the "museum as aesthetic church," and his thesis draws our attention to the complex and very difficult connection between social function and symbolic form with reference to the museum—as well as the proximity of the museum to sacrifice and the place of sacrifice.

"He has," Schrade writes, using Schinkel's rotunda of the Altes Museum in Berlin as the point of departure for his considerations, "torn the works of art from the common stream of life and erected a temple to them in which the sacrality that they reveal is withdrawn from the obtrusiveness of the profane. He has created a space in that temple which, as the imitation of an art form considered sacred by virtue of its marvelous completeness, was appointed to purify the visitor, to produce in him a disposition capable of accepting the exaltedness that awaits him with pure senses and a spirit of faith. Schinkel has created, to use the words of Hölderlin, the 'aesthetic church' [...]."[37]

Schrade's analysis, intensifying Schinkel's intention and rendering it one-sided by sealing off the experience of art, is expanded in a strangely hermetic-sounding statement regarding the socializing function of the museum: "It [the central space in Schinkel's museum] is not intended to be a place of assembly, but a place of composure; not a space for society and traffic, but a place for contemplation and the preparation of the individual for the secrets that await him, and thus a space for desocialization."[38]

Factually and in terms of the history of ideas, sacrality and sacrifice are mutually referential. The places of participation and exclusion, of division between inside and outside—in short, of the sacrifice—can also be found in the empirical order of the ancient city. The center of both city and house was constituted by the *Hestia,* the communal hearth (or hearth fire),[39] which was also the place of sacrifice. This universal institution usually assumed circular form, thus designating the center around which the order of the city was organized. This center is the place of the non-representable. While in the intention of the Secession the concept of sacrifice clearly follows the idea of surrender or the giving up of something, here the socializing function of the sacrifice comes into play: "The sacred offering concretizes the relationship of the community to the order of the sacred, and therefore of the violent, the order from which the community arises but which at the same time threatens it. The object of sacrifice is thus the external object of and in the symbolic order that constitutes the communal bond."[40]

Schrade thus speaks of the museum as both a "shrine of the center" and a place of "desocialization" because, even while affirming the idea of the cult of sacrifice, he senses the threat to society posed by the sacrifice and the sacred, as well as the relatedness of the two 'places' that represent the negativity of socialization, sacrifice and museum.

"This nothingness is the true source of community: it is the public thing (concern, issue) from which every relationship proceeds, in particular every relationship of desire and every relationship of ethical and political obligation. We need not mention the whole etymological game in which nothingness (*rien*), the cause (*cause*), and the thing or matter (*chose*) correspond between res and causa."[41]

In the history of modernism, these aspects of the museum—the creation of an external, sacred space of socialization—first appeared with the museum fantasies and designs of the period of the Enlightenment and the French Revolution. Around 1900, these characteristics were transformed and reactualized in a strangely regressive way. In a climate marked by the centrifugal cultural and political forces of

the end of the Danube monarchy, the priestly artists' community sought to reestablish a centering force for society in the restitution of the sacred and the allusion to sacrifice.

The historicist museum justified the bourgeois society through its present-oriented narrative of a historical-social self achieving awareness. This legitimizing figure, however, was torn apart by the radical 'presentness' of the aesthetics of the Secession, by the originating act in which the Secession sought to bring forth the new, and which at the same time constituted a fundamental threat to the historical.

The escapist gesture of revolt proved unfit to reconcile art and life once more in practical intent and thus rendered the Secession sterile as a political-ethical movement. The Secession building is an expression of this discord.

Notes

1 Ludwig Hevesi, Grundsteinlegung in der "Sezession"; in: Fremdenblatt 117 (Wien, April 29, 1898), 13–14
2 Otto Kapfinger and Adolf Krischanitz, Die Wiener Secession. Das Haus: Entstehung, Geschichte, Erneuerung (Wien/Köln/Graz 1986), 65
3 See Otto Kapfinger's analysis in this volume.
4 For a fuller discussion of the metaphor of the laurel in the context of the Secession building, see Kapfinger/Krischanitz (as in n. 2), 65f
5 Ibid., 65. On the diverse mythical, religious, and architectural-historical meanings of the primitive or leaf hut, cf. Joseph Rykwert, On Adam's House in Paradise: The Idea of the Primitive Hut in Architectural History (Cambridge/London 1981). On the connection between the idea of the 'sacred hut' as a conception of time and the *imago mundi,* as well as between the spatial and the spatio-temporal in the terms *templum* and *tempus,* see Mircea Eliade, The Sacred and the Profane: The Nature of Religion (New York 1959)
6 Cf. Ulrike Brunotte, Die Konstruktion der Unterwelt. Zur Architektur der Erinnerung in Kult und Psychoanalyse; in: Daidalos 48 (June 1993), 82
7 Examples might include Etienne Louis Boullée's phantasmagoria of a museum and Karl Friedrich Schinkel's museum building in Berlin, but also contemporary museum architecture, for example Hans Hollein's design for an underground Guggenheim Museum at the Mönchsberg in Salzburg. On these questions cf. Gottfried Fliedl and Karl-Josef Pazzini, Museum – Opfer – Blick. Zu Etienne Louis Boullées Museumsphantasie von 1783; in: Die Erfindung des Museums. Anfänge der bürgerlichen Museumsidee in der Französischen Revolution, ed. Gottfried Fliedl (Wien 1996). Olbrich described the creation of the Secession as an act of giving birth—"with what joy did I bear this house!"—and as the shaping of a "chaos of ideas, a mingling of good and evil," not as the result of an act of rational planning, but rather: "when I comprehended the task with my heart, when the inner feeling grew louder than mind and reason, then I had the courage to accomplish what I felt; and it was born!"Joseph Maria Olbrich, Das Haus der Secession; in: Der Architekt V (Wien 1899)
8 At issue is purification from guilt, even bloodguiltiness. In Roman triumphal entries, the general and the soldiers following the triumphal car bore the laurel decoration; in Augustus' time and later, the crowning with a laurel wreath and the holding of the laurel branch became customary. The branch was later planted to found a grove bearing the ruler's name.
9 The most prominent contemporary example of this paradigm is I. M. Pei's glass pyramid as the main entrance to the immense collections of the Louvre: visitors are first led downwards—to the ticket counters, shops, and restaurants—and then upwards once more to the various sections of the museum. In the process, they are also submerged, as it were, in the archaeological strata and therewith in the history of the museum, since the foundations of the medieval royal palace are exposed and accessible underground. Particularly ironic is the fact that the pyramid—the quintessentially inaccessible, rebuffing, hermetic architecture of death—has now become transparent, luminous, fragile, and light, has become the initiating, inviting entry space which opens up the museum and its collections.
10 Cf. Fliedl/Pazzini (as in n. 7), 131ff
11 Cf. the extensive treatment of this subject in Joseph Rykwert, The Idea of a Town: The Anthropology of Urban Form in Rome, Italy and the Ancient World (Princeton 1976)
12 Ver Sacrum, vol.1, no.1 (January 1898), 1f
13 Rykwert (as in n. 11), 46ff
14 Eliade (as in n. 5)
15 On the definition of *symbolic space,* cf. Richard D. Etlin, Symbolic Space: French Enlightenment Architecture and its Legacy (Chicago/London 1994), XX. On the relation to what Marc Augé calls the anthropological place, cf. his definition: "If we pause for a moment at the definition of the anthropological place, we note that it is first of all geometric. It can be grasped on the basis of three simple spatial forms, which are applicable to various institutional mechanisms and which in a certain way constitute the elementary forms of social space. In geometric terms, these are the line, the intersection of lines, and the point of intersection. Concretely, in the geography more familiar to us in our daily lives, we can speak on the one hand of paths, axes, or tracks leading from one place to another and which are created by people, and on the other hand of intersections and plazas where people encounter one another and assemble themselves. The latter have sometimes been given considerable dimensions in order that they, above all the market squares, may satisfy the demands of economic exchange. Finally, there are the more or less monumental centers of a religious or political nature, constructed by particular persons and which in their turn define spaces and boundaries beyond which other people are defined as the other, in relation to other centers and other spaces." Marc Augé, Non-lieux. Introduction à une anthropologie de la surmodernité (Paris 1992), 73–74

16 Quoted in Christian M. Nebehay, Gustav Klimt Dokumentation (Wien 1969), 149

17 Ver Sacrum vol. 1, no. 1 (January 1898), 3

18 Sheldon Annis, The Museum as a Staging Ground for Symbolic Action; in: Museum 151 (1987), 168ff

19 Klinger. Beethoven. XIV. Ausstellung der Vereinigung Bildender Künstler Österreichs. Sezession. April–Juni 1902, exh. cat., 9ff, cited after Gustav Klimt. Zeichnungen, exh. cat. (Hannover 1984), 144. Ernst Stöhr also advances the argument of a 'timeless' art: "This [the novel idea of an exhibition governed by and designed around a guiding idea] was now to be realized in an exhibition within the narrow confines of a house in which nothing permanent can be created, since each exhibition must necessarily swallow up the work of the preceding one."

20 Carl E.Schorske, Wien – Geist und Gesellschaft im Fin-de-Siècle (Frankfurt/M. 1982), 240. With 60,000 visitors, the exhibition was the Secession's greatest public success. Cf. Wolfgang Hilger, Geschichte der "Vereinigung bildender Künstler Österreichs" Secession 1897–1918; in: Die Wiener Secession. Die Vereinigung bildender Künstler 1897–1985 (Wien 1986), 38

21 Cf. Marian Bisanz-Prakken, Der Beethoven-Fries von Gustav Klimt in der XIV. Ausstellung der Wiener Secession (1902); in: Wien 1870–1930. Traum und Wirklichkeit, exh. cat. (Salzburg/Wien 1984), 529. Cf. also Gottfried Fliedl, Gustav Klimt. Die Welt in weiblicher Gestalt (Köln 1989)

22 Kapfinger/Krischanitz (as in n. 2), 67

23 Olbrich (as in n. 7), 5

24 Hermann Bahr, Meister Olbrich; in: Die Wiener Moderne. Literatur, Kunst und Musik zwischen 1890 and 1910, ed. Gotthard Wunberg (Stuttgart 1981), 510

25 Ibid.

26 Hermann Bahr in: Die Zeit, no. 211 (Wien 1898), 42ff

27 Ibid.

28 The continuing pervasiveness of this conception of the museum is evidenced by Walter Zschokke's review of architect Peter Zumthor's Kunsthaus in Bregenz, a review that in some of its language is amazingly close to Secessionistic escapism: Zschokke speaks of the "consecrated-meditative mood" of the interior, but above all of the tower-metaphor of the building as "a place of retreat not for art, but for man—for the encounter with art—the ascent [into the tower] as a withdrawal from the noise and busyness of the streets." Walter Zschokke, Glasgefieder wie Perlmutt; in: Die Presse, July 19, 1997, Spectrum, p. IX

29 Wilhelm Fränkel, Entwurf für einen Neubau der Kunsthalle als Museumsinsel an der Harvesterhuder Alsterseite, 1910–11. Cf. Ulrich Luckhardt, "… diese der edlen Kunst gewidmete Hallen". Zur Geschichte der Hamburger Kunsthalle (Hamburg 1994), 32

30 Rudolph Lothar, Von der Secession; in: Die Wage, vol. 1, no. 49 (December 1898), cited after Das Junge Wien. Literatur- und Kunstkritik 1887–1902, ed. Gotthard Wunberg, vol. 2 (Tübingen 1979), 921f

31 Ibid.

32 Ibid.

33 Quoted in full in Alfred Freiherr von Wolzogen, Aus Schinkel's Nachlaß, vol. 3 (Berlin 1863), 239 and 245; here quoted from Hubert Schrade, Die ästhetische Kirche; in: idem, Schicksal und Notwendigkeit der Kunst (Leipzig 1936)

34 Cf. Karl Friedrich Schinkel 1781–1841, exh. cat. (Berlin 1982), 147ff

35 Kapfinger/Krischanitz (as in n. 2), 66

36 Cf. Etlin (as in n. 15), XIX

37 Schrade (as in n. 33), 59

38 Ibid., 56ff

39 The following quotation by John Ruskin may serve as an example to elucidate the connection between the sacred, the hearth, and the temple. Ruskin's private metaphor of refuge and withdrawal corresponds strikingly to the Secessionistic conception of art described here: "This is the true nature of home—it is the place of peace; the shelter, not only from all injury, but from all terror, doubt and division. In so far as it is not this, it is not home; so far as the anxieties of the outer life penetrate into it, and the inconsistently-minded, unknown, unloved, or hostile society of the outer world is allowed by either husband or wife to cross the threshold it ceases to be home; it is then only a part of that outer world which you have roofed over and lighted fire in. But so far as it is a sacred place, a vestal temple, a temple of the hearth […] it is a home." John Ruskin, Sesame and Lilies (New York 1891), 136f., quoted in Richard Sennett, The Conscience of the Eye: The Design and Social Life of Cities (New York 1992), 20

40 Bernard Baas, Das Opfer und das Gesetz; in: Riss. Zeitschrift für Psychoanalyse 7, 21 (Oct. 1992), 53

41 Bernard Baas, Das öffentliche Ding. Die Schuld (an) der Gemeinschaft; in: Ethik und Psychoanalyse. Vom kategorischen Imperativ zum Gesetz des Begehrens: Kant und Lacan, ed. Hans-Dieter Gondek and Peter Widmer (Frankfurt/M. 1994), 112

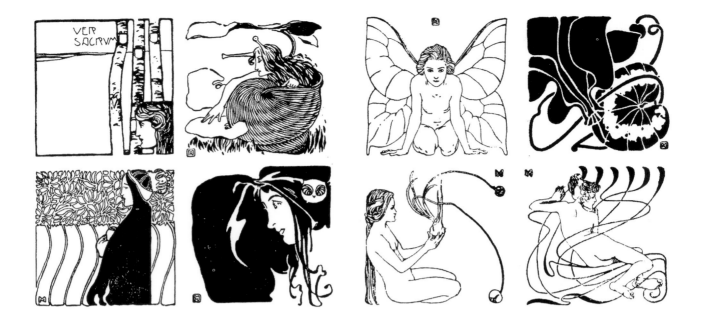

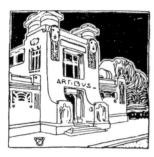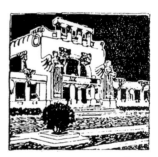

Above: Vignettes by Koloman Moser
in the catalogue of the 1st exhibition,
1898
Below: Vignettes by Josef Hoffmann
in the catalogue of the 1st exhibition,
1898

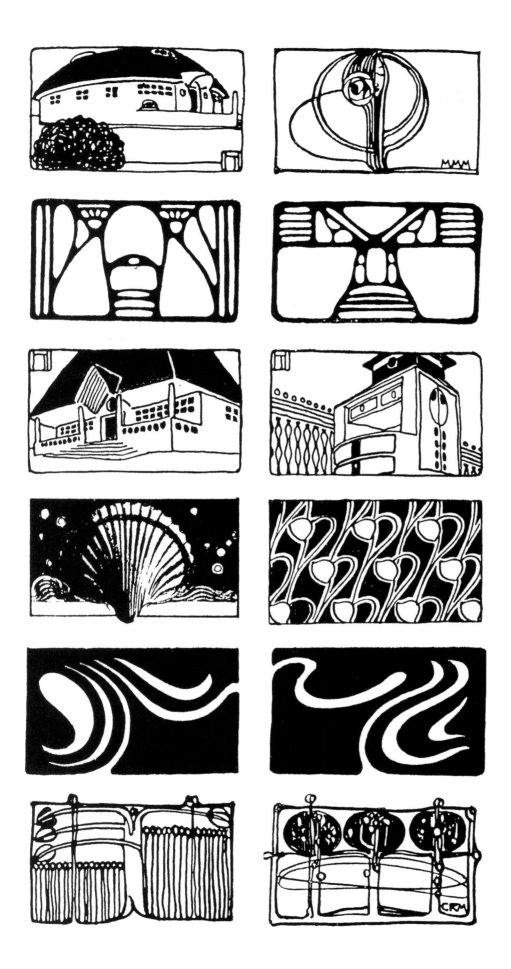

Vignettes in the catalogue of the 8th exhibition.+ Top left to lower right: Josef Hoffmann, Margaret McDonald, Koloman Moser (2), Josef Hoffmann (2), Rudolf Jettmar, Friedrich König, J. M. Auchentaller (2), Charles R. Mackintosh (2)

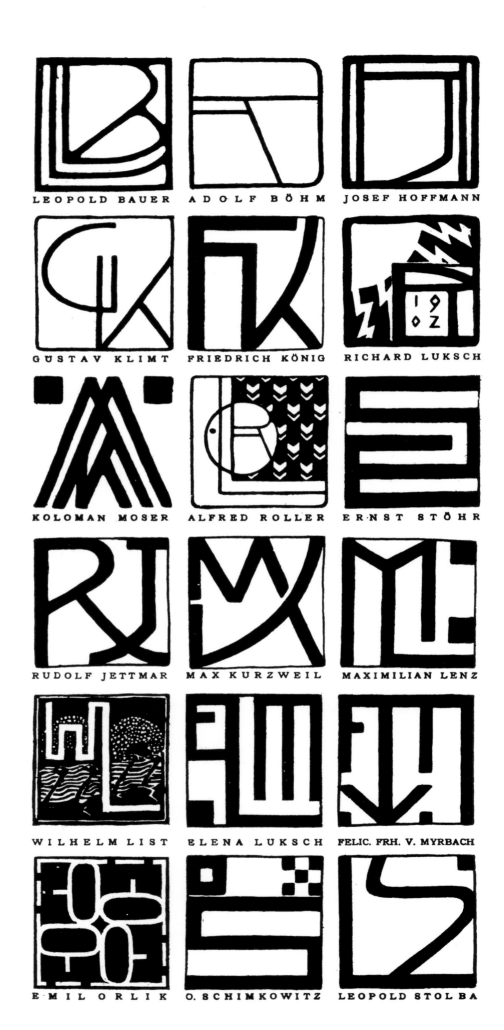

LEOPOLD BAUER ADOLF BÖHM JOSEF HOFFMANN

GUSTAV KLIMT FRIEDRICH KÖNIG RICHARD LUKSCH

KOLOMAN MOSER ALFRED ROLLER ERNST STÖHR

RUDOLF JETTMAR MAX KURZWEIL MAXIMILIAN LENZ

WILHELM LIST ELENA LUKSCH FELIC. FRH. V. MYRBACH

EMIL ORLIK O. SCHIMKOWITZ LEOPOLD STOLBA

Initials in the catalogue of the 14th
exhibition

Vignettes by Adolf Böhm, Friedrich König, Leopold Stolba, Josef Hoffmann, Wilhelm List, and Friedrich König in the catalogue of the 17th exhibition

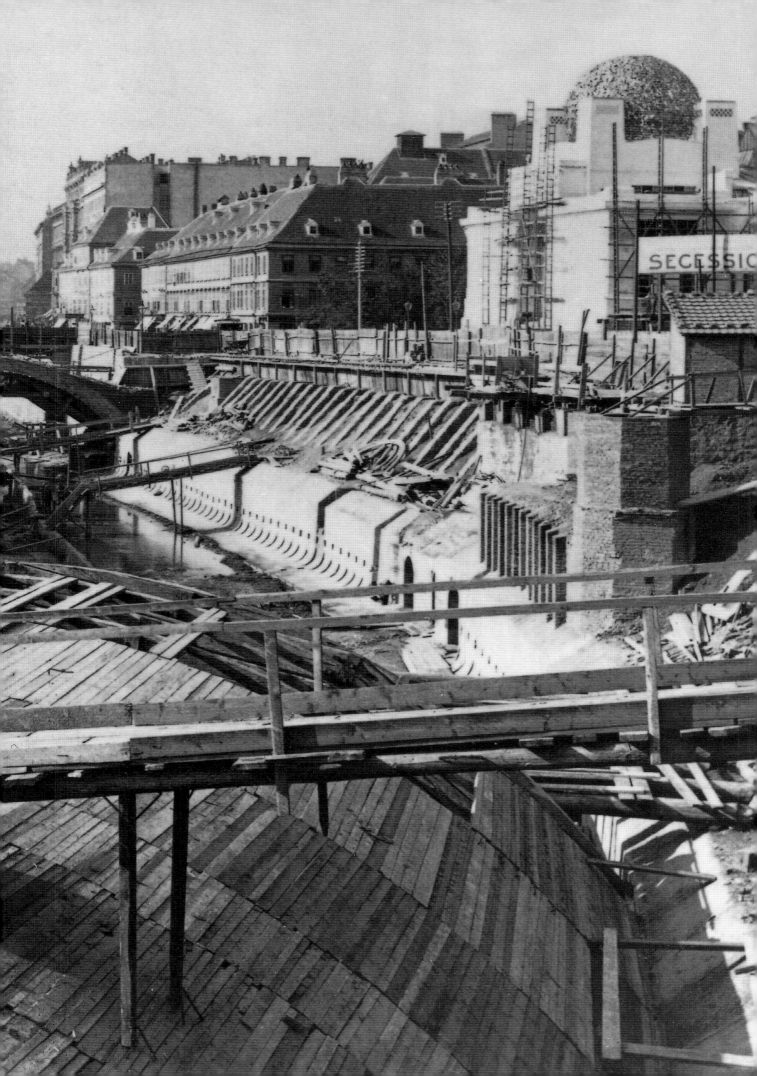

Otto Kapfinger

OLBRICH'S DREAM OF THE TEMPLE OF ART

*I wanted to hear only the sound of my own sensation, to see my warm feeling
solidified in cold walls. The subjective, my beauty, my house as I dreamed it, I
wanted and had to see.*
J. M. Olbrich

Joseph M. Olbrich.
Photo: Archiv der Wiener Secession

The exhibition building of the Vienna Secession is one of the best-known examples
of European architecture at the transition from historicism to modernism. With his
"temple of art," the barely thirty-year-old Joseph Maria Olbrich created a key
work of Viennese Jugendstil. His synthesis of the archaic and the modern, his
novel interpretation of typological and symbolic references, the contrast between
the sacred entrance beneath the dome of gilded laurel leaves and the sober
functionality of the exhibition hall—all these things shocked his contemporaries and
made the building the talk of the town, a bona fide aesthetic scandal. Since then,
the building's revolutionary spatial qualities have proven themselves under the
most diverse demands, while its concise silhouette and the aura of its interior
space have made it an established part of the Viennese art and architectural
scene. In its subjectivity of design, transgression of academic rules, and patent
contradictoriness, this early work by Olbrich touched on fundamental artistic
questions of the epoch and thus became, not the model of a new style, but rather
a kind of manifesto, an unwitting psychogram of the age.

The construction of a new exhibition building was included in the programmatic
agenda of the founding assembly of the *Vereinigung bildender Künstler Österreichs*
on April 3, 1897. A plot on the Ringstraße at the Wollzeile was chosen as a building
site. The plans were prepared by Joseph Maria Olbrich, one of the cofounders of
the Secession and at that time a leading associate in Otto Wagner's atelier. The
plans, however, met with vigorous criticism in the Viennese municipal council, and
only the choice of a less "prominent" building site on the Karlsplatz led to success.
Olbrich tailored the design to the new location and crowned the entrance area with
a laurel dome, probably also as a correspondence to the nearby Karlskirche. The
project was financed both from the rich proceeds of the first Secession exhibition,
which took place in the halls of the Horticultural Society, and the substantial
support of private art patrons, with a major part assumed by the industrialist Karl
Wittgenstein. The building site itself was donated by the city, with the stipulation
that after ten years the house would revert to public property. The building was
completed in little more than six months and inaugurated with the opening of the
second Secession exhibition on November 12, 1898.[1]

The building covers an area of ca. 990 m^2 and rises over a centralizing ground plan
characterized by interlocking quadratic and cruciform figures. The largely closed
exterior walls give the pavilion the effect of a monumental complex of massive
cubes, although in proportion to the enclosed space the walls are actually very thin.
Olbrich divided the volume into a 'head' and a 'body.' The representative entrance
area with the cruciform vestibule in the center is flanked by hermetic blocks; above
it, four pylons tower up as a setting for the dome. The adjacent exhibition hall is
covered almost entirely with tent-like glass roofs, providing uniform overhead lighting
for the interior. Olbrich conceived the exhibition area as a sober, unified, basilical
space with a quadratic central zone, lower side aisles, and a terminating transept.
Only two slender pairs of supports interrupt the continuum of this open space, which
is brightly lit even in overcast weather. Ludwig Hevesi called it a "puzzle box" that
could be outfitted with a new spatial design for each exhibition and thus present a
Gesamtkunstwerk geared specifically to the exhibited pieces or the theme.

Left page: Construction over the river
Wien with nearly completed
Secession in right background, 1898.
Photo: Direktion der Museen der
Stadt Wien

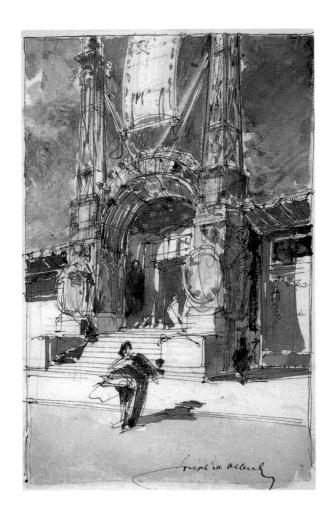

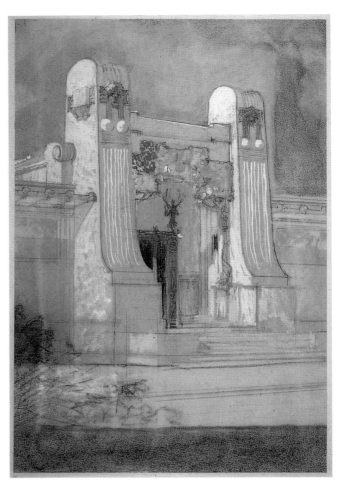

Joseph M. Olbrich, *Provisional Variant,* first design for entrance portal, 1897.
Photo: Archiv der Wiener Secession

Joseph M. Olbrich, *Exhibition Building of the Vereinigung bildender Künstler Österreichs*, first design, 1897.
Photo: Archiv der Wiener Secession

Gustav Klimt, *Ver Sacrum. Vereinigung Bildender Künstler Österreichs,* sketch for main facade, 1897.
Photo: Historisches Museum der Stadt Wien

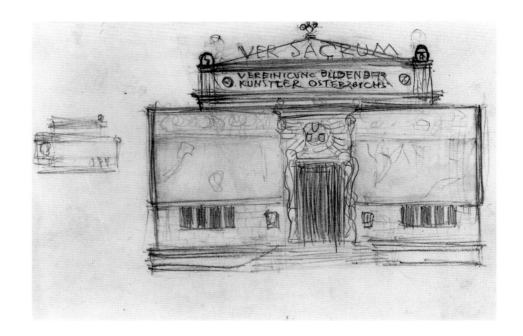

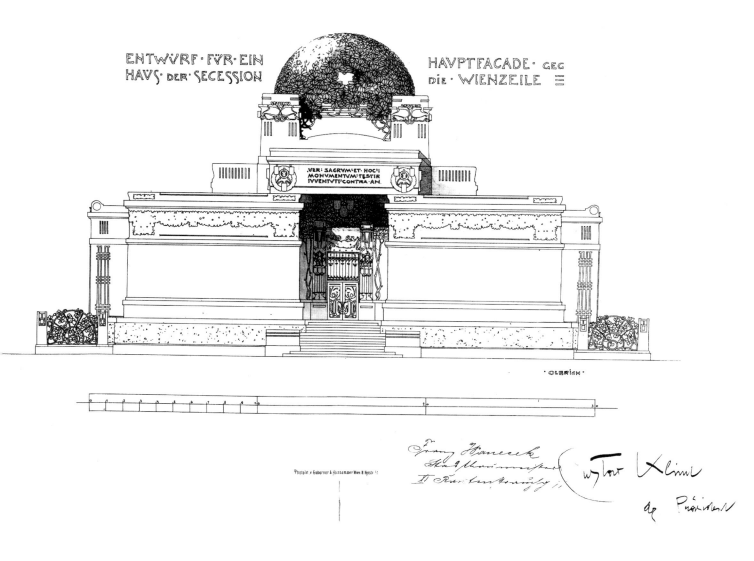

ENTWVRF·FVR·EIN
HAVS·DER·SECESSION

HAVPTFACADE· GEG
DIE·WIENZEILE ☰

·VER· SACRVM·ET·HOC·I
MONVMENTVM·TESTIR
IVVENTVTI·CONTRA·AN.

·OLBRICH·

Photodr. v Gaberner & Hastenmmer Wien II Heustr 11

Even conservative critics immediately paid tribute to the building's interior, recognizing it as a pioneering prototype. Its external appearance, on the other hand, met with sharp opprobrium. Here, too, in the tradition of the artisans' guild, a number of Secessionists had contributed to the decorative program. Othmar Schimkowitz created the sculptural decoration of the portal niche, Georg Klimt the copper repoussé facing on the entrance doors. The frescoed *Dance of the Wreath-Bearing Maidens* on the north facade and the polychrome glass rosette *The Archangel of Art* on the front wall of the vestibule were the work of Koloman Moser, while the owls on the side fronts were modeled in cement stone by Olbrich himself after drawings by Moser. The patterning of the 3,000 laurel leaves of gilded wrought iron was visibly inspired by the ornamentation of Gustav Klimt. The ambitious design of the surrounding lawns with fountains, café pavilion, playground, and tree plantings—a "living enclosure against the profane"—could only be fragmentarily realized.

Olbrich's "blessed, shining temple of art" soon became the focus of the Viennese debate on the 'new style' of architecture, a debate initiated by Wagner's appointment to the Academy. The criticism was provoked above all by the abandonment of the traditional tectonic formal canon and the contrast between the forced 'symbolism' of the front section and the 'naked truth' of the exhibition hall. It was called a "hybrid of a temple and a warehouse," a "cross between a hothouse and a blast furnace," the "tomb of the Mahdi," a "temple for tree-frogs," an "Assyrian lavatory," a "temple of the anarchic art movement," a "crematorium," a "Buddha temple," a "public convenience," a "Prater booth where exotic animals are shown," a "mosque," an "assassination attempt on good taste," an example of

Joseph M. Olbrich, *Design for a building for the Secession, main facade facing the Wienzeile*, 1898.
Photo: Archiv der Wiener Secession

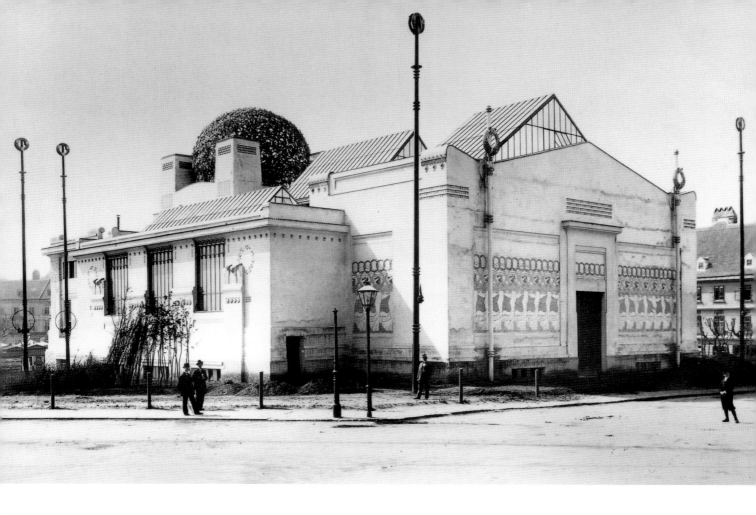

"Asiatic uncouthness" or "ornamentation that combines child-like simplicity with mystical strangeness into an unusual novelty," and so on.

In this, his first Viennese building, Olbrich mingled an abundance of typological and morphological impulses drawn not least from Wagner's Stadtbahn pavilions, in whose design he himself participated, as well as the latter's ephemeral festival architecture and his projects for monumental buildings crowned with transparent domes. But with his powerful, decorative sensibility, Olbrich transformed these motifs into a tremendously suggestive form, an original creation.

In addition to the influences just mentioned, impulses from Olbrich's own work can also be discerned. The ground plan of the Secession, for example, appears to be a purified variation on his 1891 competition design for the Landesmuseum in Troppau. His pavilion for the state and court officials' Cycling Club, created at the same time as the Secession, and particularly his sketches of antique monuments in southern Italy may also be viewed in this light. Although from 1897 on Olbrich's creative temperament demonstratively strove to overcome geometric proportional systems and academic compositional techniques, the Secession itself evinces a very strict, simple geometry in the arrangement of plan and elevation, although in the elevation the geometry is accepted only as a general framework within which Olbrich freely plays with sensitive lines, curvatures, and blendings.

A series of superimposed and inscribed squares, proceeding from both the entrance hall crossing and the central square of the exhibition space, produces the geometry of the ground floor plan, which extends to the clear, constructive rhythm of the ceiling vaults as well. The same square marked off by the pylons likewise constitutes the basis for the side wings and vertical section of the entrance area

Left page:
Top: Side and rear facade of Vienna Secession. Photo: Archiv der Wiener Secession
Bottom left: Joseph M. Olbrich, *Exhibition building of the Vereinigung bildender Künstler Österreichs. Situation of exhibition building of the Vereinigung Bildender Künstler after establishment of new building lines,* 1898.
Photo: Archiv der Wiener Secession
Bottom right: Joseph M. Olbrich, *Exhibition–building of the Vereinigung Bild. Künstler Oesterreichs,* ground plan, 1898.
Photo: Archiv der Wiener Secession

Below: Corner view of the Vienna Secession, ca. 1902.
Photo: Bildarchiv der Österreichischen Nationalbibliothek

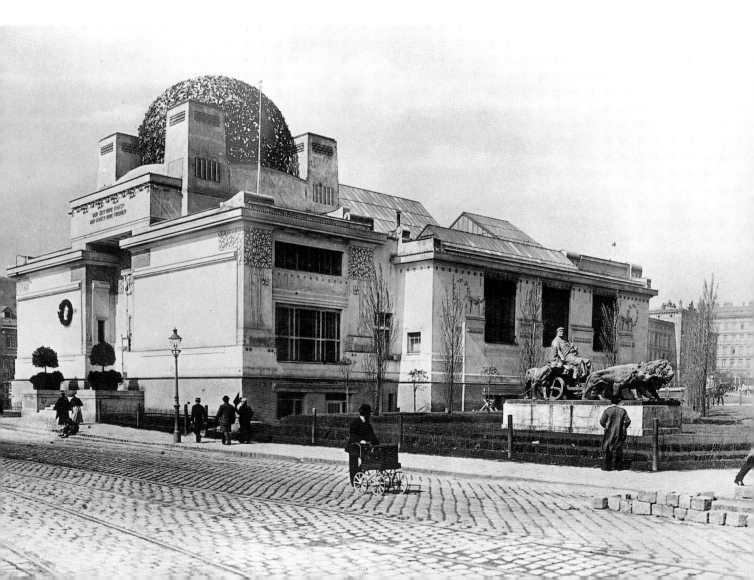

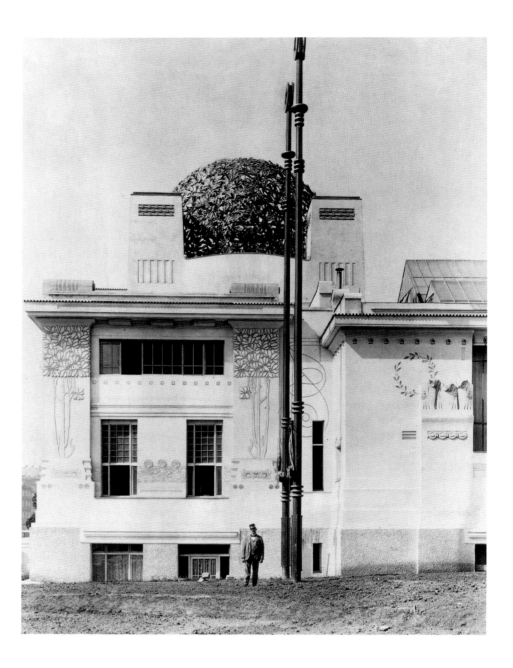

and is repeated once more in the central open area of the exhibition hall. If a fourth square extending to the center of the main hall is added to the first three in the ground plan of the entrance area and 'folded' upward, a form results which corresponds almost exactly to the outline of the main facade. Just as the cruciform plan of the vestibule is repeated and modified in the plan of the entire building, so also the ground plan of the building's 'head' is preserved in its vertical appearance. In this way, the geometry of the ground plan develops spatially and is transformed into the three-dimensional form of the building.

The most prominent symbolic element on the building is the laurel tree. It decorates the pilasters of the entrance area and portal niche, grows in the foliage of the dome above the building, and shows itself in various wreath motifs, including those of the dancing maidens on the rear facade. The perforated dome of gilded foliage, set within pylons, corresponds to a type seen in a variety of manifestations in Otto Wagner's œuvre as well, from the festival pavilion for the reception of Princess Stephanie on the Karlsplatz (1881) to the design for Berlin Cathedral (1890–91), the national monument in the Wienerwald (1897), and the hall of honor in his proposal for a new Academy building (1898). Two years before the Secession, Olbrich too had used an open, baldachin-like dome to crown his competition project for the Nordböhmisches Gewerbemuseum in Reichenberg.

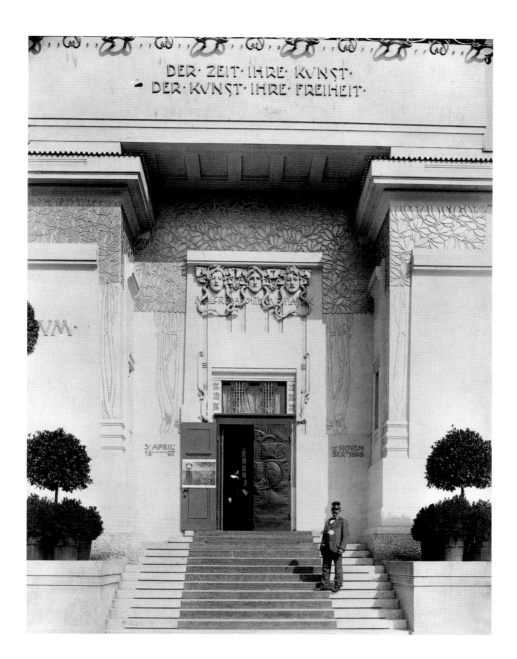

Entrance front of Vienna Secession, 1899.
Photo: Archiv der Wiener Secession

In the case of Wagner's Academy project, the significance of the metallic tissue rising up above the building and supplied with vegetal symbols is explained in the description of the interior space, which is divided into three wall zones from bottom to top corresponding to past, present and future: "The third, uppermost level [...] leads into the vault and shows sprouting plants dissolved into ornament, symbolizing the eternal germinating, growing, and blossoming of art."

Bent branches wreathed in laurel and bell-shaped bunches of foliage crowning significant, initiatory spaces symbolically connect the unknown future with the mythical deeds of an archaic past. The allusion to the primitive hut—the primeval origin of architecture with four poles vaulted over and covered with interwoven branches—develops from the ritual representations of antiquity to the festival decorations and ceremonial baldachins of the Baroque. It reaches a high point in Bernini's baldachin for St. Peter's and is revived by Wagner and Olbrich to signify the initiation of a dawning age of modern art and architecture.[2]

The entry sequence of the Secession, however, can also be compared to that of Semper and Hasenauer's Kunsthistorisches Museum in Vienna. Despite the external differences between the two buildings, both resolve the theme of a receptive, signifying space in an essentially analogous way. The Kunsthistorisches

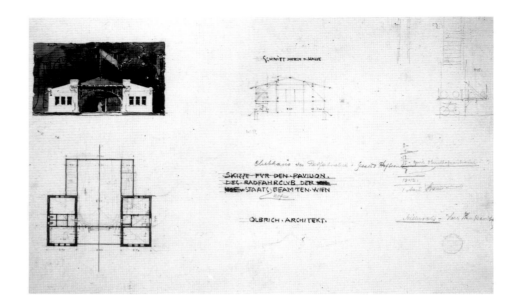

Museum represents an *architecture parlante* whose exterior constitutes an exhibition before the exhibition, a 'catalogue' defined in clear iconographic terms. The ornamentation of the facades with sculptures, reliefs, inscriptions, and medallions serves as a great textbook or guide to the art that is preserved and exhibited within the building. The entrance to the building in the central projection employs pseudo-sacral forms to celebrate the passage from the mundane world of everyday life to the high spheres of art using all the means of representation and psychological effect.

This central projection is elevated on the entrance side and forms a quadratic plateau above which the octagonal dome rises, crowned in turn by the colossal bronze statue of Pallas Athena. Four slender tabernacles mediate between the plateau and the dome and provide baldachins for seated statues representing the qualities leading to mastery in art: talent, enthusiasm, moderation, and power of will. The great dome surrounded by smaller tabernacles—a theme formerly reserved exclusively for sacral architecture—is here applied to a profane building in order to lend a cosmic, cultic aura to the place for the secularized enjoyment of art. The triple rhythm of portals and windows in the entrance area emphasizes the central axis and reinforces the sense of verticality. The first things encountered by the approaching visitor, however, are the Victories posted to the left and right on the ramp, extending bronze laurel wreaths in a gesture of coronation. In antiquity, the laurel wreath distinguished artists and athletes, victors in contest and those purified in rites and mysteries, and later, generals and statesmen as well—a custom that was resurrected in the Renaissance as the sign of the public consecration and recognition of the artist.

After mounting the front steps and entering the building, the visitor experiences the motif of elevation, of vertical ascent, in an immediate, spatially impressive way. The octagonal vestibule provides a view up into the dome through the eye of the plafond, a breathtaking vertical range of almost 60 meters. The plafond surrounding the opening in the vestibule ceiling is decorated with the heads of Bramante, Cellini, Raphael, and Michelangelo, and through this frame the viewer's rapt gaze soars upward into the heaven of the dome, inhabited not by the artists, but by the powerful donors and patrons, the emperors and kings.

The view through the small opening is followed by the majestic ascent between the cavernous, shining, marble-clad jambs of the stairway, the physical traversing of the height already experienced with the eye. The overwhelming material splendor and dramatically exaggerated size of this stairway, along with the continued iconography of the ceiling and spandrel paintings, now elevates those who enter

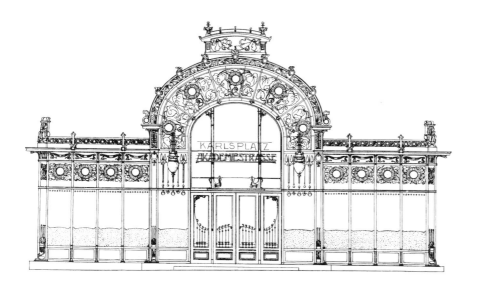

Left: Otto Wagner, *Stadtbahn station Karlsplatz,* ornaments by Joseph M. Olbrich, 1897–98. Photo: Archiv der Wiener Secession
Below: Gottfried Semper and Carl von Hasenauer, *Facade of the Kunsthistorisches Museum,* 1871–91.
Photo: Archiv Otto Kapfinger

and prepares them to immerse themselves in the realm of the aesthetic, to lose themselves in the labyrinth of halls.

Olbrich uses the same concept in the Secession, albeit in a drastically reduced form. The latent sacrality of the architecture of Semper and Hasenauer's central projection is concentrated into a hermetically archaic form; the literary language of the facade grows dumb and the opulently loquacious palace becomes a white, introverted shrine. The octagonal dome on its drum becomes a perfect sphere, the tabernacles are reduced to hieratic pylons, while the great architrave—the monumental field for inscription—remains the same. The motif of the dignifying laurel wreath, still figurally extended on the Kunsthistorisches Museum, becomes the dominant form of the building itself. The owl of Athena is repeated across the side facades. The entrance is reduced to an opening, but the tripartite motif is preserved in the number of gorgon heads over the portal. At the top of a steep stairway, exposed between blank, static blocks, a tiny, keyhole-like portal receives the visitor, while behind it the vertical power of the 'merely' nine-meter-high cruciform vestibule attains its full effect. In the entrance hall, Olbrich allows the gaze to roam upwards but no longer outwards, for there is neither a lantern nor visible

Foyer of Vienna Secession as
remodeled by Josef Hoffmann for
14th exhibition, 1902.
Photo: Bildarchiv der Österreichischen
Nationalbibliothek

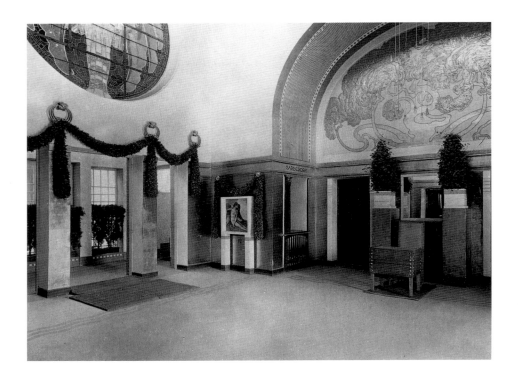

windows. Instead, the outline of the dome, no longer present on the interior, reappears as a glass rosette on the front wall toward the exhibition hall, thus mediating between the vertical and horizontal axes of the building. In the half-light of the lunettes under the galleries, the gilded stucco reflects the light of the windows hidden behind the balustrades, windows which otherwise permit a high, diffused sidelight to filter downwards.

Hermann Bahr called the entrance hall a "propylaeum," a "forecourt where those entering are purified from the mundane and attuned to the eternal." Olbrich achieves this attunement by relativizing the scale of the exterior front—an effect which both repulses and magically attracts—as well as with the ascent to the mysterious portal and the entrance into a surprising, vertically oscillating space. He uses unconventional, modern means to convey the aura of the archaic and transforms traditional building typology and spatial psychology into a provocative, subjectively sensed form.

Karl Heinz Schreyl[3] was the first to deviate from conventional architectural-historical opinion and to once again emphasize that Olbrich's "construction of the facade from the juxtaposition and superposition of blocks with closed, light plastered surfaces" constitutes "not a step toward functional sobriety, but rather an expression of purity and sublimity." The 'protocubist' stereometry and 'simple clarity of the building mass'—for which the Secession has been much praised and which pointed the way for the architecture of the 20th century—was not Olbrich's primary goal, but rather the means to a specific end. Planimetric simplicity provided him with a basis which he then sensitized with refined curvilinear, taut, and plunging lines, in this way winning subtle, organically vital, biomorphous forms from the smooth, sober (and economical) cube. Otto Wagner's rationalistic classicism here established the boundaries within which the pulsing, expressive whipline of Belgian and French Art Nouveau could unfold at the beginning of the Viennese Secession, before the latter—by then Olbrich was already working in Darmstadt—very quickly became 'strict' and 'constructive' again with Koloman Moser and Josef Hoffmann.

The Secession pavilion, in which the geometric and the organic are dialectically interwoven at every level from the building mass to the details, marks the point of intersection in this Viennese development. At first glance, the walls appear entirely cubic and rectilinear. Upon closer observation (and exact measurement), however, it

becomes apparent that there is not a single truly vertical surface or edge on these supposed prisms: all exterior surfaces taper gradually upwards, as seen most clearly in the pylons or the 'architrave' over the entrance.

At the meeting of vertical and horizontal surfaces, under the cornice projections, at the baselines of the 'corner piers,' and in the 'bearing zones,' Olbrich creates elastic transitions using convexities, small curves and counter-curves, chamfered undersides, and telescoping gradations. Even the front faces of the small square panels strung along the grooves on the rear facade are convex rather than flat. Thus in his streamlined, plastered masonry building, Olbrich employs all the techniques of curvature, convexity, and optical 'distortion' that were widely used and perfected in the stone architecture of antiquity and still appeared in Historicism in a rudimentary form. The purpose of these was to relieve the monotonous regularity of verticality, horizontality, and sequence by using forms with a slight spherical distortion to accommodate and intensify optical sensation: an anthropomorphic world of form, not as a literary reflection, organic analogy, or a naively 'natural' curvature, but rather a calculated correction of the subtle forms of rectangular planimetry, attuned to the biophysical conditions of vision and the experience of human space perception.

Through this refining of contours, Olbrich gives the terse cubes of his building a living, sensual proportionality, blurring the dimensions and attaining an intensified monumentality that suspends the sense of scale. Moreover, he accomplishes this in the details by means that are largely autonomous and freed from historical forms.

Renate Wagner-Rieger[4] observed that Olbrich's Secession represented an innovation with respect to Otto Wagner inasmuch as "the closedness of the surface acquires primary significance and completely replaces the post-and-lintel construction." It should also be noted that the facade articulation of the Secession relativizes and equivocates Wagner's system of structural supports and non-structural, infilling surfaces. On the fronts of the Stadtbahn pavilions, for example, the framing 'piers' at the corners are distinguished in the plaster relief from the framed 'walls'; the non-structural character of the wall area, moreover, is suggested by a continuous, shallow groove at the top from which foliage sprouts up to the left and right. Wagner provides an 'image' of the bearing frame and the thin wall panel set into it, a panel which, as it were, conceals a vegetal layer—the garden?—located behind it.

Side facade of Vienna Secession, detail.
Photo: Archiv der Wiener Secession

On the facades of the Secession, the same formal material—corner, pier, wall panel, floral background—are used in a different way. Here, the framing 'piers' are shown as stylized, decorative trees almost entirely overlapped by the wall panels superimposed on them. On the main facade, the vegetal ornamentation is flat; in contrast, the wall panel with its terminating cornice has a more plastic effect. Around the corner, however, the fine pattern of leaves is reinterpreted into a spatially emphasized pilaster, which now overlaps the recessed panel of the window field—windows which in the upper story constitute a prototype of the 'ribbon windows' of the 1920s. The layers and pictorial elements that Wagner had merely juxtaposed are now superimposed by Olbrich, their meaning changing as they round the corners. And unlike Wagner, Olbrich clearly questions the closed, stable frame of the facade. The corner piers become vegetal, soft, and textured, making the corners appear to be cut open and 'pierced' by floral elements. Is the white, monumental cube being split apart by the force of an 'inner nature' and decomposed into individual wall fragments without connection to one another? Or does Olbrich merely show us the image of the paradise garden of art hidden behind the shimmering walls? The first reading would account for the analogous significance of the mysterious 'chest' of the architrave, its heavy lid cracked open by a tangle of snakes pushing out. These, together with the other snake motifs and wavy lines on the building as well as its overall symbolism, raise the broader question of the extent to which this building manifests a theme characteristic of the epoch and its intellectual avant-garde, that of the breaking forth of suppressed nature, of the instinctive, creative powers bottled up in the unconscious, from the confines of outward stability, rationality, purity, and dignity.

The thoroughly ambivalent character of Olbrich's architecture is revealed in a number of other elements as well. The blockish prisms of the Secession, seemingly so 'protocubist' and 'protorationalist,' show unequivocal textile details at a number of edges and seams: the 'piped' metal edging on all the cornices, the 'woven' texture of the square patterns at the upper end of the pylons, the motif of rope and eye, belt and clasp on the 'beltline' of the wall reinforcements on the sides, and the 'garters' in the roof area of the rear facade. Gottfried Semper's theory of the textile origin of architecture and of all art, adopted almost literally by Wagner, was certainly familiar to Olbrich as well and comes to light in these surprising details. Here as on the main front, but with a different repertoire, Olbrich layers the tectonics of the masonry and alludes to tractive forces and ligatures; this motif becomes more comprehensible when we remember that for the first exhibition, he lined the hall

entirely with white and colored fabric, so that the interior was spontaneously experienced as a 'tent' by his contemporaries. The entire rear view of the building as well, with the great glass pitched roof, the two rain gutters transformed into wreath-bearing masts, and Moser's image-tapestries 'falling' in waves speak for the division of the building into the "propylaeum" of the entrance area and the "festival tent" of the exhibition hall.

As mentioned above, Hevesi called the interior of the building a "puzzle box." The same could be said of its exterior appearance. The architecture continually provides 'springboards' for the imagination: if we focus on one aspect of expression, the whole building leans in that direction; if we follow a different angle of interpretation, it immediately swings over into another course. If we pay attention to both aspects together, we experience a flickering, an irritating impression that something here is continually in motion and cannot be immediately grasped. It was only shortly thereafter that Koloman Moser created his puzzling, reciprocal bands of ornament which, whether figural or geometric, shimmeringly dissolved the edges of his furniture. Following a principle previously adopted by English and Belgian designers, the two-dimensional art of the Secession gave equal value to figure and ground, positive and negative space. In Vienna in particular, the movement, restlessness, and tension of the age come to expression less in a dynamic of depth perspective or expressive morphology than in the oscillating, energetic perception of the simultaneous in the two-dimensional.

In order to proclaim the "ver sacrum" with "resounding fanfare," Olbrich used a concentrated, symbolic language of signs that was thoroughly familiar to the art public of the time. He radicalized and actualized its expressive power, however, in a subjective, non-academic way. In addition to victory, dignity, and purity, in ancient mythology the laurel is associated above all with the initiation of the young Apollo into his full identity. Historically interpreted, it points to the overcoming of an older, matriarchal principle by a younger, patriarchal one. The myth of Apollo speaks at many levels of the appropriating and transcending of maternal, chthonic knowledge by the illumed, enlightened god of light. The representations of the arts of painting, architecture, and sculpture on the Secession—cast by Schimkowitz in the form of Gorgon heads—as well as the multiple appearances of the snake motif likewise refer to myths of regeneration, renewal, and the violent overcoming of traditional ways by new, vital forces.[5]

As a summary of these themes, the foliage of laurel branches, ennobled into the form of a golden hemisphere—the gilded laurel tree that grows up over the 'ruins' of traditional architecture—signifies a monumentalization of the universal myth of renewal and initiation. The 'return to the origin,' to the golden, paradisiacal age of the unity of art and life, a renewal through the appropriation and rediscovery of earthy vitality, of the 'fertility of the unconscious'—all this is propagated on the title page of the first edition of *Ver Sacrum* as well, where a tree drawn by Alfred Roller splits open the pot in which it grows and extends its roots downward to the native soil.

The ambivalence of the Apollonian myth of guilt and atonement, the more or less obvious aggressiveness of overthrow and transformation, manifests itself in Olbrich's architecture as well, where in various places the classical tectonics are visibly rent and the outer layer of white, crystalline masonry is split open by an internal, organic-vegetal force. This other, 'dark' side of the laurel plant—which could also be used as an intoxicant—culminates on the north facade in the triumphal, frenzied *Dance of the Maidens,* a reference to the orgiastic rituals of the cult of Dionysius.

The direct, 'barbaric' combination of symbols, freed from the classical, integrative framework of traditional architectural forms, the 'ruthless self-exposure' of these signs on the blinding nakedness of the building, and even the harsh contrast

between the massive volume and the fragile tissue of the dome may have helped manifest the ambivalent, transforming (i.e. revolutionary) aspect of these symbols and thus intensified the general aggression unleashed against the presumptuously glowing shrine, the heathen tabernacle in the midst of the city.

Carl Schorske[6] described Gustav Klimt's artistic development in the years 1897–98 as an attempt to expose humanity's instinctual, conventionally suppressed identity in the mirror of archaic myths and symbols. With reference to Klimt and the Secession, Schorske also reminds us of Karl Marx's statement that "people who are starting a revolution empower themselves by acting as if they were reviving a vanished past." The ahistorical temple of the Secession, formally reaching back beyond the conventions of classical architecture and dedicated to the dialectic of the Apollonian and the Dionysian in a multitude of ways, uses an archaic formal and symbolic language to express this will to renewal, the breaking forth and actualization of the *eros* of an all-powerful, inner nature. With the ambivalence noted earlier, however, it also corresponds to a basic characteristic of the time, the uncertainty and "crisis of the liberal self." Olbrich thus alludes to the oscillating psychological poles of 'Vienna 1900': on the one hand, the Oedipal revolt against the petrified rationality of the fathers, and on the other the attempt to invoke and aesthetically sublimate the 'irrational' sensuality of the feminine, a concept whose fertility and latent critical mass for this revolt should not be underestimated.

Up to now little attention has been paid to the early influence on Olbrich by Camillo Sitte, his teacher at the Vienna Staatsgewerbeschule, and Sitte's circle of friends, among them Hans Richter, conductor and assistant to Richard Wagner, and the art historian Rudolf von Eitelberger, founder of the Vienna Museum für Kunst und Industrie and the Kunstgewerbeschule. The circle likewise included Adalbert Ilg and Ferdinand Fellner von Feldegg, editor-in-chief of the magazine *Der Architekt* from 1895 to 1908, as well as Heinrich von Ferstel, designer of the Votivkirche and the Museum für Kunst und Industrie in Vienna.[7] Sitte, himself a student of Ferstel, had been a member of the *Academic Richard Wagner Verein* since its founding in 1872 and regularly organized private concerts in which he himself performed as an excellent cellist. As director of the Staatsgewerbeschule from 1883 on, he also made its auditorium available for the choir rehearsals of the Wagner Verein. Sitte's extensive writings and theories on the history of art and architecture, only a small portion of which have been published, are grounded first of all in his intimate knowledge and veneration of the theory and work of Richard Wagner. Secondly, through Eitelberger and his circle he obtained first-hand knowledge of the new arts and crafts movement in England. With his wife he established an atelier-residence at the Staatsgewerbeschule, which in its furnishings, arts and crafts activities, and intellectual and musical soirées has been compared by Collins and Crasemann-Collins to the *Red House* of William Morris.[8]

The circle around Sitte certainly instilled a predilection for Richard Wagner in the extraordinarily musical Olbrich; Otto Wagner, Jr., reports that Olbrich often designed views of "the Castle of the Grail or other heroic places"[9] after experiencing Richard Wagner's operas, and at Olbrich's funeral in Darmstadt a small orchestra intoned passages from the *Götterdämmerung*.[10] But here, too, already a good decade before the "Siebener Klub" and the circles around Klimt and Otto Wagner, the young Olbrich was exposed to the cult-like vision of a *Gesamtkunstwerk,* the idea of a humane "reunion with nature in the work of art,"[11] and the striving to restore the unity of art and craft.

Viewed in this context, it becomes clear why Fellner von Feldegg was the only contemporaneous reviewer to place the Secession building into the framework of Nietzsche's revolutionary work dedicated to Richard Wagner, *The Birth of Tragedy from the Spirit of Music.*[12] Feldegg, whom Olbrich called an "unreflected talent" in a positive sense, also took this opportunity to analyze the deep contradiction in Otto Wagner's modernism, which clung theoretically to Semper's materialism and

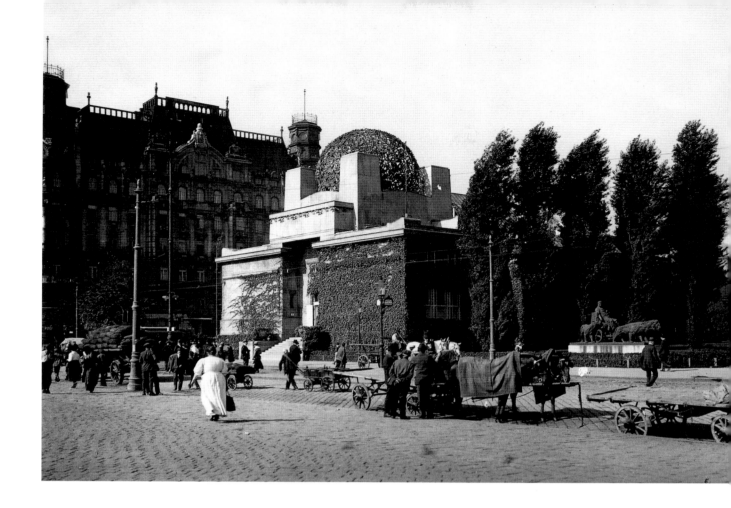

Vienna Secession after 1908.
Photo: Archiv der Wiener Secession
(Fotostudio Hassmann)

positivism but was practically indebted to an artistic idealism. Here, Feldegg's arguments were clearly taken from Alois Riegl's criticism of Semperianism and his concept of the "will to art." Shortly after Olbrich's death, Feldegg used these ideas drawn from Wagner, Nietzsche, and Riegl to formulate passages that perhaps best did justice to Olbrich's architecture of mood as expressed in the avowal quoted at the beginning of the present essay. Feldegg writes: "Cut loose from tradition and home, separated from history and the fatherland, this art had to […] sink its roots into another soil, had to draw its power from *another* sphere. And it found this soil; it found it in the mother earth of individual, personal sensation, the mother earth of *feeling* as the sure foundation, the substratum of all intellectual life. This, therefore, is the reason for the wild longing of the modern for invention […], its free, seemingly arbitrary and irregular, but in truth 'sensed' contours, drawn from individual feeling."[13]

The Secession building has been renovated and remodeled many times in its hundred-year history. As early as 1901, the vestibule was extensively redesigned by Josef Hoffmann. In 1908, after the departure of the Klimt group, many ornamental elements were removed in a first renovation, among them Moser's glass rosette and his dance of the maidens, but also Hevesi's programmatic aphorism over the portal: "To the Time its Art. To Art its Freedom." The glass-mosaic-covered planters at the entrance are the work of Robert Örley, the directing architect at that time. At the end of World War II, the building was damaged by bombs and set ablaze during the withdrawal of German troops. The roof construction was destroyed and the dome burned out. After provisional repairs, a comprehensive renovation was carried out in 1963–64 under Ferdinand Kitt, who largely reconstructed the original decoration, but inserted an additional floor as a gallery space in the vestibule. Yet another renovation and adaptation followed in 1984–85 under the direction of Adolf Krischanitz. This time the spatial typology of the vestibule and the exhibition hall were once again approximated to the original as much as possible and the entire building brought up to contemporary technical standards. The dome, as well, was

Top: The destroyed Vienna
Secession, 1945. Photo: Archiv der
Wiener Secession
Middle: Corner view of Vienna
Secession, 1978.
Photo: Archiv der Wiener Secession
Bottom: Vienna Secession with
scaffolding during comprehensive
renovation, 1985.
Photo: Margherita Spiluttini

Next page: Vienna Secession, 1997.
Photo: Matthias Herrmann

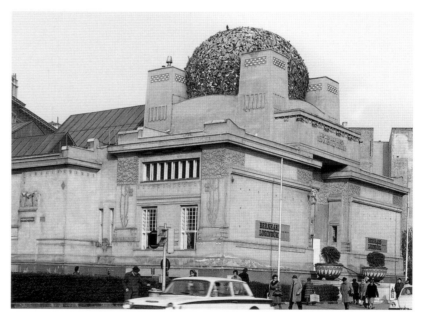

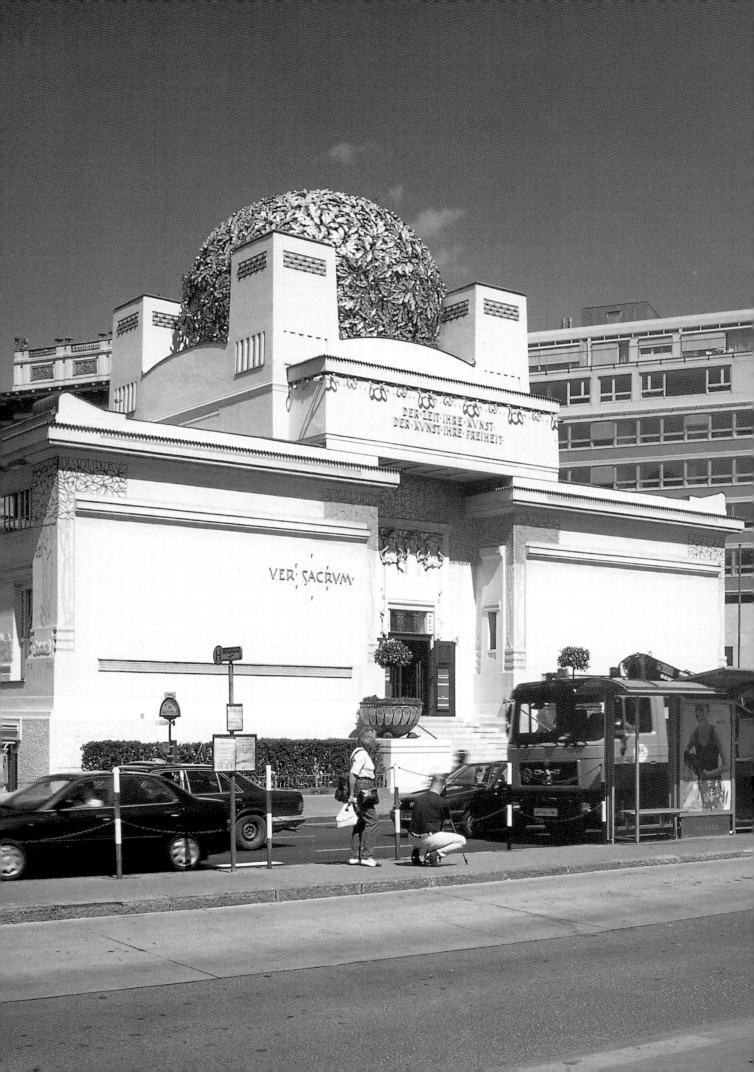

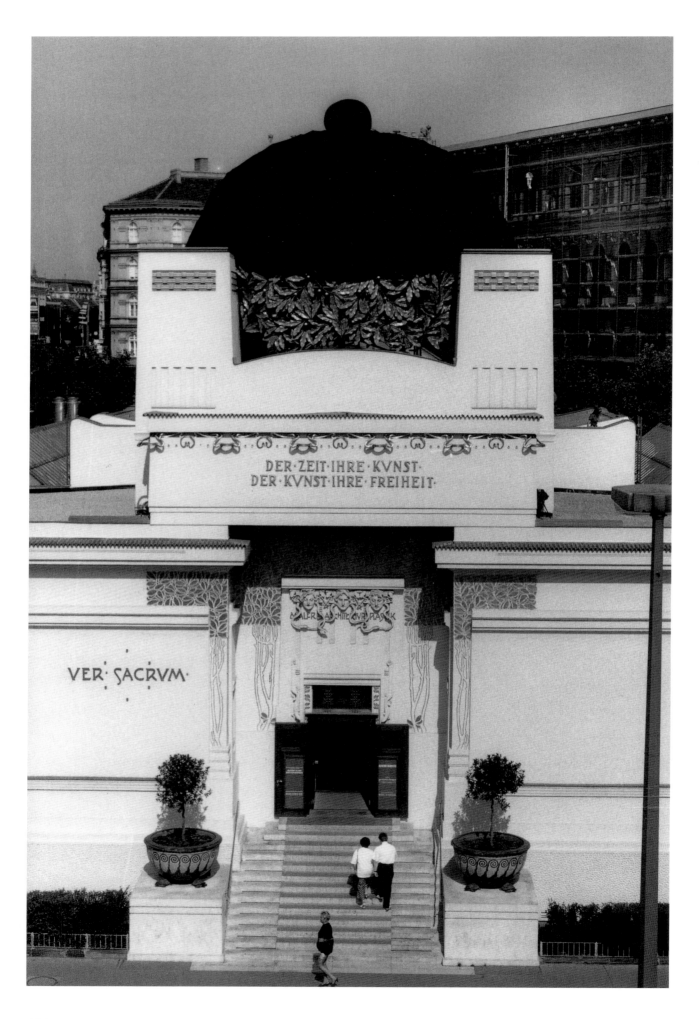

DER·ZEIT·IHRE·KVNST·
DER·KVNST·IHRE·FREIHEIT·

VER·SACRVM·

able to be genuinely gilded again and reconstructed in its original coloration. A space for the permanent exhibition of the restored Klimt frieze was also created by exploiting the previously uncellared area beneath the hall; the exhibition area in the basement story was extended as well. Olbrich's "Temple of Art" was thus completed with a 'crypt' containing a principal work by one of the founders of the Secession, a work which, now restored after extensive conservation work, programmatically represents the ideological goals of the Secession.

Preceding page:
Vienna Secession with dome cover by Markus Geiger during the exhibition *Gemischtes Doppel,* 1992.
Photo: Gerhard Koller

Notes

1 For a history of the construction and reception of the Secession building with a comprehensive bibliography of primary and secondary literature, see Otto Kapfinger and Adolf Krischanitz, Die Wiener Secession. Das Haus: Entstehung, Geschichte, Erneuerung (Graz/Wien 1986).
2 Ibid., 57–60
3 Joseph Maria Olbrich. Die Zeichnungen in der Kunstbibliothek Berlin, critical catalogue, ed. Karl Heinz Schreyl with Dorothea Neumeister (Berlin 1972), 12
4 Renate Wagner Rieger, Vom Klassizismus bis zur Secession; in: Geschichte der bildenden Kunst in Wien, Geschichte der Architektur in Wien, n.s., vol. 7, 3 (Wien 1973), 228
5 Ibid., 65ff.
6 Carl E. Schorske, Wien. Geist und Gesellschaft im Fin de Siècle (Frankfurt/M.1982), 198ff.
7 George R. Collins and Christiane Crasemann-Collins, Camillo Sitte and the Birth of Modern City Planning, Columbia University Studies in Art History and Archaeology (New York 1965), 5–15. See also the 16. Jahresbericht des Akademischen Richard Wagner Vereins (16th Annual Report of the Academic Richard Wagner Society; Wien 1886), 16
8 Collins/Crasemann-Collins (as in n. 7), 11
9 Otto Wagner, Jr., J. M. Olbrich: ein Nachruf; in: Deutsche Bauzeitung 42 (Aug. 1908), 456
10 Robert Judson Clark, J. M. Olbrich 1870–1908; in: Architectural Design 37 (Dec. 1967), 571
11 Richard Wagner, Das Kunstwerk der Zukunft (1850); in: Sämtliche Schriften und Dichtungen, vol. 3 (Leipzig 1911), 60
12 Ferdinand Fellner v. Feldegg, J. M. Olbrich; in: Der Architekt 5 (Wien 1899), 37–38
13 Idem, Josef Maria Olbrich, sein Leben und sein Wirken; in: Zeitschrift des österreichischen Ingenieur- und Architektenvereins 61 (Wien, June 4, 1909) 367–69

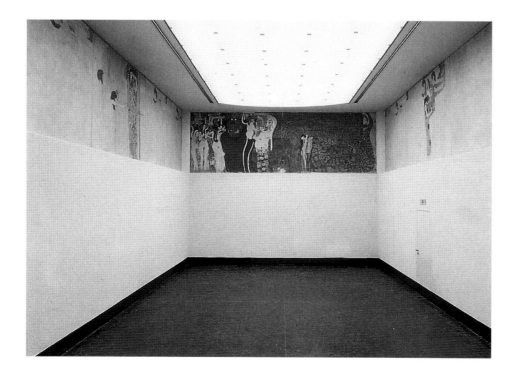

Room with *Beethoven Frieze* by Gustav Klimt, after 1985.
Photo: Margherita Spiluttini

III. AUSSTEL-
○ LUNG DER ○
VEREINIGUNG
BILDENDER
KÜNSTLER
ÖSTERREICHS
SECESSION

IV. AUSSTEL-
○ LUNG DER ○
VEREINIGUNG
BILDENDER
KÜNSTLER
ÖSTERREICHS
SECESSION

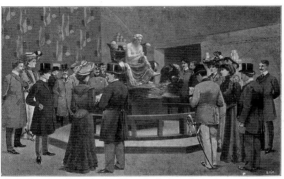

In der Secession während der Ausstellung des Beethoven-Denkmales von Max Klinger.

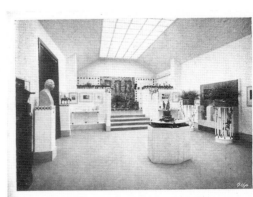

XV. AUSSTEL-
○ LUNG DER ○
VEREINIGUNG
BILDENDER
KÜNSTLER
ÖSTERREICHS
SECESSION

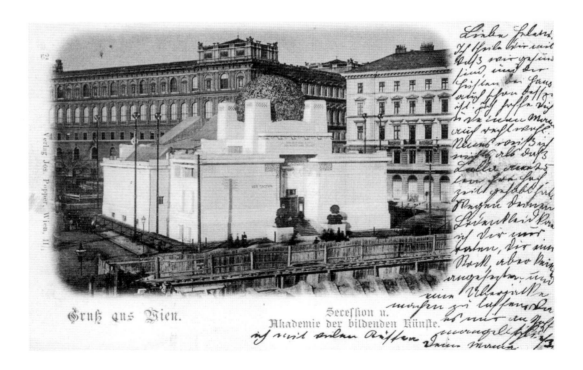

Gruß aus Wien.

Secession u.
Akademie der bildenden Künste.

Top: Publicity postcards with motifs
from exhibitions of the Vienna
Secession, 1899–1902
Below: Postcard *Gruß aus Wien*,
1899

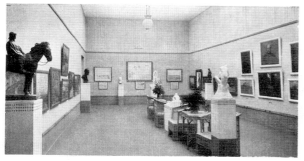

XVI. AUSSTELLUNG DER VEREINIGUNG BILD. KÜNSTLER ÖSTERR. SECESSION

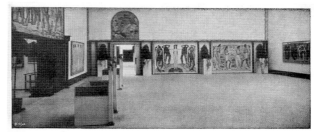

XIX. AUSSTELLUNG DER WIENER SECESSION. JAN.=FEBR. 1904.

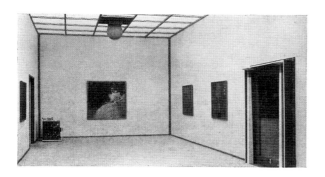

COLLECTIVAUSSTELLUNG GUSTAV KLIMT. SECESSION WIEN. NOV.=DEZ. 1903.

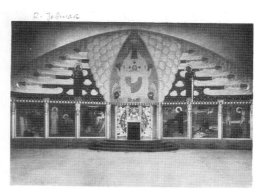

SECESSION
WIEN 1905

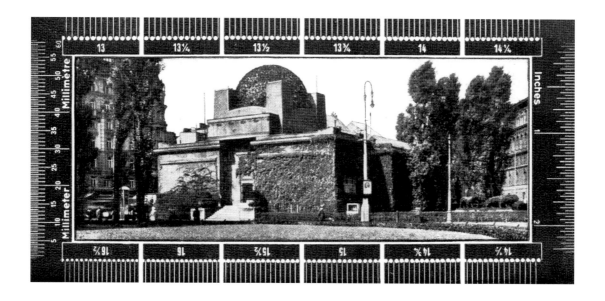

Top: Publicity postcards with motifs
from exhibitions of the Vienna
Secession, 1903–1905
Below: Publicity postcard of the Piral
firm with postage-stamp perforation
key, on the reverse special imprint of
the WIPA, July 5, 1933

Brigitte Felderer / Eleonora Louis

THE CONSTANCY OF THE EPHEMERAL

ON THE SELF-REPRESENTATION OF ART IN THE VIENNA SECESSION

SECESSION-PERMANENZ
KARTE Nr.
GILTIG FÜR:

SEKRETÄR. PRÄSIDENT.
DIE KARTE IST UNÜBERTRAGBAR.

Season ticket to exhibitions of the
Vienna Secession, before 1908.
Photo: Archiv der Wiener Secession

The Vienna Secession is one of the oldest artists' unions in Europe still operating
on the basis of its founding statutes. The Secession building—erected in 1898 by
Joseph M. Olbrich, a pupil of Camillo Sitte and Otto Wagner—continues to
accommodate a lively program of exhibitions and events to the present.

Since its founding, the Secession has served as an independent exhibition
space for contemporary art; its emphasis has always been on the presentation of
international modern art and a young generation of artists. In the Viennese art world
of the turn of the century, there was a clear need for an independent institution of
this kind. Like other European metropolises such as Paris, Berlin, or London,
Vienna had no exhibition spaces programmatically dedicated to radical or at least
new modern art. In this context, the Secession emerged "to show the officers of a
troop at the front lines of battle."[1] The military language manifests the pressure
under which the Secessionist artists found themselves: the site, along with its
building, was to revert to the city of Vienna after ten years. The decade they were
given was full of promise, especially after the tremendous success of the first
exhibition; at the same time, however, the Secessionists also felt the need to raise
their profile, to acquire an institutional identity, as well as the desire to see the
enshrinement of their work in their own lifetime. Thus the founding statutes of the
young artists' union called for a 'gallery of modern art,' a demand that could also
be read as a statement on the cultural politics of contemporaneous Vienna.

The Secessionists had created their own exhibition hall, and as it turned out,
were able to maintain autonomous control over it. On the other hand, the general
economic crisis of the interwar period forced the Secession to rent out its
premises (in the meantime no longer so splendid) to other groups, including
various furtherance societies and the Catholic Church, for their exhibition projects,
a situation that resulted in a disparate series of exhibitions with no unifying theme.
In 1924, for example, the *Gesellschaft zur Förderung moderner Kunst* (Society for
the Advancement of Modern Art) showed the international avant-garde in the
Vienna Secession under the title *Internationale Kunstausstellung* (International
Art Exhibition) and in the Konzerthaus as the *Internationale Ausstellung neuer
Theatertechnik* (International Exhibition of New Theater Technology). Artists such
as Filippo Tommaso Marinetti, Enrico Prampolini, Fernand Léger, and Theo van
Doesburg responded to organizer Friedrich Kiesler's invitation to participate in
the exchange with other artists. As an expert and theorist in modern design
(*Raumkunst*), Doesburg published his ideas on exhibition technique in the article
Das Problem einer aktiven Ausstellungsmethode (The Problem of an Active Method
of Exhibition) in the *Neues Wiener Journal* on October 31, 1924. The Secession
itself, however, did not pursue contact with these representatives of the avant-
garde; such a progressive program seemed to provide little guarantee for public
success.

In the years 1925 and 1933, two art exhibitions with Christian themes were
organized by Clemens Holzmeister. In late 1935 and early 1936, one year after the
cultural agreement between the Austrian Republic and Fascist Italy, the Secession
showed *Italienische Plastik der Gegenwart* (Contemporary Italian Sculpture)
in cooperation with the Italian Cultural Institute. The next year even saw the
presentation of *Italiens Stadtbaukunst* (Italian State Architecture) with Mussolini's

Left page:
Vienna Secession, view of the
main hall, 1997

109

Top: *Verkehrsspektakel.* Design by
Hans Staudacher, 1962.
Photo: Archiv der Wiener Secession
Below: *Spiralenspektakel,* 1956,
Josef Mikl (in front), and Wolfgang
Hollegha

Rome at the center of the exhibition. In the year of the annexation to Nazi Germany, in favor of which the majority of Austrians had voted, Alexander Popp, president of the Secession from 1935 to 1939 and an illegal National Socialist, was finally given the opportunity to realize his long-cherished project of an exhibition of German architecture: *Deutsche Baukunst und deutsche Plastik am Reichssportfeld in Berlin* (German Architecture and German Sculpture at the Reichssportfeld in Berlin). In the same year, the Secessionists changed their name from *Vereinigung bildender Künstler Österreichs Secession* to *Vereinigung bildender Künstler Wiens* in an effort to avoid the impression of 'secessionist' sentiments with regard to the new political order. The representatives of the Secession, among them the painters Oswald Roux, Robin C. Andersen, Alfred Gerstenbrand, Wilhelm Dachauer, and Richard Harlfinger as well as the sculptor Wilhelm Frass and the architect Ferdinand Kitt doubtless hoped, like so many other Austrians, to be able to preserve their own interests in this way. But even card-carrying National Socialists like Wilhelm Dachauer and Wilhelm Frass could not prevent the Vereinigung from being dissolved in 1939 and merged with the Künstlerhaus. Under the dispassionate designation "Exhibition Hall Friedrichstraße," the Secession spent the following years as a dependency of the Künstlerhaus, the very institution from which it had seceded forty years earlier.

Spiralenspektakel.
Design by Hans Staudacher, 1956.
Photo: Archiv der Wiener Secession

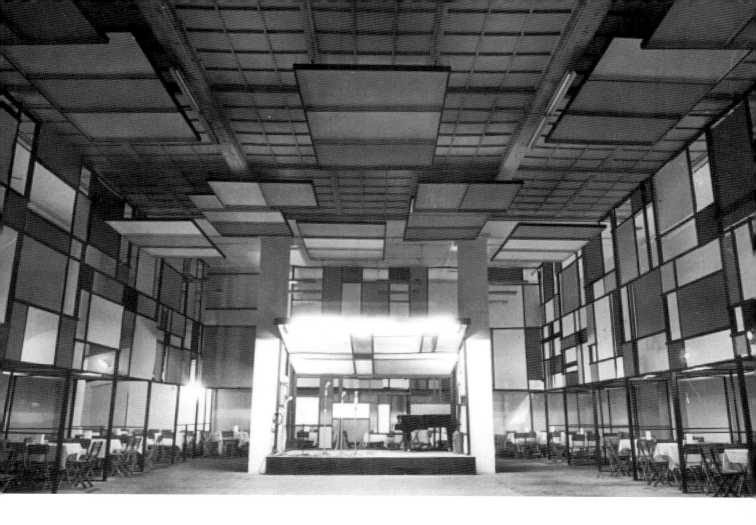

In 1945, the Secession reconstituted itself and continued its pre-war tradition. After Karl Stemolak, Josef Hoffmann was elected president in 1948, followed in 1950 by Albert Paris Gütersloh. After the reconstruction of the building, a regular program could once again be planned from 1949 on. The institution still struggled to establish an identity amidst the tension between its own programmatic goals and its function as a central location available to other associations and groups in Vienna, including the confectioners, the naturalists, the model railroad building school, the Viennese State Board of Retail Trade and Drugs, the tourism society, and the Institute for Economic Advancement. The Secession also served as a venue for the activities of the Viennese avant-garde *Art Club,* incorporated into the Secession by Albert Paris Gütersloh. In the 1950s and 60s, Art Club members such as Hans Bischoffshausen, Rudolf Hausner, Fritz (later Friedensreich) Hundertwasser, Anton Lehmden, Josef Mikl, and Grete Yppen were repeatedly shown in the Secession. In addition to young artists, an older generation of Secessionists was documented as well: artists such as Herbert Boeckl, Josef Dobrowsky, Sergius Pauser, Fritz Silberbauer, or Franz von Zülow, who had been active above all in the interwar period, were exhibited in an effort to establish a link to the period before 1939. Festivals, organized primarily by young artists such as Hans Staudacher or Josef Mikl, likewise played an essential role in creating an identity for the new, post-war generation of Secessionists. The Viennese art scene congregated at the *Spiralenspektakel* (Spiral Spectacle) of 1956, *Off Limits* of 1957, the *Isotopischer Spektakel* (Isotopic Spectacle) of 1958, and the *Verkehrsspektakel* (Traffic Spectacle) of 1961, in a manifestation of the revolutionary spirit of the times. The exhibition design for these carnival celebrations and masquerade balls revived the Viennese tradition of the artists' festival and constituted spectacular contemporary explorations of the possibilities of Olbrich's interior space at the highest qualitative level.

Above: *Off Limits,* 1957, Mondrian main hall. Design by Bruno Buzek, Hans Staudacher.
Photo: Archiv der Wiener Secession
Below: *Off Limits,* 1957. Design by Bruno Buzek, Hans Staudacher.
Photo: Archiv der Wiener Secession

Ver Sacrum. First major art exhibition of the Vereinigung bildend. Künstler Österreichs Secession, postcard, 1898.
Photo: Archiv der Wiener Secession.

In the decades leading up to the comprehensive renovation of the building in 1985, the program alternated between exhibitions by members and individual traveling exhibitions and the renting out of the premises, undertaken to improve the budget. The difficult financial situation had its roots in the fact that the founding myth of the Secession could no longer be publicly maintained in an era of reconstruction grounded in repression, a phase of unqualified fascination with technology, and a period of activist generational conflict. The preciousness, the fine craftsmanship, the elitist upper-middle-class mentality, the aristocratic arrogance, the comfortable sacrality of the early Secession—all of this was ill-suited to rising mass tourism, the folkloristic Austria clichés of Paula Wessely and the young Romy Schneider, and a petty bourgeois understanding of culture that for ideological reasons was forced to reject both the elitism of the educated bourgeoisie and the cultural and political agenda of Red Vienna of the 1920s. In this period of relative obscurity, misunderstanding, and underestimation, the Tuesday club evenings at the Secession provided the Viennese art scene with a semi-public place for exchange, for cultivating a Secessionist identity, and for laughing and drinking—one of the few places in Vienna available for this purpose up to the early 1980s. Later, during the urbanistic trends of the 1980s, the Yuppie emerged as the patron of the inner-city infrastructure and culture as a counterweight to the front-lawn idyll of the suburbs. Enjoyment of culture became the indispensable accessory of an upwardly mobile lifestyle.

In January 1986, the Secession reopened under a freshly gilded dome. The newly published catalogues in square, Hoffmannesque format and the restored *Beethoven Frieze* by Gustav Klimt, now immortalized in its own space, once again invoked the founding myth of a Secession that had set out in 1897 to 'design' new forms for the enjoyment of art. Simply by virtue of the fact that in the Secession, decisions were made and the program was shaped by artists rather than scholars, critics, collectors, connoisseurs, or even (as has recently been the case on the international scene) political functionaries, the building fulfilled and continues to fulfill a unique function in Viennese cultural life: artists exhibit artists, i.e. an essential share of the city's exhibitions are determined by artists and by their reception on the Austrian and international art scene.

Since its founding, the Secession has also served as a venue for dance performances, concerts, readings, and lectures, programs that have always found an interested public there. As early as February 1902, Isadora Duncan performed in the Secession; a representative of the modern dance of her time, she presented an alternative to classical stage dance, rejecting confining costumes and toeshoes. In contrast to conventional ballet, Duncan chose unusual places—places like the Secession—to display her body and its possibilities for movement. Her choreographic references to an ancient Greek formal language gave the Secessionists both the occasion and an excuse to allow this still scandalous dancer to perform before an illustrious public in their consecrated spaces.

In the same year, Gustav Mahler was asked to conduct several movements from Beethoven's Eighth Symphony for the opening of the so-called *Beethoven Exhibition.* The performance served to prepare a cheerful opening public for the sacred, dedicatory veneration of art.

Or to mention another example, this time from the Secession's more recent history: in 1989 and 1991, the musician Edek Bartz and the cultural historian and music journalist Wolfgang Kos put together the musical series *Töne Gegentöne* (Tones Countertones). The musicians who took part were making experimental references to a wide variety of musical cultures from around the world. Programs like these have always left a positive impression and have helped to anchor the Secession in the perception of the Viennese cultural scene as a place where the unusual and the

exciting happens. As diverse and wide-ranging as the Secession's program has been though, the Secessionists as organizers and hosts have always been able to bank on the history and tradition of their building.

The annual program, intended to give an international and up-to-date overview of happenings in the art world, is put together by the committee of the Secession, which chooses a president from among its members. The latter assumes the task of raising additional funds and representing the Secession to the outside world. Since the renovation of the building in 1985, the Secession and its full elected members, recruited exclusively from the ranks of Austrian artists, have been assisted by the *Gesellschaft der Freunde der Secession* (Society of Friends of the Secession), who use American-style "socializing" as a modern, urban network of communication. By organizing society events, they support the continued existence and public recognition of the institution and its programs.

"WE WELCOME THE SECESSION AS A DRIVING AND REJUVENATING FORCE"

With this melodramatic pronouncement, Karl von Vincenti, art critic of the liberal newspaper *Neue Freie Presse,* greeted the Secessionists on March 31, 1898.[2] It was the opening day of the Secession's first exhibition, which took place in the

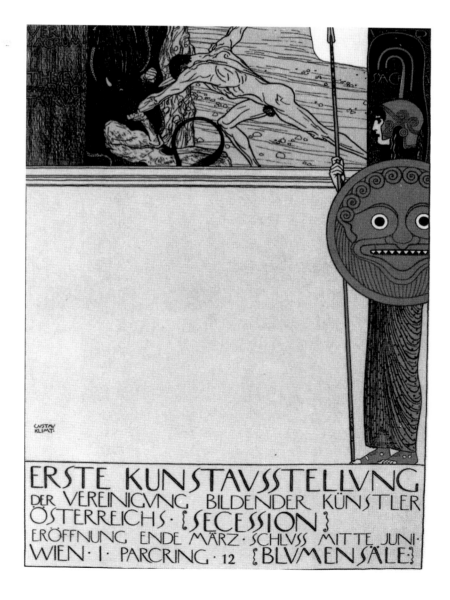

First art exhibition of the Vereinigung bildender Künstler Österreichs Secession, uncensored version of poster after a design by Gustav Klimt, 1898.
Photo: Archiv der Wiener Secession

rented rooms of the now no longer extant Horticultural Society. Vincenti's words hailed the Secession as the promising successor to an aging generation of artists, a generation whose critics—including Vincenti—reflected the spirit of a liberal populism that considered art "neither as luxury nor as momentary pleasure, nor as food for the nerves, nor the fashionable dictates of education," but rather as "the most noble medium of the people's education."

Nervous luxury, epicurean fashions, and upper-middle-class arrogance at the end of the 19th century were symptomatic of a bourgeoisie whose social self-representation was oriented to that of the Austrian monarchy, and which long ago had abandoned any political visions or calls for renewal (in contrast to the 'masses,' in whom all the political energy seemed to be concentrated). Art was appropriated as an element of the bourgeois lifestyle and served only to aestheticize the lifestyle of an affluent class. Poverty and extravagance alike were the symptoms of rapid technological progress; the purpose of art was not to define or even prescribe the relation to reality, rather it was the art market which provided customers with set pieces to help them attain the bourgeois lifestyle with its new pretensions to culture.

The proper demeanor, the corresponding fortune, and stylishly correct surroundings allowed the bourgeoisie to rise in a world previously dominated exclusively by birth, but in which money had more recently emerged as a means of upward mobility. At the world expositions, art placed itself at the service of a commercial aesthetic: everything was designed, ornamented, decorated, arranged, and offered for sale. The exclusivity of an object was proven precisely by the fact that it was one among many. The purchase of the individual product always implied the availability of others as well: the act of choosing among them constituted an expression of one's own refinement. The commodities had to supply, in other words, certain necessities of bourgeois existence: the acquisition of an object was associated with a catalogue of desires, the desire to behave in a class-conscious manner, to engage in conspicuous consumption, to assert oneself as a member of an affluent society.

The world expositions arrested history, as it were, in a single place for a single moment, for they represented history in terms of the fascination with progress. History became comprehensible and finally only bearable through the modern presentation of set pieces from a national canon of the past, the range of historical

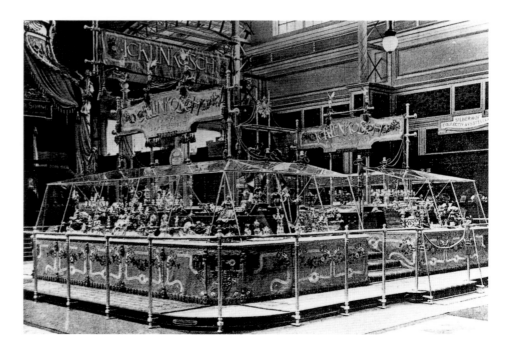

Otto Wagner, vitrine for the Klinkosch firm at the Imperial Jubilee exhibition, 1898.
Photo: Archiv Sabine Forsthuber

styles available for consumption. The western industrial nations represented themselves with immense and spectacular presentations of the newest inventions, of unique and improbable attractions such as Ferris wheels, enterable globes, glass palaces, faraway worlds, and cinemascopic paintings. Such displays were intended to amaze visitors and send them home from this wonderland as proud citizens of the exhibiting nation—proud to belong to a nation with such accomplishments to show, proud to have contributed to this industrial progress through their own efforts, and proud to have seen the (exchange) value of the products they had manufactured, possessed, or soon hoped to buy.[3]

Hans Makart, *Portrait of Hanna Klinkosch,* 1884.
Photo: Historisches Museum der Stadt Wien

The art exhibitions typical of the late 19th century likewise presented art as a commodity. Supply was determined by demand: buyers did not want to be confronted with a marginal genius and his subversive misery, but to belong to the court of the princely painter. The opulent, semi-public spaces of the Makart atelier were the scene of a recurring rendezvous between the artist and his public. The artist became the mediator between different levels of society: he created a socially ambiguous sphere in which nobility and bourgeoisie could encounter one another in mutual veneration of the master, and aestheticized the burgeoning self-awareness of the bourgeoisie by means of historical models drawn from the world of the aristocracy. In this way, an artist like Makart lived out the image that high society had created for him.[4]

The extravagant abundance of the exhibitions of the 'Makart period' also suggested a self-confident viewer fully capable of choosing the most beautiful, most moving, and finally the most suitable painting from a choice of two to three thousand. As early as the middle of the century, Anselm Feuerbach had described the same forms of exhibition and marketing from which the Secessionists later vehemently sought to distance themselves: "All human seeing, hearing, thinking, feeling, has its limits. Everyone covers his ears when three barrel organs play at the same time. Our exhibitions are pathological institutions of anxiety. At such large art markets I am constantly overwhelmed by a feeling of dejection."[5] Art seemed to have degenerated into a mere commodity subject to the vicissitudes of constant economic competition. In principle, the model of the world expositions determined art exhibitions as well, including those of the *Genossenschaft bildender Künstler Österreichs* (Society of Austrian Artists), where works by German, French, Belgian, and English painters and sculptors were shown alongside those of Austrian artists. This strategy of internationalization in the interest of self-representation and the enhancement of one's own market value may have been responsible for the fact that works from other countries, some of them quite significant, were seldom bought. Of the 700 works of art shown in the *Kaiser-Franz-Joseph-Jubiläums-ausstellung,* for example, the only two pictures by Monet were both returned unsold. For its part, the jury merely distinguished Monet, along with 40 other artists, with a "small gold medal of state."[6]

The exhibitions of the *Genossenschaft bildender Künstler* presented art in a class-organized context: as a show of accomplishments of a professional association, membership was the sole prerequisite for exposing oneself to the public's judgment.

In the interests of the class as a whole, all artists were shown; the arrangement of the exhibitions, however, reflected hierarchical distinctions. Younger artists aspired to slowly work their way to the middle, to the places on the wall reserved by the selection and installation committee for the 'best' pictures. What counted was not only the artistic production itself, but also the artist's position in the group and his relation to the tradition of official artistic taste.

This vulnerability to the art market and the lifelong dependence on the hierarchical power structures of their class representation led to the oft-cited "Oedipal crisis"

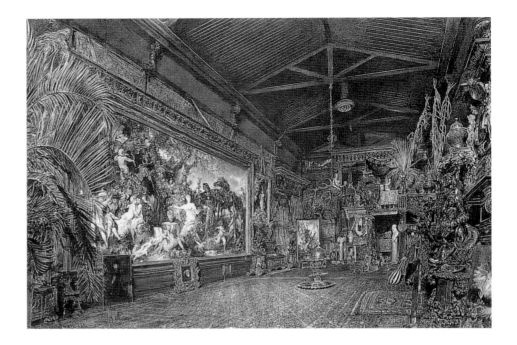

(Carl Schorske) among the younger artists, which finally culminated in the departure of the Secession.

"What is disputed is not some development or change in art, but art itself, the right to create artistically. That is the issue. Our Secession is not the battle of the new artists against the old, but the elevation of the artists against the peddlers who pose as artists and have a business interest in not allowing any art to be produced."[7]

Although some of the future Secessionists held influential positions within the *Genossenschaft der bildenden Künstler Wiens,* the conservatives nonetheless employed protectionist methods by assigning their works to inferior places in the shows or censoring them in the jury. At first it seemed that the *Vereinigung bildender Künstler Österreichs* could exist as a club within the *Genossenschaft.* On April 3, 1987, the constitutive assembly of the new Vereinigung took place: Gustav

Anton Romako, *Gentleman and Lady in the Salon,* 1887.
Photo: Historisches Museum der Stadt Wien

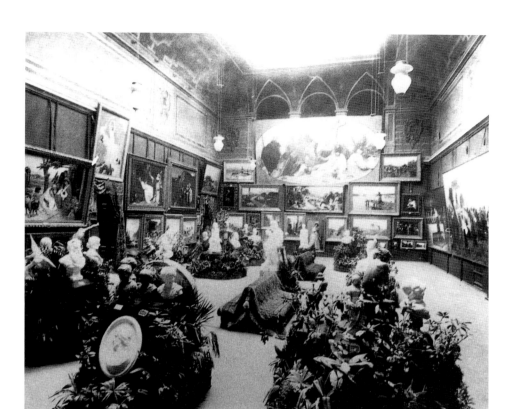

Jubilee exhibition in the Künstlerhaus, 1888.
Photo: Archiv Sabine Forsthuber

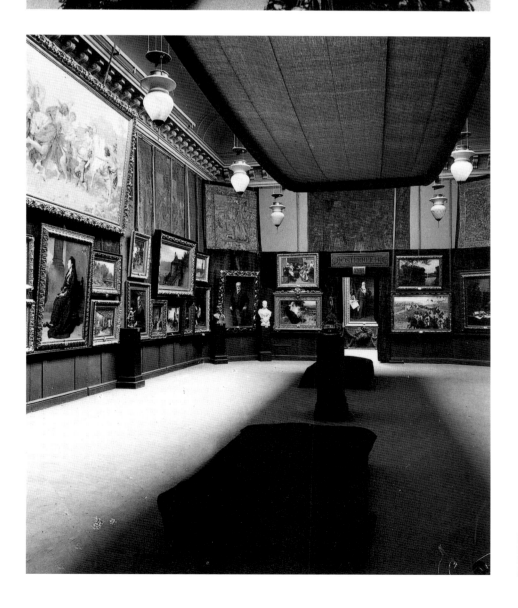

International art exhibition in the Künstlerhaus, view of main hall, 1894.
Photo: Bildarchiv der Österreichischen Nationalbibliothek

The Advantage of Athletic Exercise for Young Painters, Victorian caricature, ca. 1860

Klimt was elected as president, while the 85-year-old Rudolf von Alt, a lifetime advocate of the young, was named Honorary President. The formation of the new association, which immediately sought to acquire funds and a site for a new exhibition building, was reported in the Vienna daily newspapers with a note of expectation. As Ludwig Hevesi announced in the *Fremden-Blatt:* "[…] the art city of Vienna, this gigantic small town, will now finally become the metropolis of Vienna, a true New Vienna."[8] But when fierce differences arose concerning the delegations to exhibitions in Dresden and Munich, the artists around Gustav Klimt finally declared their secession on May 24–25. The break with the Künstlerhaus manifested itself in a change in the *Vereinigung*'s statutes as well, forbidding its members to participate in the public exhibitions of other houses.

The Secession prepared the journalistic ground for future exhibitions by immediately founding the magazine *Ver Sacrum* as the organ of the new movement, intended to appeal to a newly constituted public following. The magazine fused art and literature, language and graphic art into an experimental field for new synaesthetic combinations.

"The nonconformists are rebelling against the betrayal of art to the market. They are assembling under the banner of 'l'art pour l'art.' This slogan reflects the conception of the *Gesamtkunstwerk,* which attempts to protect art from technological development."[9] Art was to be returned to a context in which only the 'true' connoisseur could enjoy it; and unlike the art exhibitions and world expositions where the value, meaning, and significance of the object were produced solely by the presentation itself, here the exhibition was once more to become the object of artistic intervention: "[…] and so, in the midst of the busy confusion of modern life, a space was opened up for the newest manifestation of artistic creativity, the '*Raumkünstler.*'"[10]

Pif, *Au Salon. Un peintre dont l'oeuvre est mal placé installe un téléscope…* , Le Charivari, May 23, 1880

THE SECESSIONIST MOLD

Marie (animated): He also draws toilets? What that man can't do. Furniture,
buildings, lamps—
Max: That's modern now! It's called interior design.
Marie (amazed): Interior design? When someone does everything, you call that?—
Max: Yes.
Marie (as above): When an architect draws a toilet, you call that interior design?
Why?
Max (complacent): Well, if you don't know!

Hermann Bahr, *Wienerinnen.* Lustspiel in drei Akten, premièred October 3, 1900,
Deutsches Volkstheater (Bonn: Verlag Albert Ahn, 1911) 1st Act, p. 35

In this scene from Hermann Bahr's comedy *Wienerinnen* (Viennese Women), the
young Max Billitzer ("from a very good family [...], they have an uncle in the
ministry"[11]) finally gets his chance to be one step ahead of his trend-conscious
fiancée Marie Fischl. The exchange makes all too clear the extent to which the
Vienna Secession had become a synonym for the fashionable lifestyle of Viennese
high society. The subject of the conversation is the (interior) designer Josef Ulrich, a
thinly veiled reference to Josef Maria Olbrich. In the comedy, the 'interior designer'
Ulrich serves as the spokesman for a Secessionist ideology whose melodramatic
vocabulary sometimes descends into formulaic pronouncements; his new wife
gives her first salon in the Secessionist ambience: "modern, unique, but simple,
and very Viennese, like the arrangements of Olbrich."[12] The interior designer greets
his wife's guests by informing them that they are in the house of a carpenter—a
carpenter like his father and grandfather before him, distinguished only by a
different title and "a bit more money."[13] He vehemently distances himself from, as he
calls it, "the insiders' club," the "critical people," who lack "the best thing a man can
have: pleasure in his own work!"[14]

Hermann Bahr in his study in the
13th district of Vienna, interior design
by Joseph M. Olbrich with Gustav
Klimt's *Nuda Veritas* on the right.
Photo: Österreichisches Theater-
museum

The play caricatures a foundational principle of Secessionist Jugendstil: the belief in
handicraft and the artist's calling to create meaning, in contrast to the intellectuals
who can only dissect and critically question it. Two fundamentally different
conceptions of modernity are here contrasted with one another. The Viennese
Jugendstil represents an 'aesthetic insulation' against the pressure of technological
progress, imprisoned in the perfection of a Secessionist salon. The radical
modernism of Karl Kraus, on the other hand, saw provocative cultural criticism as
the only way to establish a critical, analytical in the face of the speed and culture-
creating grip of technological progress, without withdrawing from it; in the final
analysis, it is the artist's duty to reveal technology as a cultural practice and
therewith to make it comprehensible. The interior designer of *Wienerinnen* not only
propagates a lifestyle in which everything is custom-designed from dwellings to
"trousers,"[15] but also becomes the designer of his own marriage: he is finally able to
convince his young wife that it is *not* one of the duties of a respectable architect's
wife to host brilliant salons.

Hermann Bahr, the "bugle boy" (Karl Kraus) of the Secessionist movement, uses his
comedy to express contemporary clichés about the Secession. His model was the
fierce controversy between himself and Karl Kraus, whose character is forcefully
represented in the play. From the beginning, Kraus had accused the Secessionists
of a "false modernity,"[16] inasmuch as they did not seek radical confrontation, but
simply competed for the favor of critics and buyers: "A dramatic revolution has
occurred in Viennese artistic taste: the salons of our wealthiest men are now no
longer furnished by Sandor Jaray, but by Olbrich or Hoffmann; and instead of the
youngest Ninetta by Blaas or the oldest invalid by Friedländer, they are adorned
with the newest creations of Klimt and Engelhardt. What does it mean? Simply that

those gentlemen who today are rich and tomorrow might be poor always take care to buy commodities that are as marketable as possible whenever they invest a part of their fortune in art."[17]

Kraus's censure of the Secession for "fighting the wrong antiquarianism for the propagation of an inauthentic modernity"[18] may also express the disappointment of the voyeur who has once again witnessed a less than radical break. "Now the same gentleman [Hermann Bahr] proclaims that a picture by Klimt in the Secession (the 'Schubert') is simply the best picture ever painted by an Austrian. Well, the picture is really not bad at all, and the good Herr von Dumba, who in his old age has had his living room decorated à la Secession, only needs to hang it in a dark corner. Herr von Dumba as a Secessionist is a very funny thought in itself. It just happened that way. He had ordered the pictures for his music room from Klimt when the latter was still working in the demure style of the Laufberger Schule, allowing himself at the most a few Makartesque extravagances. In the meantime, however, Klimt had been buttonholed by Khnopff [translator's note: a play on the word Knopf, 'button'] and has become (to get to the point) a pointillist. And of course the patron has to go along with it. So Herr von Dumba has become a modernist."[19]

From Kraus's perspective, the Secessionists failed to develop a cultural countermodel. Instead, they continued to pursue the religion of art, loathe to renounce either the myth of the historicist artist-genius or the veneration accorded to an artist-prince; they wanted to be loved by society while still claiming the full legacy of the sacrality of art—but now, of course, *their* art. They remained a not-so-radical minority, claiming the allegiance of an art public in the sense of a better society, a culture ignited by the spark of art. Seen in this light, the Secessionists continued the heroization of the late bourgeois artist and further embellished the narcissistic epic. In his essay *Gustav Klimt: Die Malerei und die Krise des liberalen Ich* (Gustav Klimt: Painting and the Crisis of the Liberal Ego),[20] Carl Schorske used the example of the *Beethoven Frieze* to show how the Secession around Gustav Klimt stagnated as well, inasmuch as the movement never fully realized the

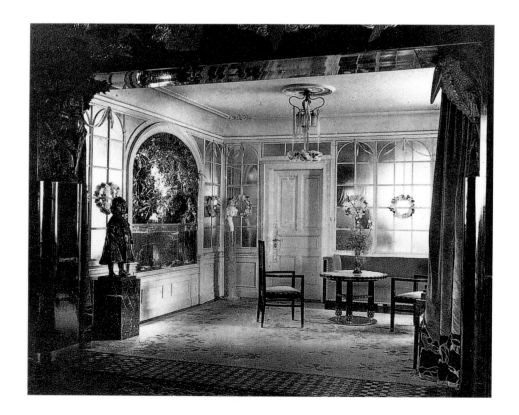

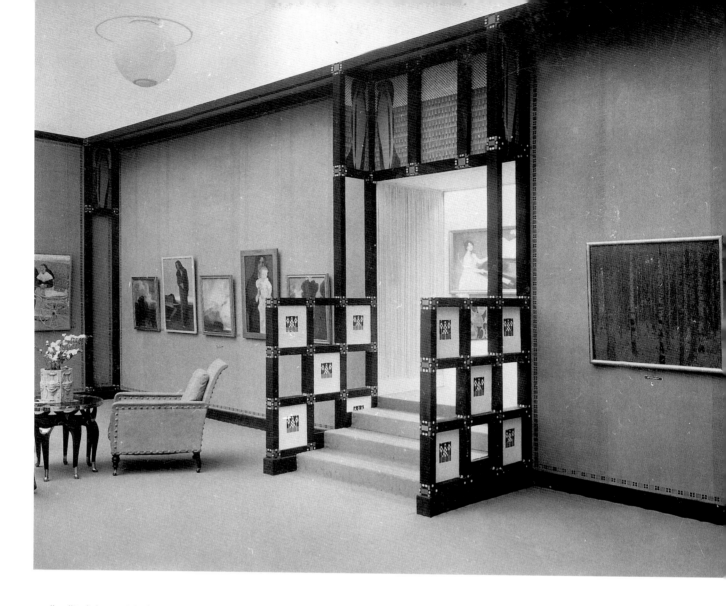

Stairs leading to left side hall of 13th exhibition, 1902. Exhibition design by Kolo Moser.
Photo: Bildarchiv der Österreichischen Nationalbibliothek

radicality inherent in its program. Schorske calls the frieze the "proclamation of narcissistic regression and utopian bliss,"[21] stating that "if ever there were an example of collective narcissism, this was it: artists (of the Secession) glorified an artist (Klinger), who in his turn glorified a hero of art (Beethoven). The catalogue of the exhibition spoke of the Secession's longing for a monumental endeavor, and from this there arose the idea of undertaking the task demanded of the artist by his time, namely the effective development of interior space. In actual fact, the Beethoven exhibition is a Gesamtkunstwerk of aestheticized interiority."[22]

A short quotation from one of the many enthusiastic reviews published on the occasion of the first exhibition illustrates the Janus-faced character of the early Secession exhibitions in general: "Blunt obelisks flank the entrance; on the pedestals stand exquisite metal and marble sculptures by Frampton, Richard Dautenhayn, and the Munich artists Floßmann and Beyerer; decorative plants surround uniquely appealing furniture after English patterns with ornamental vessels and bibelots, while the frieze above shows a fantastical aster motif. Through a mighty horseshoe arch, the viewer's gaze penetrates to the apse with the three-part cartoon designed by Puvis de Chavanne for the Pantheon; it depicts a vivid scene from the Genevieve legend (famine). In the center stands a funerary monument ('Le monument des morts') by the Parisian sculptor Bartholomé. The vaulted ceiling is transformed into a light tent roof; a frieze of golden foliage, luxuriantly growing over the portal arch, marks the upper boundaries of the taupe-colored walls at a moderate height. Recent watercolors by Honorary President R. v. Alt lean against easels."[23]

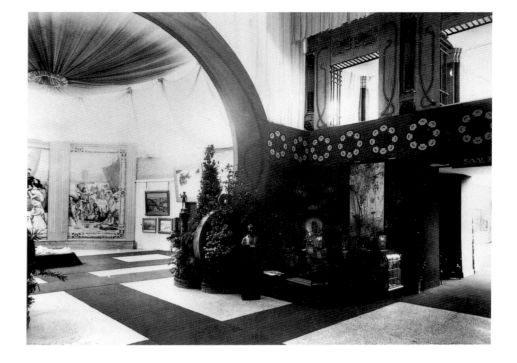

View of entrance area of 1st
exhibition of the Vereinigung
bildender Künstler Österreichs in the
halls of the Horticultural Society,
1898.
Exhibition design by Joseph
M. Olbrich.
Photo: Bildarchiv der Österreichischen
Nationalbibliothek

This first exhibition design by Joseph Maria Olbrich clearly shows how the
Secessionist rejection of historicism, while indeed giving rise to a new kind of
design, nonetheless failed to make a radical break with tradition. The set pieces of
the presentation allude to those of the artists' houses and ateliers of the 19th
century: pictures on draped easels, luxuriant plant decoration, furniture as applied
art as well as the object of possible use, and the whole punctuated with late
historicist sculpture. Olbrich's exhibition design thus retained the familiar
atmospheric furniture from the 19th century, while still constituting the expression of
a new kind of design, one that wanted to "revolutionize […] the field of artistic
arrangement."[24] In actual fact, the new approach to spaces and surfaces
manifested itself in the Ver Sacrum room, entrusted to the young Josef Hoffmann.
Hoffmann's exhibition designs soon replaced those of Olbrich and finally succeeded

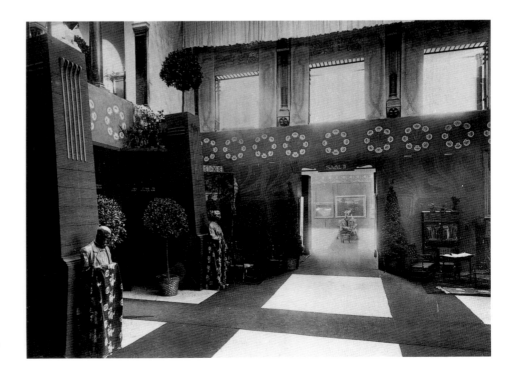

View of apse with triptych by Puvis
de Chavanne in the 1st exhibition of
the Vereinigung bildender Künstler
Österreichs in the halls of the
Horticultural Society, 1898. Exhibition
design by Joseph M. Olbrich.
Photo: Bildarchiv der Österreichischen
Nationalbibliothek

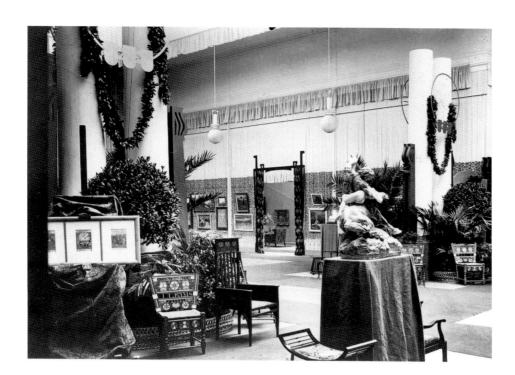

The main hall in the 2nd exhibition, 1898. Exhibition design by Joseph M. Olbrich.
Photo: Bildarchiv der Österreichischen Nationalbibliothek

in breaking the "Secessionist mold" (Ludwig Hevesi). It was Hoffmann, as well, who would later reject the early Secession's international models, including Henri van de Velde, as unmodern. In this way, the Secession's view of its own history became that of a stylistic overthrow, which in turn became the point of departure for an Austrian modernism essentially defined by the 'design' of Hoffmann and the Werkbund. Thus the Secessionists rebelled against an authoritarian 'father-generation' not only to achieve recognition for their work, but also to realize an artistically autonomous approach to the medium of exhibition.

"In our view, the value of an art exhibition is determined not by the number of objects, but by their quality and the manner in which they are presented."[25] The quotation is from a letter of January 26, 1904, addressed to the ministry by the

Ver Sacrum room of 1st exhibition, 1898. Exhibition design by Josef Hoffmann.
Photo: Archiv Sabine Forsthuber

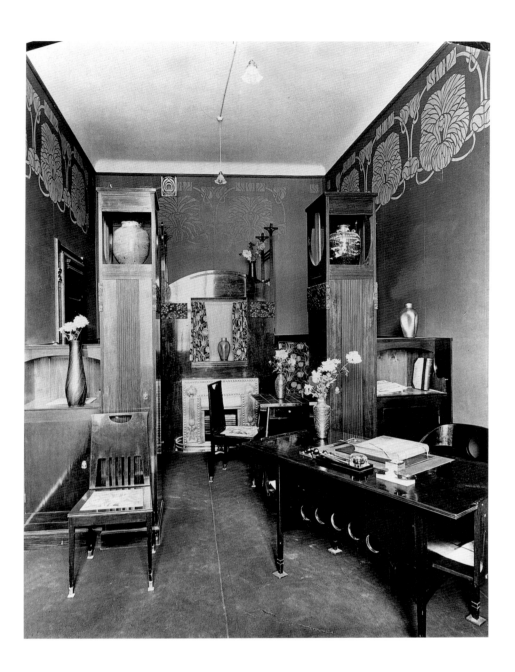

working committee of the Secession. The Secession had been invited to participate in the 1904 world exposition in St. Louis; the Secessionists' project, however, which called for the one room available to be devoted exclusively to works by Gustav Klimt in an exhibition design by Josef Hoffmann, was rejected by the ministry on the grounds that too few works of art were shown and that only a part of the membership was represented. In response, the Vereinigung withdrew its participation in the world exposition.

Three paradigms of design and the treatment of space were to be essential for the first eight years of the Secession's history (until the departure of the Klimt group). The first was a s p a t i a l s t r u c t u r e that defined the exhibition space as a sacred place of art, in which a primary work could be transformed into an object of cultic veneration through lighting and the incorporation into the sacred ground plan. In the first exhibition of 1898, the *Genevieve triptych* of Pierre Puvis de Chavanne constituted the center of the presentation; in the second, it was Henri Martin's *Vers l'abîme,* and in the third, Max Klinger's *Christus im Olymp.* This principle of consecration culminated in the 14th exhibition in the orientation of every single work of art, and indeed the space itself, toward a single piece: Max Klinger's *Beethoven sculpture.*

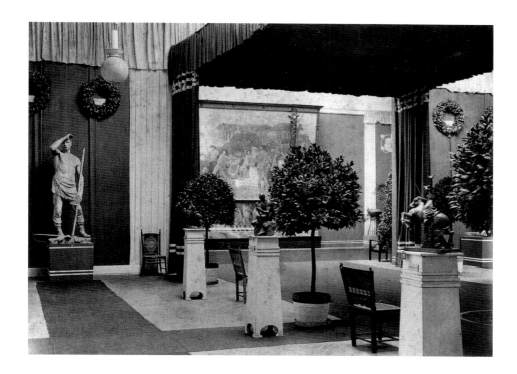

View of Max Klinger's *Christus im Olymp*, 3rd exhibition, 1898. Exhibition design by Josef Hoffmann. Photo: Bildarchiv der Österreichischen Nationalbibliothek

In a second paradigm, the w a l l as a field for ornament became both surface for pictures and a frame for the exhibited objects. In the early exhibitions, ornamental friezes with stylized plant and flower motifs organized the spaces of the exhibition into a coherent sequence and defined their upper boundaries. Over the years, however, exhibition designers increasingly abstracted and repeated these floral ornaments into patterns extending like wallpaper over the entire surface of the wall. This suggestion of the private demonstrated to visitors the proper way of engaging in the true, ideal enjoyment of art by means of a corresponding mounting of artistically designed objects. To a certain extent, the Secessionist frieze dominated the exhibited works of art, including those of non-Secession artists; such works were conceived as elements in the spatial design of a Secessionist *Raumkünstler*. This approach to art, space, and handicraft comes to clearest expression in the transformation of the individual wall surface into a frame; according to the principles

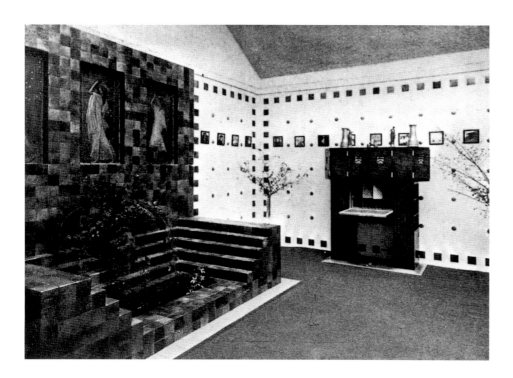

15th exhibition, 1902. Exhibition design by L. Bauer, K. Tichy, L. Plečnik, F. Messer, K. Moser. Photo: Bildarchiv der Österreichischen Nationalbibliothek

18th exhibition, 1903. Exhibition design by Koloman Moser (and Joseph Hoffmann).
Photo: Archiv Sabine Forsthuber

of Jugendstil, frame and picture together constitute a unity with respect to both form and content. Furthermore, the frieze as an artistic means, as ornament or image transferred directly onto the wall, was an intentional trace of the physical presence of the artist. It bore witness to the immediate act of artistic creation and manifested the desire to relieve the individual work of art, now no longer portable, of its status as a commodity and immortalize it as the essential element of an ornamental syntax.

In the early presentations of the Secession, the medium of exhibition was varied from show to show, from design to design, indicating the existence of a rule governing these creative manifestations as a kind of underlying grammar. The exhibition sequence of the first eight years of the Secession can also be read as the origin of a single exhibition type, though each individual exhibition represented a

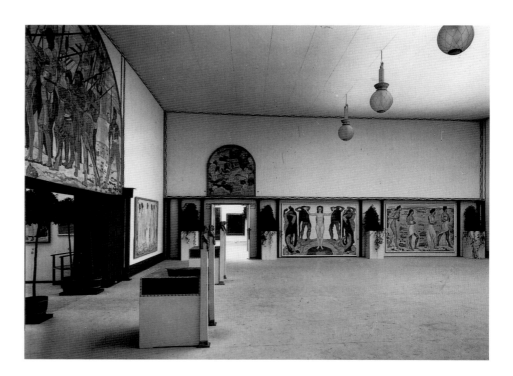

19th exhibition, 1904. Exhibition design by Koloman Moser.
Photo: Bildarchiv der Österreichischen Nationalbibliothek

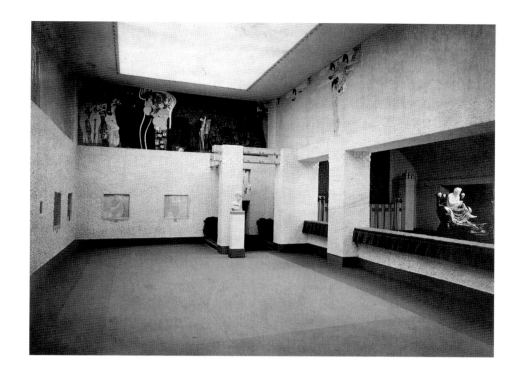

new chapter in the design of the complete Secessionist lifestyle, from the cover of the catalogue to the wallpaper of a private salon. In this connection, one is also reminded of the *Schweindlfeste* of the Primavesi, a family closely associated with the Secessionists: at these summer masked balls, guests wore costumes made from the same fabric that covered the walls of the festive rooms.

Finally, a third principle resulted, according to which the e x h i b i t e d o b j e c t itself—whether belonging to the fine or applied arts—both plays a role in and is affected by the design of the space in which it is shown. This principle found its clearest expression in 14th exhibition in the spring of 1902. Here, the "aesthetic church" (Hölderlin) attained its perfection: the epicenter of the entire spatial design was marked by a single artistic image, a tabernacle and cult object: the statue of Beethoven. Christian iconography such as Adam and Eve or the Crucifixion (on the

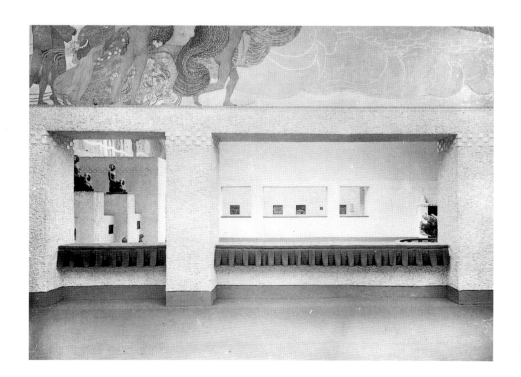

ORIENTIERUNGS-
PLAN FÜR DIE
WANDMALEREIEN
UND PLASTIKEN.

rear side of the artist's throne) joined with motifs from pagan antiquity to create a metaphor of redemption whose conceptual and visual medium was the work of art. In a subtle choreography, the view into the room was at first denied to the visitor; then, as one strode down the left aisle past Gustav Klimt's wall painting, the sculpture of Beethoven gradually became visible through the large openings into the main hall, as in a film sequence. Finally, moving once more in the opposite direction, the visitor arrived in front of the work of art, the pledge of redemption. In this exhibition, the participating Secessionists subordinated themselves both to the artist Klinger, representative and theorist of the Gesamtkunstwerk, and the genius Beethoven, source of the leitmotif of the entire exhibition. This attitude manifested itself in a qualitatively new conception of space: the idea of the Gesamtkunstwerk came to expression simultaneously in an architectural-spatial design, in the work of art at its center (Klinger's statue), and in the guiding theme of the exhibition as a whole—a sacralization of both topography and content that remained unsurpassed. Indeed, with its combination of techniques, colors, and materials, Klinger's sculpture itself represented, *pars pro toto,* the idea of the Gesamtkunstwerk. Klinger's programmatic essay *Malerei und Zeichnung* (Painting and Drawing), in which he disseminated his theory of the Gesamtkunstwerk, had appeared in Leipzig in 1891 and had been reprinted six times by 1919. The text was well known to the Secessionists; an excerpt was even published in the exhibition catalogue. The 19th-century cult of the artist and genius was here intensified to the point of apotheosis—the Beethoven-worship of the time bringing over 60,000 visitors to the exhibition during its four-week duration—and consummated in the total design of the space. Here the Secession appears to have attained both an end and a new beginning: even before the opening of the Beethoven exhibition, the statutes of the Vereinigung prescribed that from that point on, exhibitions had to have either 'gallery' or *'Raumkunst'* character.[26] This statement manifested not only a distinction between design principles, but also the

division of the Vereinigung into Secessionists and the so-called *Klimt-Gruppe,* who were to leave the Secession three years later.

To be sure, the Secessionists seem to have recognized from the start that the suggestive power of innovative design in presenting costly works of art could not help but invest them once again with the character of a commodity, the very thing the Secession had so vehemently rejected at its founding. In the beginning, the new exhibition space, for its period conspicuously plain (not to say naked), was repeatedly clothed with an ephemeral architecture that presented itself as a place of exquisite consumption. The work of art, caught within the self-referential net of 'l'art pour l'art,' simultaneously exuded the aura of the exclusive commodity. Even the friezes and panels of costly materials inlaid in the walls, originally conceived as inseparable from the architectural space and thus not intended for purchase, sold well with the public. On July 6, 1902, a newspaper noted that of "the wall paintings and sculptures that had served as a frame for Klinger's Beethoven," 32 works had passed into private collections; with reference to the decorative panels, it was remarkable how "eager the public was to acquire even these trivialities."[27]

The intensive cooperation among the artists in the Beethoven exhibition had taken on the character of an artisans' guild, placing the work of the individual at the service of a shared idea. Klimt's *Beethoven Frieze* remained in place for several successive exhibitions, until it was finally taken down and turned over to its purchaser (Carl Reininghaus). For its contemporaries, the frieze's content and process of creation embodied the leitmotif of a new 'Kunstvolk' ('people of art'); this, however, did not prevent them from putting it up for sale. Thus instead of being preserved as a programmatic expression of the Secessionist idea, the frieze was sold to a private collector as a valuable object from the master's hand. For Karl Kraus, this once again exemplified the Secessionist double standard, the discrepancy between melodramatic claims and commercial interest.

"Already the whitewashers are arming themselves to scrape off the casein paint that has covered the walls of the Secession for the last several months. No one regrets it but Herr Bahr, who, as we know, holds no sway over the readers of the *Volkszeitung* or in Austria. If he did—so he announced in the culture pages—then

Wall panel by Maximilian Lenz, 14th exhibition, 1902.
Photo: Bildarchiv der Österreichischen Nationalbibliothek

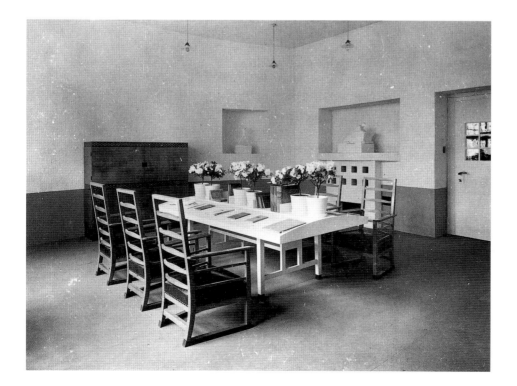

Reading room in current Ver Sacrum room. Design by Leopold Bauer, 14th exhibition, 1902.
Photo: Bildarchiv der Österreichischen Nationalbibliothek

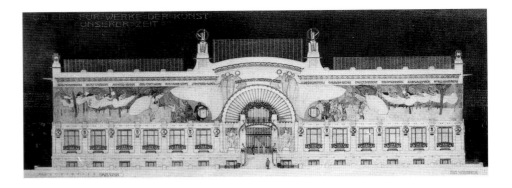

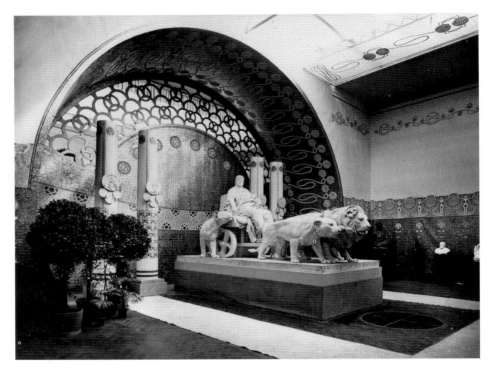

'the Secession building would never be altered again.' This suggestion, by the way, is not entirely objectionable. For at least then—if the presentation of Klinger's Beethoven could be preserved intact—we would be saved from all future exhibitions of the Secession. And one can also agree with Herr Bahr's statement that the immortalized Beethoven Exhibition was 'a monument for posterity of the longing and t o r m e n t of this people' (of present-day Vienna). But it is certainly more humane to spare posterity our torment."[28]

There can be no doubt that in addition to the new idea of collecting international contemporary art and making it available to an interested public, the Secession also sought the enshrinement of this very art in a museum-type setting. The statutes of the Secession had already codified its demand for the founding of a 'gallery of modern art.' Art presented in an ephemeral exhibition was therefore also to assume a place in a necessarily static collection. The 4th exhibition, designed by Olbrich with Arthur Strasser's sculpture *Mark Antony in his Chariot Drawn by Lions* at the center—a sculpture now permanently installed next to the building—was intended as the model for the founding of a sculpture museum, an Austrian Glyptothek.

In 1925, arguing against the "unnatural concentration of the aesthetic in the isolation of the museum,"[29] the art historian Hans Tietze spoke out against the founding of a museum of modern art (and resigned in the same year when his proposal for the reorganization of the museum system was not accepted), a museum that had

always been demanded by the Secession. Tietze continued to develop his concept of a middle ground between gallery and museum (or as he called it, "Purgatorio"[30]), thereby adopting an idea of Otto Wagner. In his project for a building for the 'modern gallery,' Wagner had conceived a museum with flowing spatial boundaries, in which, over the course of the decades, a museum of the exhibition designs of artists and architects would slowly develop. Here the museum was devoted not to the individual object, but to the designed space itself. But what the architect Wagner had seen as a Gesamtkunstwerk, the art educator Tietze viewed as an aesthetic document of the times that always made (critical) reference to its social context.

Tietze's ideas on popular education stood in stark contrast to the aestheticizing displays of the early Secession exhibitions. As an admirer of Adolf Loos and Karl Kraus, Tietze spoke out in decisive terms against the decorative and the ornamental. In his exhibition *Die Kunst in unserer Zeit* (The Art of our Time), for example, shown in 1930 in the Künstlerhaus, recordings of works by contemporary composers were played in a section devoted to music. Interactive museum education for the common man, oriented to the needs of the visitor, stood in opposition to the synaesthetic experiences reserved for invited guests at the Secession openings. Tietze's concern was to place not the individual artist, but the work of art as the bearer of non-aesthetic (i.e. social) information at the center of the exhibition, if necessary even using photography as comparative material. For these attempts he was accused, not only of Bolshevist propagandizing, but also—from the artists' perspective, as expressed by the painter Erwin Lang—of striking "a flagrant blow to the freedom of artistic creation under the pretext of education."[31] For Tietze, the freedom of art in an aesthetic enclave was no longer worth defending. The temple of art should be open to everyone, even the worker, not merely to those who could flash their high society admission ticket. This claim, essentially derived from Tietze's perception of the international avant-garde, was not without consequence for the contents of the precious Secessionist 'jewel case.'

79th exhibition, *Internationale Kunstausstellung,* 1924.
Photo: Bildarchiv der Österreichischen Nationalbibliothek

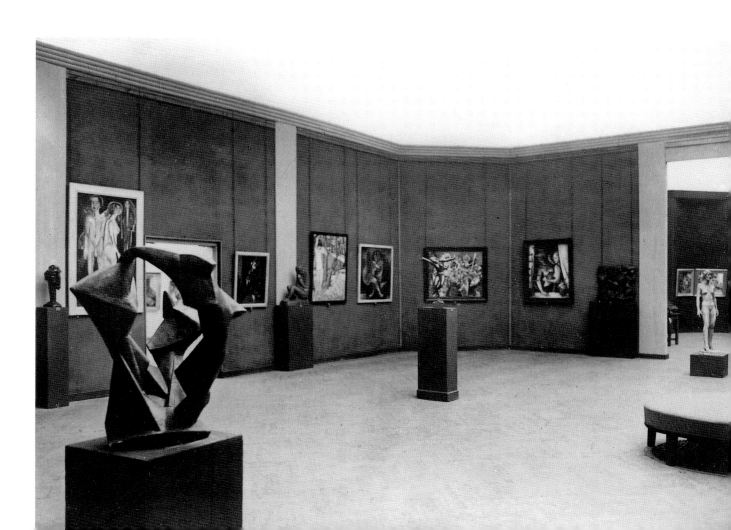

Ground plans of the exhibitions: (top
left to lower right)

7th exhibition, design by A. Böhm
15th exhibition, design by L. Bauer,
K. Tichy, L. Plečnik, F. Messer,
K. Moser
17th exhibition, design by
J. Engelhart, J. Hoffmann, K. Moser
23rd exhibition, design by J. Plečnik
24th exhibition, design by J. Plečnik
35th exhibition, design by R. Örley
Photos: Archiv der Wiener Secession

THE PRESENCE OF AN EXHIBITION TYPE

Until the departure of the Klimt group, the Secession exhibitions clearly codified the values and self-representation of the upper middle class in turn-of-the-century Vienna. Artists and connoisseur collectors, curators and exhibition visitors entered into a unique symbiosis, in which art functioned both as an autonomous work and as an indispensable part of a whole way of life; in the very sacrality of its presentation, art acquired the character of an exquisite commodity. The exhibitions were the medium or catalyst that set and kept this complex network of references in motion. The Secessionist exhibitions presented art as an experience: the gallery became the sacred space for the veneration of art, with the works themselves "anchored" in this consecrated space as the elements and medium of an elaborate exhibition design. Such designs rendered the architecture itself almost invisible, while emphasis was placed on those artistic forms—above all wall painting—that bore witness to the actual moment of artistic creation. Such were the formal means employed to create a spatial effect that could provide the public with a feeling of "pleasurable contentment."[32] One may also conceive of this presentation technique as a grammar, an underlying structure that was varied and supplied with new effects at each exhibition, events eagerly anticipated by the public.

It was the exhibition itself that was the focus of artistic attention, not the individual works. Even those exhibitions whose design revolved around a single piece embedded it in a continuum that permitted the interior space to be experienced as a hermetic whole, a self-contained unity. The Secessionists never doubted the autonomy of the work; rather, their exhibitions pursued the self-imposed task of using spatial design as an artistic means to guide the reception of the works. The Secessionist treatment of space was intended, as it were, to regulate the viewing of art, the aesthetic experience created by the artist's hand. Underlying the impersonal numbering of the exhibitions was a theme, the theme of the designed space itself, in which the work of art was subordinated to the overall effect intended by the *Raumkünstler:* "It is his duty to artistically orchestrate the scattered creations, to organically order all of the details into a unified, purposefully invented space […]. Therein is expressed modern man's compelling need to be rescued from the nerve-wracking confusion of disconnected impressions and placed on the solid ground of a unified, self-contained artistic effect by the power of the creative personality. Thus in the newly-opened Secession exhibition, the overall spatial effect first greets us with a feeling of pleasurable contentment."[33]

The ephemeral character of the individual exhibitions contrasted with the constancy of Secessionist exhibition design and its formal means, a strategy intended both to counteract the interchangeable, transitory nature of the mere exhibition hall, and to contrast with the art museum's claim to immortality. To be shown in the Secession, therefore, did not necessarily promise the incorporation of the work into a prospective modern gallery, and even the exhibition design itself used new means to pursue traditional goals: to be presented 'Secessionistically' promised a particular form of appreciation, in the literal sense of the word.

Had Tietze succeeded in his efforts to call attention to the significance of art as a social and historical sign, as the bearer of information to be presented as neutrally as possible, a conservative segment of society would have been confronted with itself: its ideologies and value systems would have been subjected to public debate in a historical phase—the period between the two World Wars—in which Vienna was marked by the political conflict between the Socialist and Christian Socialist parties. Instead, the years of the Austrian Republic were characterized by a conception of art still derived from the turn of the century, which constituted a reaction to the exploitation of art by the demands of the market. Now, however, this conception—seemingly so value-neutral, entirely subordinated to aesthetic

View of *Pietà* by Anton Hanak in 86th exhibition, *Christliche Kunst,* organized by the Society for Christian Art. Exhibition design by Clemens Holzmeister (with Peter Behrens and Ferdinand Andri), 1925.
Photo: Bildarchiv der Österreichischen Nationalbibliothek

pleasure, a semi-public dramatization of bourgeois private life—was invested with new meaning and used for purposes whose ideological content was clearly apparent.

Thus in 1933, Clemens Holzmeister organized an exhibition in the Secession entitled *Das Kredo in der Gegenwartskunst* (The Credo in Contemporary Art). The occasion was the General German Catholic Convention taking place in Vienna, over which Holzmeister presided. Since his appointment to the Akademie der Bildenden Künste in Vienna in 1924, the young architect had experienced first-hand the institution's unstable economic situation. Furthermore, the Academy's function was changing; as an institution obligated to an artistic aristocracy, it hardly knew how to defend itself against the criticism of a rising "art proletariat."[34] Under Clemens Holzmeister and Peter Behrens, the Academy entered into an open alliance with the Austrian Republic on the occasion of a school exhibition in the same year as the exhibition in the Secession (1933); again in the same year, it was entrusted with the building of a church. Holzmeister recognized the power of an exhibition in the still-famous Secession to provide publicity and instrumentalize history for the purpose of "identification and agreement with the dominant politics"[35] of the Republic, which a few years later would lead to widespread popular support for the annexation to National Socialist Germany. In this sense, the exhibition of Christian art invoked both the aesthetic withdrawal of the Secession from the art market, its anti-didactic conception of the exhibition as a Gesamtkunstwerk for an artistic cult gathering, and the modernist position of Hans Tietze, who wanted to make the historically relevant work of art, and not merely the socially privileged artist figure, accessible to a large public. The aestheticism of the Secession could even make controversial statements in the name of artistic freedom and use the supposedly 'pure' experience of the exhibition to indulge in a manipulative pathos; Tietze, on

the other hand, showed how the exhibition could be used as a medium of education, and therefore also propaganda. Inevitably, Tietze's conception of art, originally intended as a medium of popular education and enlightenment, was to founder on that very propagandistic appropriation by the new/old cultural politics of the 1930s.

In his exhibition design, Holzmeister employed both the Secessionist tradition of sacral exhibition design and a modern language of forms. While the early Secession exhibitions had focused on an idealized, mythological art and the veneration of the artist, Holzmeister's spatial structure appropriated the hierarchical order of the Christian church with its symbol of suffering, a crucifixion group. As early as 1925—when Holzmeister had designed his first exhibition in the Secession, *Christliche Kunst* (Christian Art)—he had punctuated the strict choreography with a *Pietà* by Anton Hanak as the symbol of personal, individual suffering.

In the exhibition of 1933, the architecturally prescribed geometry of the space, the purist rectilinearity of movement and visual perspective, conveyed a sense of order and austerity. The real issue at stake here was not the presentation of art, but rather

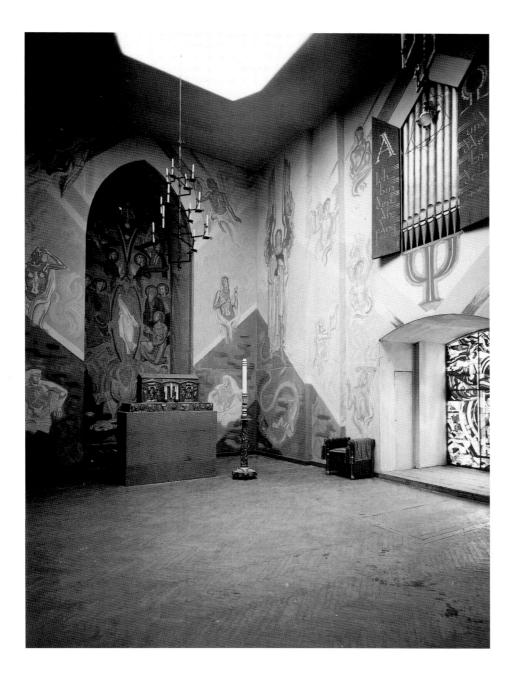

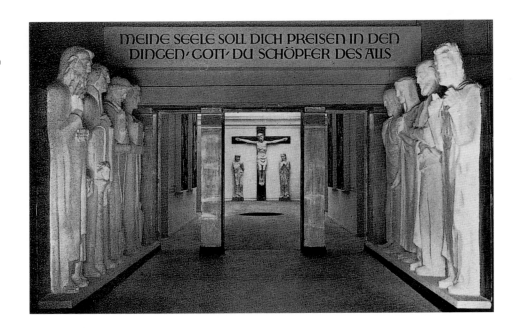

the manifestation of a cultural and political change, in which the new status of the church as the conjunction of political and ecclesiastical power in the early years of the Republic was translated directly into a spatial design. The evocation of ecclesiastical space in a secular temple signified the conversion of the aesthetic to the new power structures. Holzmeister's *Raumkunst* was addressed not to the petty bourgeoisie of National Socialism, but was entirely obligated to the ecclesiastically-sanctioned elitism of the Viennese society of the Republic, a society whose aesthetic self-representation was expressed in terms of modern functionality and which in Holzmeister had found a stage director of the modernistic variety. Then as now, Clemens Holzmeister's name stood for an Austrian cultural politics that appropriated a contemporary and international formal language for purposes that were nonetheless socially conservative and elitist, geared to the interests of a Catholic upper middle class.

With the exhibition *Das Kredo in der Gegenwartskunst* in 1933, the Secession placed both its building and its historical significance at the service of a designer whose status as a state artist had been indisputable since his declared alliance with the Republic. Holzmeister's 'conquest' of the Secession effected its conformity to the dominant cultural politics and transformed it into a venue for the presentation of state art by converting the temple of art into a Christian sacred space.

Much later, in the 1980s, the appropriation of the Secession as a representative frame for state cultural politics continued with the enshrinement of the Secessionists around Klimt in major exhibitions such as *Traum und Wirklichkeit* (Dream and Reality) and the marketing of Jugendstil as Austria's contribution to international modernism. In this light, the 1987 exhibition project of Hermann Nitsch in the Secession, a concept on which the artist had worked for a long time, seems 'actionistic' from a number of perspectives. The artist alluded to the 'Secessionist myth,' the attitude toward the history of the building that had recently been revived not least through the elaborate restoration of 1985. The *Beethoven Frieze* had been returned to the building: a wall painting that had formerly contributed to an overall spatial effect was now permanently installed as an autonomous work in its own specially-designed space, thus also constituting a highly valuable asset for the Vereinigung, both ideologically and commercially. With the permanent installation of the frieze, a historical image of the Secession was, as it were, frozen in place.

It was a particular challenge for Nitsch to enter into dialogue with the space and the place, to present his own œuvre, itself with the character of a

Gesamtkunstwerk, in relation to the intentions of the early Secessionists. Nitsch's practice of art as ritual, closely related to theater as a form of Gesamtkunstwerk, alluded both to the history of the place and to its dramatization of the artist figure. The references to history were numerous and consciously introduced. The charismatic figure of the artist, the priest of an aesthetic religion of art, was reflected in a historical costume: "Klimt painted in a ritual robe. In the same way, already in my first *Malaktionen* (painting-actions) I wore the cowl-like shirt without which my current painting rituals would be inconceivable."[36] History is repeated in the artist's own history, and is even carried a step further: the painting shirt becomes a part of the exhibition as a 'relic' on which the traces of the act of painting are inscribed. This "*vera ikon*"[37] constitutes a direct manifestation of the creative act, "a gripping language of the event"[38] that eludes the boundaries of verbal language. No longer imbued with the threatening concept of progress, the rationalistic constructions of language are exchanged for a 'psychophysical' mood, seismographically inscribed on the red canvases. These identify the space as a shell, an enclosure, that clearly divides the inside from the outside, the psychic structure from the analytic one. Nitsch's references to the early Secession go beyond the formal and symbolic principle of conceiving the space in its essential sacred structure, and accordingly supplying it with altar table and triptych. An interview in the catalogue likewise confirmed the artist's awareness of and special reference to the Secessionist Gesamtkunstwerk, to Gustav Klimt and the *Beethoven Frieze.* And so the dangerous proximity from which Nitsch addressed the cultural knowledge of the place became a celebration of distance and thus a point of departure for a critical position with respect to the business of art and culture in the 1980s.

Hermann Nitsch, *20. Malaktion 18. – 21. Februar 1987,* February 27 – March 22, 1987. Photo: Archiv der Wiener Secession

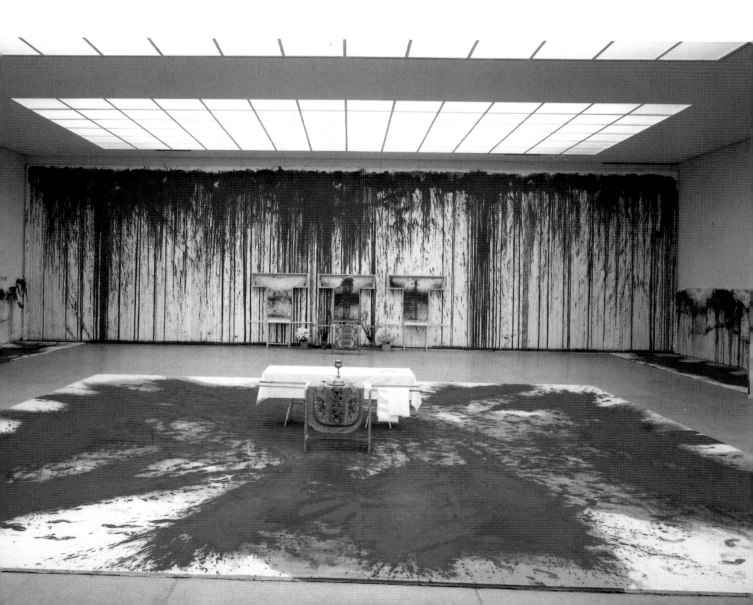

The institutionalization of contemporary art in the museum and the booming art
market of those years allowed the artist to emerge as a new cultural hero, but at
the same time claimed him as the accessory of an art society that outspokenly
presumed the right to pronounce aesthetic judgment. At issue in the 1980s was
less the autonomy of the work of art than the autonomy of the artist with respect to
collectors, curators, dealers, and critics, who meanwhile self-confidently asserted
their share in artistic production. The place of the *Raumkünstler* had been taken
over by the curator who discovered and promoted artists, conceived and designed
exhibitions, and established contact with collectors. The differences in function
between artists, curators, culture managers, and art consultants became more
and more difficult to determine, with the go-betweens finally assuming artistic
responsibilities as well. This problem could be critically addressed in the Secession
as an institution self-administered by artists and in whose exhibitions the selection,
presentation, and perception of art was determined by artists. Seen in this light, the
historical significance of the Secession provided artists with the freedom to take a
stand regarding the business of contemporary art by making reference to the place
of exhibition. If Hermann Nitsch had invoked the idea of the Gesamtkunstwerk, he
had done so in order to allow the viewer of this Gesamtkunstwerk to help complete
it, using an architectonics of emotion to translate linguistic terminology into
subjective repertoires. The event-character of his *Malaktion* was probably intended
to make it impossible for consumers and voyeurs to withdraw from the work of art,
to distance themselves from it linguistically; the effect was supposed to be direct,
circumventing all rationalistic repression. The artist himself was to be the sole
orchestrator of collective feeling.

Two and a half years after the *Malaktion* by Hermann Nitsch, in another exhibition in
the Secession the visitor was confronted first by a wall bearing the words "curated
by Joseph Kosuth" in addition to the title of the exhibition. Only behind this wall did
the exhibition itself begin. The prominent mention of the exhibition's conceptualist
reflected an international trend in which exhibition programs increasingly profiled
themselves with the formula 'curated by.' The idea of an artist as curator was
certainly not new; here, however, it was intended as an answer to the kind of
curator who appropriated to himself a kind of theatrical artist's gesture—unlike
Hans Tietze, who had consciously excluded artists from his *Gesellschaft zur*
Förderung moderner Kunst in order to counter the aura of the experiential with the
didactic and cultural-historical. While the Secessionists had understood the

Gesamtkunstwerk as the union of artistic techniques and individual styles toward a common goal (in particular the homage to an artist or to art itself), a synthesis of artistic production and content, Kosuth's project represented the coincidence of curatorial responsibility and artistic creativity as an homage to the autonomous artist.

Works of conceptual art from the 1960s to the 80s were arranged in loose sequence along the walls, framed by quotations from Ludwig Wittgenstein's *Tractatus logico-philosophicus* and the *Philosophische Untersuchungen.* Kosuth's concept called for groupings of works within which "family resemblances" could emerge, invisibly networked on a second level with other works in other parts of the space. The works were hung on a wall divided horizontally into a grey and a silver-colored area; above these color zones, quotations from the two works by Wittgenstein were arranged in bands.

The viewer was confronted with a 360° panorama like an endless text, not with autonomous groups of individual works; rather, the latter constituted elements of a single work, Kosuth's. In this oscillation between the curatorially organized group exhibition and the work of conceptual art, the homage to the philosopher became an homage to the figure of the artist himself, signifying as well an allusion to the Secession as an artists' union. With Kosuth, the Secession had chosen an 'exhibition maker' whose own work since the 1960s had dealt with Sigmund Freud and Ludwig Wittgenstein, representatives of an Austrian intellectual history in exile. In addition, for Kosuth himself the Secession represented one of the last remaining bastions of artistic self-administration, of the aesthetic cult of the autonomous artist, a place especially appropriate for a conceptual artist who—not least in a political sense—advocated creative autonomy and the control of the artist over his or her own work.

Joseph Kosuth in the exhibition *Wittgenstein – Das Spiel des Unsagbaren. Wittgenstein und die Kunst des 20. Jahrhunderts,* September 13 – October 29, 1988. Photo: Margherita Spiluttini

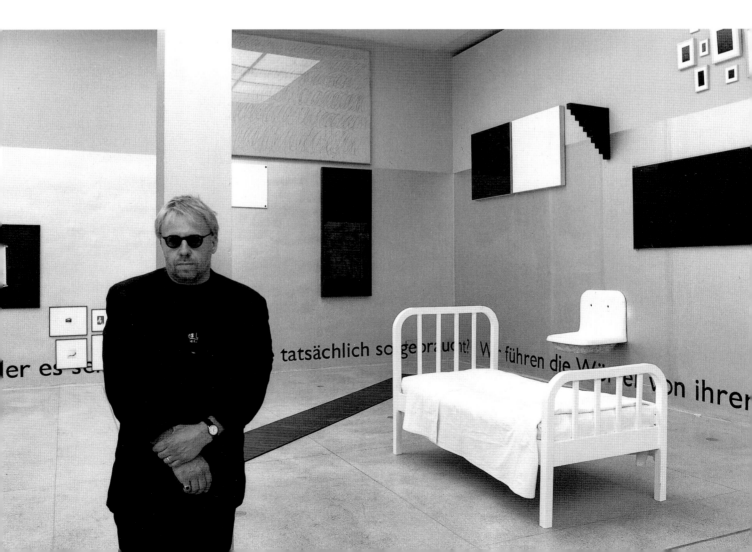

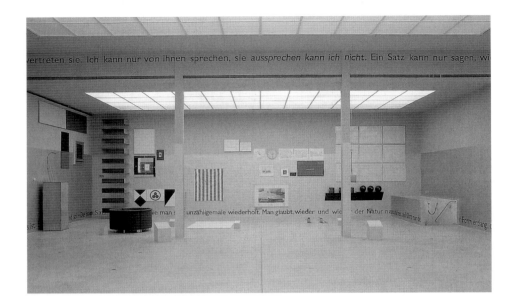

Kosuth alluded to the history of the place and thus also to the *Raumkunst* of the
first Secession exhibitions, which had expressed an internalized reverence for the
individual work of art and the process of artistic creativity. This was a state of mind
incapable of adequate expression in language, experiencable only through the
design of the space. With Kosuth, an artist of the 1980s showed that only such as

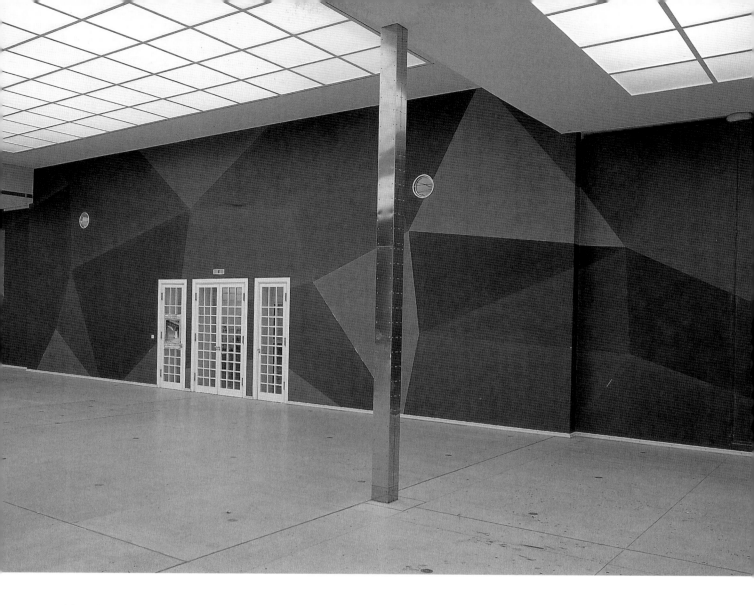

Sol LeWitt. Wall Drawings.
Continuous Forms with Color and
Gouache Superimposed,
May 28 – June 3, 1988.
Photo: Margherita Spiluttini

himself were in a position to make statements about art, to use art to describe itself, an idea reflected as well in the subtitle of the exhibition: *Das Spiel des Unsagbaren* (The Game of the Unspeakable). In contrast to Nitsch's dramaturgy, which had created a 'psychophysical' space rich in detail, here the unity of the work of art was elevated to the analytic category of thought.

Both Kosuth and Nitsch celebrated the figure of the artist in the face of the pressure of a booming art market; both used the reference to the history of the Secession as the 'temple of art' to underline their polemical position.

In his exhibition of 1989 in the Secession, Sol LeWitt reacted against the special aura that the presence of the artist bestowed on painting applied directly to the wall. What was presented here was neither the intimate act of artistic creation nor the reference to an overarching theme, but rather a self-referential structural concept. Accordingly, Sol LeWitt used the Secession not as a cultural space, but as a functional, architectural one, to which he added an additional layer,[39] conceived as both a space of illusion and an actual layer of paint. At the end of the exhibition, this layer could once again be covered over with whitewash, making the wall available for other wall paintings; at the same time, however, modern techniques of reproduction could preserve the layer in memory. Just as the Secessionists had helped the wall to come into its own as a pictorial space, LeWitt's designs of the 1980s helped overcome 'the white wall of modernism,' conceiving of it as a 'space' that is situated on the surface. LeWitt's flat geometric forms were transformed into illusionistic color spaces; two- and three-dimensional

Daniel Buren. Im Raum: Die Farbe,
November 17 – December 14, 1989.
Photo: Aglaia Konrad

space was subsumed into a picture puzzle that received the visitor within the architectural shell of Olbrich's building, but at the same time expanded it illusionistically. Despite their strictness, the colored wall paintings of Sol LeWitt constituted a conceptual work of painterly opulence, an almost monumental decorative space. The reciprocity of ornamental surface design and spatial elements in the work above all of Josef Hoffmann was noted by Hermann Bahr, who described Hoffmann's Ver Sacrum room of the first exhibition as a 'poster,' as a flat, decorative art.[40]

Immediately following Kosuth's Wittgenstein show in 1989, an exhibition by Daniel Buren presented a counterpoint to the spatial design of Sol LeWitt. *In situ,* a designation Buren has used for his exhibitions since 1969, refers to the work on location. This location is not treated as a neutral topography available to the artist; rather, the analysis of the space and its cultural history—and thus also the institution—becomes the foundation of the work. The only things that remain neutral are the awning-like stripes themselves: it is the way "in which they operate in relation to their placement that accounts for the meaning of each piece."[41] Here, in the avoidance of personal gesture and the neutralization of any painterly handwriting, Buren shows points of contact with LeWitt. And yet in the total composition, the colorful stripes constitute the unique significance of the work for the place. Buren's Secession exhibition takes the place 'literally': the point of departure for the formal structure of the work is the physical reality, the uniqueness of the place in its present and historical disposition—"its history, a particular size, a physical presence, a cultural weight."[42] In the Secession, Buren made reference to the dimensions of the ground square and the number seven, which he had discovered in the proportional relationships of the space.

In the end, however, Daniel Buren decided to mount his stripes on the walls rather than presenting them as corporeal installations in space. This decision was justified not, as with Sol LeWitt, by the naked shell of the architecture, the givens of the building itself, but by a reference to the Beethoven Frieze, a part of Secessionist history situated 'in perpetuity' in the basement of the building and therewith programmatically anticipating all references to the institution's history: "[…] for me, the frescoes by Gustav Klimt, a work in situ, require a work on the walls rather than a work in space."[43]

Gerwald Rockenschaub,
July 15 – August 21, 1994.
Photo: Matthias Herrmann

In 1988, Gerwald Rockenschaub had installed a golden square on red velvet pillows in front of Klimt's frieze, thereby alluding to Klimt's use of materials and Hoffmann's formal design as they had remained in general memory and had been commercially exploited. In so doing, he also pointed to that gesture of memory, the taking of an ephemeral work, created as an element in a larger spatial installation, and framing it in order to 'renaturalize' it. Thus the striving of the young Secession to survive its first ten years in order to at last be able to define the canon for the reception of the international development of art seemed finally to have been fulfilled. The Secessionist form had become enshrined: the reinstalled frieze may be viewed as the icon of a unique and unmistakable exhibition hall for contemporary art, where the individual work of art is no longer collected, archived, inventoried, or catalogued.

In the 1980s, the history of the Secession and its organizational structure served as an essential point of departure for artists like Hermann Nitsch, Joseph Kosuth, Sol LeWitt, and Daniel Buren. The Secession owed its elaborate renovation to the boom of these years; at the same time, however, exhibition projects like these also manifest its status as a retreat, a place which, rather than engaging in the controversial discussion of the autonomy of art, reaffirmed the figure of the artist and his social role both in the aesthetic and the analytical treatment of art.

A younger generation of artists—including Gerwald Rockenschaub—views the artist not as a priest or a magician, but rather as a more transparent entity who no longer wants to withdraw into the formal freedoms of a protected space. In Rockenschaub's 1994 exhibition in the Secession, the main hall was narrowed into a passage; two corridor walls led visitors from the entrance directly through to the open rear door without allowing a view into the (empty) spaces. The visitor moved along past photo tableaus showing urban zones, traffic situations, and public places. Interior and exterior here met in the gaze of artist and visitor, in the real and the medialized, in the tension between aesthetic isolation and openness to the urban surroundings. No longer was there 'pleasurable contentment' in an interior space produced by an architecture of civilized forms of encounter. The Secession

was no longer a familiar place with familiar faces, a rendezvous for an appropriate occasion, but rather an anonymous passage in urban space.

And one can only agree with the artist when he states that the controversy regarding the autonomy of art and the artist can only emerge in certain spheres, that the temple of art itself prescribes certain forms of behavior and communication. Rockenschaub dared to pose the question of the role and position of the artist outside the temple walls; in so doing, he obligated himself to a social-political approach in which artistic freedom only acquires fundamental significance and consistency when it is not confined to and defended within a protected space, like a reservation. Rockenschaub refuses every opportunity to withdraw into the place which, in its aesthetic isolation, permits the self-representation of the artist.

It is this radical position with respect to the history of the Secession and its exhibitions that reveals both its limits and its possibilities.

Notes

The names of the authors of this text are listed in alphabetical order.

1 Katalog der I. Ausstellung der Vereinigung bildender Künstler Österreichs (Wien 1898), 2
2 Karl von Vincenti, Secession; in: Neue Freie Presse (March 31, 1898), 3
3 Cf. Elke Krasny, Zukunft ohne Ende – das Unternehmen Weltausstellung; in: Wunschmaschine Welterfindung. Eine Geschichte der Technikvisionen seit dem 18. Jahrhundert, ed. Brigitte Felderer (Wien 1996), 314–39
4 Cf. Hans-Peter Schwarz, Im Spannungsfeld von Fürstenhof und Bürgerstadt. Die Entstehung der Künstlerhäuser im 16. Jahrhundert; in: Künstlerhäuser. Eine Architekturgeschichte des Privaten, exh. cat., ed. idem with Heike Lauer and Jörg Stabenau, Deutsches Architekturmuseum, Frankfurt/M., Sept. 16 – Nov. 26, 1989 (Braunschweig 1989), 68
5 Anselm Feuerbach, Ein Vermächtnis (Berlin, n.d.), 177; quoted in: Manfred Schneckenberger, documenta – Idee und Institution; in: documenta – Idee und Institution, ed. idem (Munich: Bruckmann, 1983), 8
6 Gabriele Hammel-Haider, "Moderne Galerie in Wien" – "Neue Galerie in der Stallburg" – Und nun?; in: Gottfried Fliedl, Roswitha Muttenthaler, and Herbert Posch, Museumsraum Museumszeit. Zur Geschichte des österreichischen Museums- und Ausstellungswesens (Wien 1994), 189
7 Hermann Bahr, Ver Sacrum, in: idem, Secession (Wien 1900), 11–14, here 13
8 Ludwig Hevesi, Acht Jahre Secession (Wien 1906; reprint Klagenfurt, 1984), 1
9 Walter Benjamin, Paris, die Hauptstadt des 19. Jahrhunderts; in: Illuminationen. Ausgewählte Schriften (Frankfurt/M. 1955), 196f
10 Neue Freie Presse (November 10, 1900), 1–4, title: "Kunst im Handwerk," signed "F.S-s.," p. 1, review of the 8th exhibition of the Secession, which showed only applied arts
11 Hermann Bahr, Wienerinnen. Lustspiel in drei Akten, premièred October 3, 1900, Deutsches Volkstheater (Bonn: Verlag Albert Ahn, 1911), 1st act, 21
12 Bahr's stage direction for the 2nd act of the play (ibid., 71)
13 Ibid., 129
14 Ibid., 130
15 Ibid., 74
16 Karl Kraus in: Die Fackel no. 89 (mid-Dec. 1901, 3rd year), 24
17 Idem in: Die Fackel no. 29 (mid-Jan. 1900), 16
18 Idem in: Die Fackel no. 89 (mid-Dec. 1901, 3rd year), 24
19 Idem in: Die Fackel no. 1 (early Apr. 1899), 28
20 Carl E. Schorske, Gustav Klimt: Die Malerei und die Krise des liberalen Ich; in: idem, Wien. Geist und Gesellschaft im Fin de Siècle (Frankfurt/M. 1982), 195–264
21 Ibid., 240
22 Ibid.
23 Neue Freie Presse (March 26, 1989), 3–4, "Bei den Secessionisten," signed "v.V."
24 Katalog zur I.Ausstellung der Vereinigung bildender Künstler Österreichs (Wien 1898), 2
25 Die Wiener Secession und die Ausstellung in St. Louis; in: Ver Sacrum, Sonderheft (February 1904), 1–40

Passage Jouffroy (1845–1847) by
François Hippolyte Destailleur and
Romain de Bourge, Paris.

26 Note from March 5, 1902, documented in the 4th annual report (1902), 24
27 Hevesi, Secession (April 18, 1902), (as in n. 7), 393
28 Kraus in Die Fackel no. 106 (June 16, 1902, 4th year), 20f
29 Hans Tietze, Lebendige Kunstwissenschaft (Wien 1925), 60, quoted in Sabine Forsthuber, Hans Tietzes
 kunstpädagogische Ausstellungen; in: Fliedl et al (as in n. 6), 169f
30 Tietze (as in n. 29), 54
31. Quoted in Forsthuber (as in n. 29), 181
32 See n. 10
33 Ibid.
34 Irene Nierhaus, Erwartungshorizont. Ausstellungen als Gestaltungsmittel autoritärer Politik an Wiener Beispielen
 aus den dreißiger und vierziger Jahren; in: Fliedl et al (as in n. 6), 156f
35 Ibid.
36 Malaktionismus. Ein Gespräch zwischen Hermann Nitsch und Otmar Rychlik; in: Hermann Nitsch. 20. Malaktion,
 18. – 21. Februar (Wien Secession 1987), 6
37 Ibid., 7
38 Ibid., 12
39 In context of the exhibition Freiplatz Kunst in 1983, Edelbert Köb, president of the Secession from 1983 to 1991,
 had developed a work of art that presented the wall as an endless layering, a series of superimposed skins
 which, as an aesthetic product, manifested the character of the place as an invisible archive.
40 Bahr, Ver Sacrum (as in n. 7), 35
41 Anne Rorimer, Daniel Buren at the Renaissance Society: 1983; in: A History of the Renaissance Society, 65
42 Edelbert Köb, Buren contra Secession; in: Im Raum Die Farbe. Arbeit in situ von Daniel Buren (Wien Secession
 1989), 7
43 Daniel Buren in an interview with Hildegund Amanshauser, in ibid., 10

Expansion – Internationale Biennale
für Graphik und Visuelle Kunst
June 23 – July 22, 1979
Photo: Archiv der Wiener Secession

*Richard Paul Lohse. Modulare und
Serielle Ordnungen*
March 20 – April 27, 1986
Photo: Margherita Spiluttini

Above: *David Mach*
September 1 – October 4, 1987
Photo: Archiv der Wiener Secession

Next page, top:
Sol LeWitt. Wall Drawings.
Continuous Forms with Color and
Gouache Superimposed
May 28 – June 3, 1988
Photo: Margherita Spiluttini
Below: *Franz Erhardt Walther. Dialog*
der Sockel. Wandformationen
January 18 – February 19, 1989
Photo: Archiv der Wiener Secession

Above: *Reimo Wukounig. Zeit der
Trauer, October 18 – November 13,
1983*
Photo: Archiv der Wiener Secession

Next page, top:
Tony Cragg
October 2 – November 3, 1991
Photo: Archiv der Wiener Secession
Below: *Gilbert & George*
April 9 – May 17, 1992
Photo: Archiv der Wiener Secession

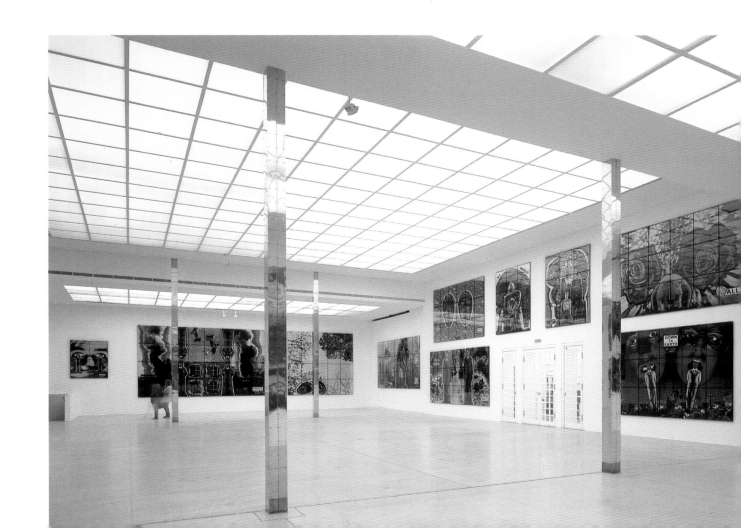

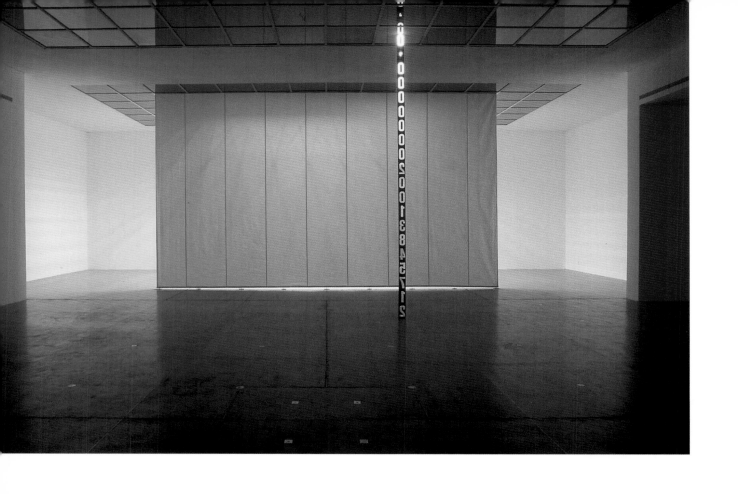

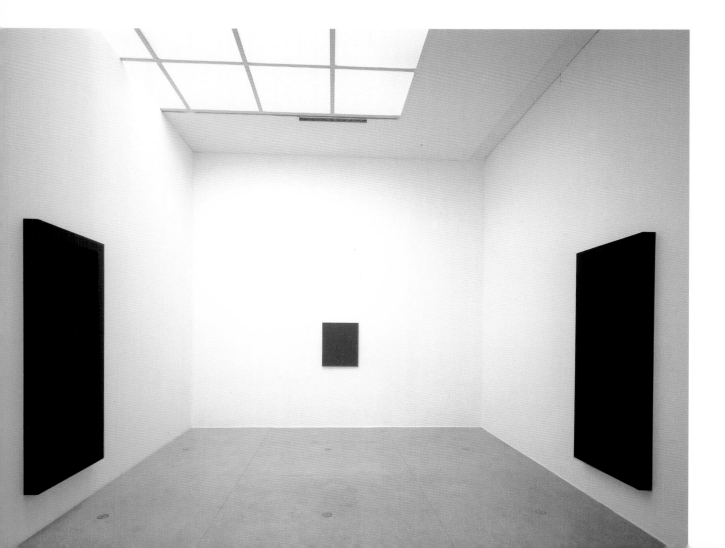

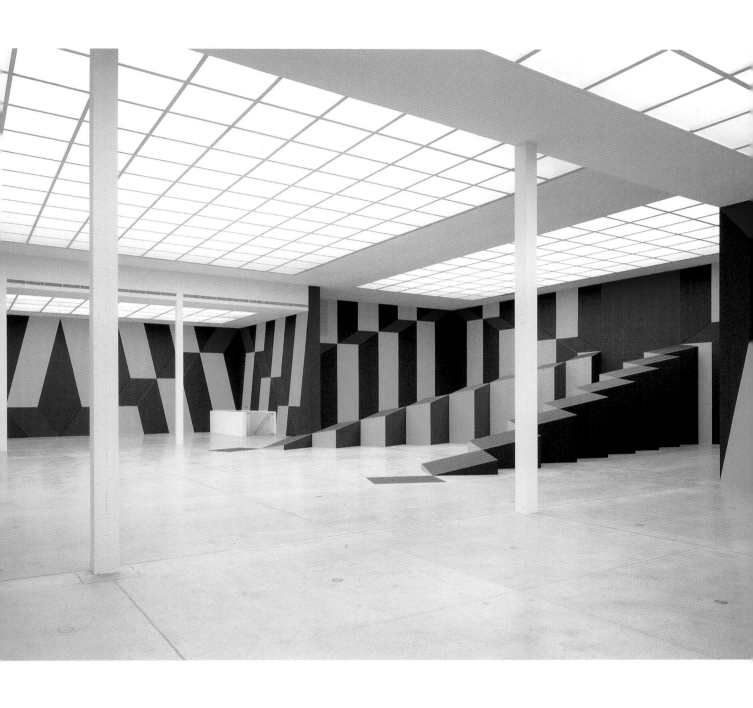

Above: *Roland Goeschl*
November 3 – December 11, 1994
Photo: Margherita Spiluttini

Left page, top: *Brigitte Kowanz*
September 8 – October 17, 1993
Photo: Matthias Herrmann
Below: *Aura. Die Realität des
Kunstwerks zwischen Autonomie,
Reproduktion und Kontext*
September 2 – October 16, 1994
Photo: Matthias Herrmann

Above: *Peter Kogler*
October 20 – November 17, 1995
Photo: Margherita Spiluttini

Left page, top:
Dieter Roth
February 10 – March 19, 1995
Photo: Margherita Spiluttini
Below: *Maurizio Nannucci*
April 5 – May 14, 1995
Photo: Archiv der Wiener Secession

Kurt Kren. tausendjahrkino
January 26 – March 10, 1996
Photo: Margherita Spiluttini

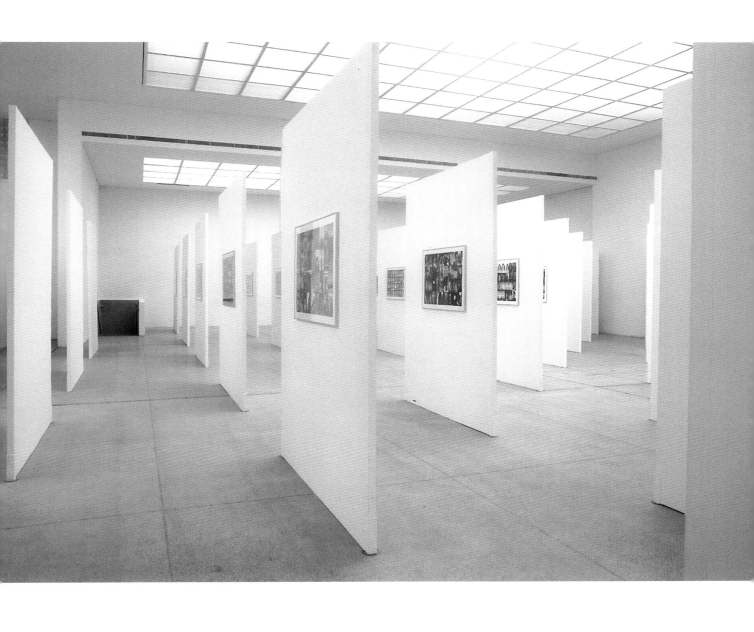

Elke Krystufek. i am your mirror
January 31 – March 6, 1997
Photo: Matthias Herrmann

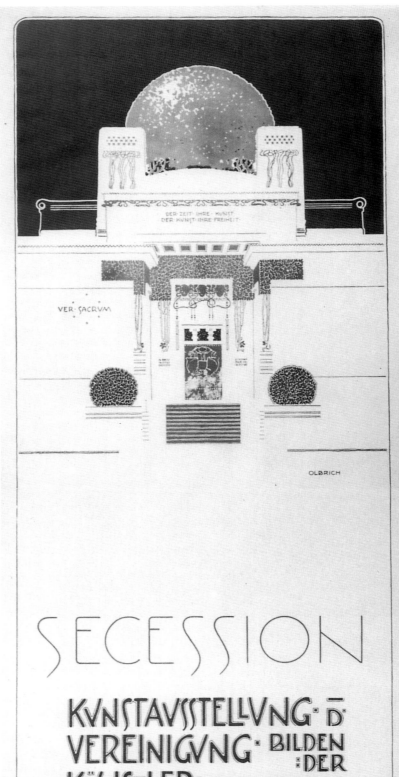

SELECTED, ANNOTATED LIST OF EXHIBITIONS IN THE MAIN HALL OF THE VIENNA SECESSION, 1898–1998

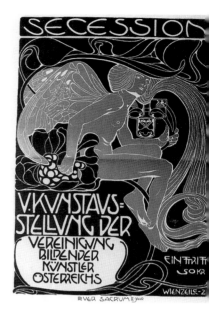

1st Exhibition of the Vereinigung bildender Künstler Österreichs
March 26 – June 20, 1898
Floral halls of the Imperial and Royal Horticultural Society (k.k. Gartenbaugesell-schaft), Wien 1, Parkring 12.
Selection and installation committee (Hängekommission): Adolf Böhm, Josef Engelhart, Carl Moll
Exhibition design (Raumgestaltung): Joseph M. Olbrich, Josef Hoffmann (Ver Sacrum room)
The exhibition showed European art with works by Puvis de Chavanne, Auguste Renoir, Fernand Khnopff, Giovanni Segantini, Max Klinger, Max Liebermann, Franz von Stuck, and many others. The show was innovative in terms of both exhibition design and public relations (tours were offered by members of the Secession). The generous proceeds of the 1st exhibition and the assistance of private sponsors enabled the Vereinigung to attain one of its primary goals, the construction of an exhibition building of its own for the realization of its artistic ideas.

2nd Exhibition of the Vereinigung bildender Künstler Österreichs
November 12 – December 28, 1898
Vienna Secession
Selection and installation committee: Josef Engelhart, Eugen Jettel, Carl Moll
Exhibition design: Joseph M. Olbrich, Josef Hoffmann, Kolo Moser
The move into the new building marked the beginning of an exhibition program whose presentations were intended to unify all the artistic media and means of expression (Raumkunstausstellung), a conception informed by the idea of the Gesamtkunstwerk. Selected works by members of the Secession were shown.

4th Exhibition of the Vereinigung bildender Künstler Österreichs
March 18 – May 31, 1899
Selection and installation committee: Rudolf Bacher, Eugen Jettel, Carl Moll
Exhibition design: Joseph M. Olbrich, Josef Hoffmann
Both spatially and thematically, the plaster model of Arthur Strasser's sculpture *Mark Antony in his Chariot Drawn by Lions,* created in 1895, constituted the center of the exhibition. The sculpture was later cast in bronze for the 1900 Paris Exposition and now stands next to the building. Joseph M. Olbrich conceived the central hall of his building containing the colossal sculpture as the scale model of a future sculpture museum. A bust by Auguste Rodin was acquired with the proceeds of the exhibition and designated for the prospective modern gallery.

6th Exhibition of the Vereinigung bildender Künstler Österreichs Secession
January 20 – February 15, 1900
Selection and installation committee: Rudolf Bacher, Josef Engelhart, Franz Hohenberger, Friedrich König, Anton Nowak
Exhibition design: Koloman Moser
The collection of Japan specialist Adolf Fischer made possible a comprehensive view of Japanese art and culture. While the artists of the Secession had been inspired by works of Japanese art, the exhibition itself received little attention from the Viennese public, drawing only a few visitors. Shortly thereafter, the collection was acquired by the Museum für Völkerkunde in Berlin.

7th Exhibition of the Vereinigung bildender Künstler Österreichs Secession
March 8 – June 6, 1900
Selection and installation committee: Josef Maria Auchentaller, Rudolf Bacher, Koloman Moser
Exhibition design: Adolf Böhm
The 7th exhibition was overshadowed by the controversy surrounding Klimt's painting for the aula of the university, *Philosophy.* The picture aroused the protest of university professors and divided all of Vienna into opponents (the "unphilosophical," as Karl Kraus called them) and supporters of the image. Shortly thereafter, the painting was sent to the Paris Exposition, where it received little attention from either critics or public.

Left page: Poster for 2nd exhibition, 1898.
Design: Joseph M. Olbrich

8th Exhibition of the Vereinigung bildender Künstler Österreichs Secession
November 3 – December 27, 1900
Selection and installation committee: Ferdinand Andri, Josef Hoffmann, Carl Moll, Koloman Moser
Exhibition design: Leopold Bauer, Josef Hoffmann, Koloman Moser
The 8th exhibition was the first to be devoted to the applied arts. It showed a representative cross-section of the most innovative works of the time, with particular emphasis not only on Austrian, but also on British and Belgian artists. In addition to Hoffmann, Moser, and Wagner, works by Charles Robert Ashbee, Charles Rennie Mackintosh, Margaret Macdonald-Mackintosh, and Henry van de Velde were shown. Shortly thereafter, the Mackintosh couple received the commission to decorate a music salon in the house of Fritz Wärndorfer, cofounder of the Wiener Werkstätte. In addition, Ferdinand Hodler and Edgar Degas were shown at the Secession for the first time.

9th Exhibition of the Vereinigung bildender Künstler Österreichs Secession
January 13 – February 28, 1901
Exhibition design: Alfred Roller
Giovanni Segantini, who died shortly before the exhibition, was honored with a retrospective, and his painting *Wicked Mothers* was acquired for the prospective modern gallery of the Secession. 14 sculptures by Auguste Rodin were also shown, along with a fountain by George Minne, whose figures exercised a great influence on young artists like Oskar Kokoschka and Egon Schiele.

10th Exhibition of the Vereinigung bildender Künstler Österreichs Secession
March 15 – May 12, 1901
Selection and installation committee: Ferdinand Andri, Friedrich König, Carl Moll
Exhibition design: Leopold Bauer, Koloman Moser, Josef Plečnik
The controversy around Gustav Klimt that had marked the 7th exhibition continued when his second painting for the university, *Medicine,* was shown. When studies and nudes for Medicine were published in the magazine of the Vereinigung, *Ver Sacrum,* the public prosecutor's office demanded the confiscation and destruction of the issue. The court refused its consent on the sole grounds that the magazine was intended 'only' for artists. The 'scandal' even went before the parliament. As before, however, the polarization of public opinion brought record numbers of visitors to the exhibition.

14th Exhibition of the Vereinigung bildender Künstler Österreichs Secession Wien Klinger Beethoven
April 15 – June 15, 1902
Selection and installation committee: Rudolf Bacher, Adolf Böhm, Josef Hoffmann, Alfred Roller
Exhibition design: Josef Hoffmann (main halls), Leopold Bauer (passages, reading room)
Popularly known as the "Beethoven Exhibition," the 14th was the most internationally renowned exhibition of the early Secession years. Centering around the *Beethoven sculpture* by Max Klinger, works by 21 members of the Secession were exhibited in an homage to Ludwig van Beethoven, a unique presentation that embraced every available artistic medium and means of expression (Raumkunstausstellung). Among the works shown was the *Beethoven Frieze* by Gustav Klimt, a monumental interpretation of the composer's Ninth Symphony. In the context of this exhibition, the Secessionist idea of a Gesamtkunstwerk reached a climax with the performance of a transcription for winds of the fourth movement of Beethoven's Ninth Symphony, arranged and conducted by Gustav Mahler. After lengthy negotiations, however, Klinger's sculpture was not able to be secured for Vienna and instead was acquired by the museum in Leipzig.

16th Exhibition of the Vereinigung bildender Künstler Österreichs Secession Wien Entwicklung des Impressionismus in Malerei und Plastik (The Development of Impressionism in Painting and Sculpture)
January 17 – March 1, 1903
Selection and installation committee: Wilhelm Bernatzik, Friedrich König, Othmar Schimkowitz
The exhibition—the first in Vienna to address the Impressionist movement—traced a broad line of development from Tintoretto, Rubens, Vermeer, Goya, and Delacroix to

Cézanne, Gauguin, Manet, Monet, Toulouse-Lautrec, and van Gogh. The didactically oriented exhibition was the first in Vienna to attempt a scholarly, historical presentation of the development leading to the art of the present. Experts such as Richard Muther and Julius Meier-Graefe were invited to speak.

18th exhibition of the Vereinigung bildender Künstler Österreichs Secession Wien
Kollektivausstellung Gustav Klimt (Gustav Klimt Retrospective)
November 14, 1903 – January 6, 1904
Exhibition design: Koloman Moser, Josef Hoffmann
In this retrospective of the work of Gustav Klimt, one of his university paintings, *Jurisprudence,* once again became the focus of widespread public outrage. As a result, Klimt withdrew the university paintings and refunded the payment he had received.

19th Exhibition of the Vereinigung bildender Künstler Österreichs Secession Wien
January 15 – March 6, 1904
Selection and installation committee: Wilhelm List, Carl Moll, Koloman Moser, Felician Freiherr von Myrbach
Exhibition design: Koloman Moser
The exhibition used historical examples to trace the roots of modernism, with the work of living artists shown as well. Accordingly, the exhibition of 31 pieces by Ferdinand Hodler, in part large-scale works, brought the artist long overdue international recognition.

22nd Exhibition of the Vereinigung bildender Künstler Österreichs Secession Wien
January 14 – February 28, 1905
Exhibition design: Leopold Bauer
The 22nd exhibition was the first to be dedicated exclusively to sculpture. Works by Max Klinger, Constantin Meunier, and Antoine Bourdelle were shown; Auguste Rodin, on the other hand, was not represented. Works were also shown by the Secessionists Ivan Mestrovic, Anton Hanak, and Josef Müllner.

In the spring of 1905, the so-called 'Klimt-Gruppe', consisting primarily of the architects and designers (Raumkünstler), the most significant and internationally renowned members of the Vereinigung, left the Secession. The members who remained were those grouped around Josef Engelhart, who devoted themselves primarily to painting.

24th Exhibition of the Vereinigung bildender Künstler Österreichs Secession Wien
November 9 – December 27, 1905
Exhibition design: Josef Plečnik
After the departure of the group around Gustav Klimt, the 24th exhibition showed religious art in reaction to the Klimt group's liberal persuasions. Here the Beuroner Kunstschule was shown for the first time. In the exhibition design, however, Josef Plečnik strove to continue the Secessionist tradition of the Gesamtkunstwerk.

34th Exhibition of the Vereinigung bildender Künstler Österreichs Secession Wien
Engelhart
October 22, 1909 – January 2, 1910
The exhibition was devoted to Josef Engelhart, one of the few remaining founding members and the new president of the Vereinigung. Engelhart had been one of the central figures in the original departure from the Künstlerhaus and had already been president of the Vereinigung once before in 1900. Of late, however, he had emerged as the principal opponent of Gustav Klimt and the so-called Raumkünstler.

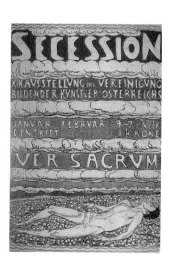

37th exhibition of the Vereinigung bildender Künstler Österreichs Secession Wien
Die Kunst der Frau (The Art of the Woman)
November 5, 1910 – January 8, 1911
Selection and installation committee: Olga Brand-Krieghammer, Baroness Helene Krauss, Ilse von Twardowska-Conrat, Josef Engelhart, Friedrich König
The exhibition was organized by the *Vereinigung bildender Künstlerinnen Österreichs* (Austrian Association of Women Artists) under its president Olga Brand-Krieghammer. Entrance into the Vereinigung bildender Künstler Österreichs

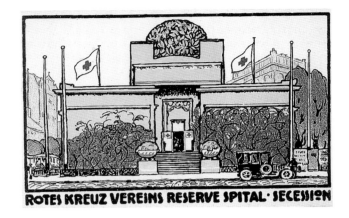

Secession Wien, however, continued to be denied to women artists. *Die Kunst der Frau* presented works by women artists since the 16th century, from Angelika Kaufmann, Elisabeth Vigée-Lebrun, Eva Gonzalés, and Berthe Morisot to the Austrian artists Emilie Mediz-Pelikan, Olga Wisinger-Florian, Tina Blau-Lang, and Marie Egner.

42nd Exhibition of the Vereinigung bildender Künstler Österreichs Secession Wien
Rudolf von Alt Gedächtnisausstellung (Rudolf von Alt Memorial Exhibition)
November 13, 1912 – January 6, 1913
Selection and installation committee: Rudolf Bacher, Alfred Hofmann, Maximilian Liebenwein, Josef Stoitzner, Rudolf Jettmar, Anton Nowak
On the 100th anniversary of his birth, tribute was paid to the first honorary president of the Vereinigung, Rudolf von Alt, in a retrospective of his life's work extending from the Biedermeier period to the beginnings of modernism.

From 1914 to 1917, the building of the Vereinigung bildender Künstler was converted into the "Reserve Hospital of the Red Cross – Secession."

49th Exhibition of the Vereinigung bildender Künstler Österreichs Secession Wien
March 1918
Selection and installation committee: Anton Faistauer, Johannes Fischer, Otto Friedrich, Hermann Grom-Rottmayer, Albert Paris Gütersloh, Richard Harlfinger, Egon Schiele
The exhibition drew attention to a new generation of artists. In addition to Egon Schiele, the show's organizer, the "Secession exhibition of the Expressionists" (Schiele) showed works by Anton Faistauer, Robin C. Andersen, and Albert Paris Gütersloh, all members of the Neukunstgruppe (New Art Group) founded in 1909. Austrian post-war Expressionism was exhibited along with works by Harta, Merkel, Fischer, Birnbaum, and Jungnickel. Egon Schiele died a few months later.

From 1923 to 1935, the *Verein der Museumsfreunde Wien* (Viennese Friends of the Museum) organized seven large exhibitions in the Secession building, all with historical themes not going beyond the 19th century. The selection of themes and artists was enthusiastically received by both critics and public. The following exhibitions were shown:
Von Füger bis Klimt (From Füger to Klimt)
September – October 1923
Meisterwerke italienischer Renaissancekunst aus Privatbesitz (Masterpieces of Italian Renaissance Art from Private Collections)
1924
Die führenden Meister der französischen Kunst im 19. Jahrhundert (Leading Masters of 19th Century French Art)
Selection and installation: Carl Moll
March – April 1925

Jahrhundertschau Deutscher Malerei (A Century of German Painting)
Selection and installation: Carl Moll
Exhibition design: Fritz Zeymer
March – April 1926
Meisterwerke englischer Malerei aus drei Jahrhunderten (Masterpieces of English
Painting from Three Centuries)
Selection and installation committee: Francis Howard, Ferdinand Kitt, Fritz Zeymer
Exhibition design: Fritz Zeymer
September 8 – November 6, 1927
Drei Jahrhunderte Vlämische Kunst 1400–1700 (Three Centuries of Flemish Art
1400–1700)
January 11 – February 23, 1930
Bildende Kunst der Francisco-Josephinischen Epoche (Visual Arts of the Age of
Franz Joseph)
Selection and installation: Heinrich Schwarz
May – October 1935

79th Exhibition of the Vienna Secession
Internationale Kunstausstellung (International Art Exhibition)
September 11 – October 20, 1924
The exhibition was organized by the *Gesellschaft zur Förderung moderner Kunst in
Österreich* (Society for the Advancement of Modern Art in Austria) founded by the
art historian Hans Tietze. It was presented as part of the international music and
theater festival in which the famous exhibition of theater technology (exhibition
design by Friedrich Kiesler) was also featured. The *Internationale Kunstausstellung*
showed a cross-section of European modernism including the most important
exponents of German Expressionism (*Die Brücke*), Verismus, and the Bauhaus (Paul
Klee, Wassili Kandinsky), French Cubism (Pablo Picasso, Georges Braque) and the
Fauves, as well as Constructivism (Piet Mondrian, El Lissitzky, Naum Gabo).

86th Exhibition of the Secession
Ausstellung für christliche Kunst (Exhibition of Christian Art)
1926
127th Exhibition of the Vereinigung bildender Künstler Wiener Secession
Das Kredo in der Gegenwartskunst (The Credo in Contemporary Art)
September 1933
Both exhibitions, the former sponsored by the *Gesellschaft für christliche Kunst*
(Society for Christian Art) and the latter organized on the occasion of the Catholic
Convention of 1933, were designed by Clemens Holzmeister. Both the theme and
the presentation were unusual. Clemens Holzmeister revived the old Secessionist
idea of the Gesamtkunstwerk and created two exhibitions that in different ways
adapted the sacral allusions of space and location. These exhibitions served to
interrelate the space of art and the church.

99th Exhibition of the Vereinigung bildender Künstler Wiener Secession
Gedächtnisausstellung Gustav Klimt (Gustav Klimt Memorial Exhibition)
June 27 – July 31, 1928
At the instigation of Carl Moll, an exhibition was once again devoted to Gustav
Klimt, the dominant personality of the early years of the Vereinigung.

The *Kunstschau* (including Robin C. Andersen, Josef Frank, Josef Hoffmann, Oskar
Kokoschka, Max Oppenheimer, Oskar Strnad, Franz Zülow), also known as the
Bund österreichischer Künstler (Association of Austrian Artists) or *Sonderbund,* had
existed since the departure of the Klimt group and constituted the actual "Austrian
modernists" of the interwar period. Without their own building, the Kunstschau
participated in Secession exhibitions on numerous occasions either as a group—as
in the 104th exhibition in the spring of 1929—or individually. After the dissolution of
the group in 1930, a large (non-Jewish) part of its membership was invited to join
the Secession.

The sympathy of a large part of the Vereinigung bildender Künstler Wiener Secession with the political tendencies of the time came to expression in numerous Fascist and National Socialist propaganda exhibitions, including the following:
115th Exhibition of the Vereinigung bildender Künstler Wiener Secession
Deutsche Kunst der Gegenwart (Contemporary German Art)
December 31, 1930 – February 15, 1931
Selection and installation committee: Wilhelm Frass, Ferdinand Kitt, Theodor Klotz-Dürrenbach, Othmar Schimkowitz
138th Exhibition of the Vereinigung bildender Künstler Wiener Secession
Ausstellung italienischer Plastik der Gegenwart (Contemporary Italian Sculpture)
November 1935
144th Exhibition of the Vereinigung bildender Künstler Wiener Secession
Deutsche Baukunst—Deutsche Plastik am Reichssportfeld in Berlin (German Architecture—German Sculpture at the Reichssportfeld in Berlin)
April 7 – May 17, 1937
Selection and installation committee: Alexander Popp, Oswald Roux
147th Exhibition of the Vereinigung bildender Künstler Wiener Secession
Italiens Stadtbaukunst (Urban Architecture in Italy)
November – December 1937

On September 18, 1939, the merger of the Secession with the Künstlerhaus was resolved. The Secession building became a dependency of the Künstlerhaus as the "Exhibition Hall Friedrichstraße." Converted into a armament factory in 1944, the building was completely destroyed by bombing in February 1945.

Wiener Secession. Ausstellung im Künstlerhaus (Vienna Secession. Exhibition in the Künstlerhaus)
April – May 1946
Selection and installation committee: Robin C. Andersen, Rudolf Buchner, Josef Dobrowsky
The first exhibition after the dissolution of the Vereinigung bildender Künstler Wiener Secession and the destruction of the building at the end of the war was shown in the very institution from which the Vereinigung had originally seceded and with which it had more recently been reunited: the Künstlerhaus. War damage made the Secession building itself unusable. Conventional works with inoffensive themes, portraits, still lifes, and landscapes were shown.

Anton Hanak
June 30 – October 31, 1949
Vienna Secession
Selection and installation committee: Josef Hoffmann, Wilhelm Frass, Josef Humplik, Rudolf Haybach
In the still half-ruined spaces, a large exhibition was mounted with drawings and sculptures by Anton Hanak, in his lifetime closely associated with the early artists of the Secession. The show was intended to make the Secession a center of attraction again, but with little success: the exhibition drew only 3,636 visitors.

Art Club. Internationale Ausstellung (Art Club. International Exhibition)
October 7 – November 12, 1950
From 1950 on, the Vereinigung gradually began to reconstitute itself. The Vienna Secession manifested all the essential tendencies of post-war Austrian art, yet was unable to profile itself as a distinct group. Under president and figurehead Albert Paris Gütersloh (Academy professor, Art Club president, etc.) the premises were made available above all to the newly founded Art Club, in which the "Phantastische Realisten" were represented along with the "Abstrakte." Already the first Art Club exhibition took place in the Secession building.

Gemälde und Plastiken. Erste Ausstellung der Föderation moderner bildender Künstler Österreichs (Painting and Sculpture. First Exhibition of the Austrian Federation of Modern Visual Artists)
May 29 – August 17, 1952
Exhibition directors: Albert Paris Gütersloh, Josef Hoffmann, Fritz Wotruba
The first exhibition of the *Föderation moderner bildender Künstler Österreichs,* which

brought together the Vienna Secession and the Art Club as well as the groups *Neue Hagenbund, Der Kreis, Secession Graz, Salzburger Gruppe, Der Bund Innsbruck,* and other independent artists, provided a survey of contemporary Austrian art and established contacts between the principal artists' unions in Austria.

Der Anteil der Wiener Secession an der österreichischen Kunst der Gegenwart (The Role of the Vienna Secession in Contemporary Austrian Art)
June 4 – July 20, 1954
The exhibition, intended to demonstrate the current significance of the Vienna Secession for Austrian art, showed primarily the old guard of established artists. "Until a few years ago, the Vienna Secession, once the first revolutionary alliance in Austria, could be defined as the artists' union that wisely kept a middle ground between 'conservative' and 'modern'"(Johann Muschik in *Der Abend,* June 10, 1954).

Oskar Kokoschka
October 15 – November 13, 1955
Werner Hofmann, engaged by the Secession in 1955–56 as "art historical consultant," put together a solo exhibition for the Secession's honorary president Oskar Kokoschka, one year before the latter's 70th birthday. A major Kokoschka anniversary exhibition was planned for the following year in Milan, Brussels, and Stockholm, but not Vienna.

Moderne Kunst aus USA. Auswahl aus den Sammlungen des Museum of Modern Art New York (Modern Art from the USA. Selected Works from the Collections of the Museum of Modern Art in New York)
May 5 – June 2, 1956
Curators: Dorothy C. Miller, William S. Liebermann, Arthur Drexler
Moderne Kunst aus USA was the first exhibition in Austria devoted exclusively to 20th-century American art—not only painting and sculpture, but also printmaking, architecture, and photography.

*1956 Spiralenspektakel (*Spiral Spectacle)
Design: Hans Staudacher
1957 Off Limits
Design: Bruno Buzek, Hans Staudacher
1958 Isotopischer Spektakel (Isotopic Spectacle)
Design: Gerhard Swoboda, Hans Staudacher
1961 Verkehrsspektakel (Traffic Spectacle)
Design: Hans Staudacher, Oskar Bottoli, Franz Fischer, Bruno Schwaiger
"D.E.: Was it perhaps a secret inclination toward the idea of a Gesamtkunstwerk that caused you, without realizing it, to follow in the footsteps of the Secession's founders at Carnival time?
H.S.: Yes; what object art and the new Raumkunst do nowadays, you could only do at festivals back then…In essence it was an opportunity for all the artists to work on a large scale, something they have little chance to do otherwise, for a number of reasons." (Daniel Eckert in an interview with Hans Staudacher)

Who is who?, 1961

165

Aspekte 59
June 4 – July 5, 1959
Since 1955, younger artists had once again been gaining entrance into the Vereinigung. The work of a new generation of artists had already been shown in 1949 (*Neue Junge Kunst*); in 1958, students from the two art schools in Vienna exhibited under the title *Die junge Generation* (The Young Generation). Aspekte 59 now presented the newest contemporary Austrian art. From its inception, one of the primary concerns of the Secession had been to show the work of young artists.

Who is who?
July 11 – July 23, 1961
Concept: Hans Staudacher
The exhibition *Who is who?*, conceived by Hans Staudacher as a guessing game and characterized by a free exhibition design, showed unlabeled works by numerous young artists, including some who later caused an international sensation as the "Wiener Aktionisten" at the end of the 1960s.

Abstractive Malerei und Plastik in Österreich (Abstractive Painting and Sculpture in Austria)
June 5 – July 5, 1961
Der Gegenstand in der österreichischen Malerei und Plastik (The Object in Austrian Painting and Sculpture)
October 16 – November 19, 1961
In 1961, Paul Meissner, then president of the Secession, organized a survey of "abstractive (!) painting and sculpture in Austria," followed in the autumn of the same year by an exhibition dedicated to 'the object.' According to Meissner, both exhibitions together were necessary to give "a survey of recent production in the area of the visual arts in Austria." The program of the Secession thus aimed to reflect a pluralism rather than an ideology of style.

Ferdinand Hodler 1853–1918
November 6, 1962 – January 6, 1963
Exhibition Design: Ferdinand Kitt
The Ferdinand Hodler exhibition of 1962–63, organized by the city of Vienna, was inspired by the 19th exhibition of the Secession in 1904, which had brought Hodler international recognition in an exhibition design by Kolo Moser. With Ferdinand Kitt, himself president of the Vereinigung from 1926 to 1929, one of the most important Austrian artists of the interwar period was now invited to devote himself to the presentation of Hodler's works.

The years 1963–64 saw the first comprehensive renovation of the Secession building. The original condition was considerably altered by the insertion of an additional story in the vestibule. The original decoration, removed in a first renovation in 1908 by Robert Oerley, was restored again, along with Ludwig Hevesi's programmatic motto "To the Time its art. To art its freedom," which had likewise been removed in the course of the first remodeling.

Wien um 1900 (Vienna 1900)
June 15 – August 30, 1964
Vienna Secession, Künstlerhaus, Historisches Museum der Stadt Wien
Ferdinand Kitt, Franz Glück, Peter Pötscher
The exhibition, organized by the cultural office of the city of Vienna, brought widespread public recognition to the Austrian version of Art Nouveau. It was the first of many successful "Vienna 1900" exhibitions in Austria and other countries. On August 11, the Secession greeted its 50,000th visitor.

Richard Gerstl
June 8 – June 29, 1966
With its first solo exhibition by Richard Gerstl, the Secession showed one of the most important figures in early Austrian Expressionism, an artist whose development and influence had long been unappreciated. In the press, the exhibition was acclaimed among other things as a "milestone in Austrian art history."

Secession '68
April 9 – April 28, 1968
Wirklichkeiten (Realities)
May 3 – May 22, 1968
The Vereinigung bildender Künstler faced the turbulent year 1968 by taking inventory: instead of assuming a position, it emphasized diversity; instead of conflict, it sought consensus. The press remarked above all on the installation of the pictures (in part hanging freely from the ceiling) and the arrangement of the sculpture: "Much is new in the Secession—the unconventional exhibition design, for example, which makes the best of the new Secession interior" (Otto Breicha in the Kurier, April 24, 1968). New art was also shown, as in Wirklichkeiten, an artists' group whose members included Wolfgang Herzig, Martha Jungwirth, Kurt Kocherscheidt, Peter Pongratz, Franz Ringel, and Robert Zeppel-Sperl. The exhibition, one of the most important of these years, was perceived by many as a provocation.

Forum Stadtpark in der Secession Wien (Forum Stadtpark in the Vienna Secession)
November 3 – November 26, 1972
The guest exhibition of *Forum Stadtpark* at the Vienna Secession, with artists including Peter Gerwin Hoffmann, Cornelius Kolig, Norbert Nestler, Friedrich Panzer, Ferdinand Penker, Jeanner Rebeau, Rainer Verbizh, and Erwald Wolf-Schönach, introduced a group of young visual artists who for the last ten years had shaped the development of the lively art scene in Graz.
In a controversial general assembly in 1973, the majority of Secessionists nominated the print shop owner Anton Tusch for the office of president. Alfred Hrdlicka vehemently opposed the choice and called for a "counter-Secession." Tusch's election was prevented and the new president of the Vereinigung became Adolf Frohner, who had left the Secession. In a brochure, the Vereinigung documented the internal process as well as the numerous reactions from the press; in the Secession itself, nothing changed.

Christo. The Running Fence
February 9 – March 11, 1979
The Running Fence was the first in a series of conceptually oriented exhibitions. With Christo, the Secession showed a representative of American Land Art for the first time, thus opening itself again to the international contemporary art scene.

Expansion – Internationale Biennale für Graphik und Visuelle Kunst (Expansion. International Biennial for Graphic and Visual Art)
June 23 – July 22, 1979
Concept: Horst Gerhard Haberl
While a number of biennials devoted to the graphic arts had emerged in the 1970s, *Expansion* showed art forms that transgressed the 'traditional' boundaries of the medium, including Body Art and Performance as well as Media and Conceptual Art. The exhibition drew much attention from the public as well as from the press.

Freiplatz Kunst. Künstler arbeiten in der Secession (Free Space for Art. Artists Work in the Secession)
March 27 – April 30, 1980
January 13 – February 6, 1983
For the exhibition *Freiplatz Kunst,* ten artists' spaces were installed in the main hall of the Vienna Secession using movable partition walls. In these "ateliers,"

installations or exhibition pieces were created on location and then exhibited. In addition, the public was given the opportunity to observe the creative process by visiting the artists and discussing their work with them.

Junge Szene Wien (Young Scene Vienna)
August 9 – September 1, 1983
July 31 – August 26, 1984
July 10 – August 17, 1986
Junge Szene Wien, conceived as a series from its inception, offered young artists the opportunity to show their work in context of a larger exhibition. The selection was made by a jury of Secession artists with only two criteria: current art of high quality.

Markus Lüpertz. Bilder. Plastik (Markus Lüpertz. Paintings and Sculpture)
June 26 – July 22, 1984
"Recalling the great tradition of Secessionist exhibition design, the internationally acclaimed German painter Markus Lüpertz has conceived and developed a show especially for the main hall of the Vienna Secession." (Maria Buchsbaum in the *Wiener Zeitung,* June 30, 1984)

In 1984–85, the Vienna Secession building was comprehensively renovated and adapted. The vestibule and exhibition hall were largely restored to their original form and at the same time brought up to modern technical standards. In the basement, a space was created for the permanent installation of the restored Klimt frieze.

Weltbilder. 7 Hinweise (Worldviews. 7 Allusions)
January 26 – February 9, 1986
The Vienna Secession reopened with an exhibition of contemporary art. Seven artists were invited to create works in dialogue with the *Beethoven Frieze,* for "we presuppose an artistic practice that ponders its history, its traditions, its social and appellative possibilities, its synthetic power to formulate a broad range of concerns – all that simultaneously, but above all its striving to manifest something: to use its language decisively and boldly to challenge the entire world." (Otmar Rychlik)

Left: *Freiplatz Kunst,* 1980
Right: *Weltbilder. 7 Hinweise,* 1986

Georg Baselitz. Bäume (Georg Baselitz. Trees)
October 15 – November 23, 1986
"[…] we decided on an exhibition entitled *Bäume.* The choice of theme must have
been the work of higher powers, if not the unconscious, for only in retrospect did
we realize that the tree is the very symbol of the Secession, its building crowned by
a roof of foliage and its portal framed by tree reliefs." (Edelbert Köb).

Emilio Vedova
December 11, 1986 – January 11, 1987
Emilio Vedova was the first of a number of artists to make conscious reference to
the architectural symbolism of the Vienna Secession.

Hermann Nitsch. 20. Malaktion (Hermann Nitsch. 20th Malaction)
February 18 – February 21, 1987
In the exhibition series Raumgestaltungen, the Vienna Secession provided artists
with the opportunity to enter into dialogue with the main hall as a spatial structure
and historic location. In his *20. Malaktion,* Hermann Nitsch redefined the exhibition
hall as a monumental cult space. "The Secessionists' striving for sacrality and the
Gesamtkunstwerk always struck a chord with me and essentially corresponded to
my intentions." (Hermann Nitsch)

Junge Szene Wien
July 21 – August 23, 1987
Up to this point, multimedia art had been excluded from the series *Junge Szene
Wien* for financial and technical reasons. The situation was rectified in 1987 in
response to the new scene that had developed around this medium and to which
little attention had been paid in conventional exhibitions.

Sol LeWitt. Wall Drawings
May 28 – July 3, 1988
Daniel Buren. In Situ
November 17 – December 14, 1989
The wall designs by Sol LeWitt and Daniel Buren, whose ephemeral character
eluded presentation in the museum, nonetheless suggested themselves in reference
to the *Beethoven Frieze* of 1902, itself once conceived as a temporary installation.
Seemingly alike, yet developing out of entirely different theoretical approaches, the
two exhibitions offered an exciting opportunity to compare two internationally known
conceptual artists and their artistic practice of the 1980s.

IN SITU
July 15 – August 28, 1988
Concept: Markus Brüderlin
The exhibition *IN SITU* once again foregrounded not only the "tendency toward the
ornamental," but also the significance of the place: "*IN SITU* is intended to revive the
theatrical style of presentation so ingeniously developed in the decorative spatial
concepts of the Secessionists with their emphasis on the Gesamtkunstwerk, above
all in the legendary 14th exhibition of 1902, where Gustav Klimt's famous Beethoven
frieze made its emphatically celebrated, but also controversial public debut."
(Markus Brüderlin)

Wien Möbel (Vienna Furniture)
June 7 – July 16, 1989
Concept: Adolf Krischanitz
Wien Möbel was the first since the 8th exhibition of 1900 to be dedicated to the contemporary applied arts. Prototypes of furniture were created by important designers of Viennese Raumkunst together with renowned Austrian manufacturers.

Wittgenstein – The Game of the Unspeakable. Wittgenstein und die Kunst des 20. Jahrhunderts.
September 13 – October 29, 1989
Concept for main hall: Joseph Kosuth
(Concept for biographical section: Michael Nedo)
"For the 100th birthday of the philosopher Ludwig Wittgenstein, the Secession organized the largest exhibition project in its history: international contemporary art and historical material were united in a comprehensive cultural-historical research and documentation project along with an artistic reflection on Wittgenstein's philosophy."(Eleonora Louis)

Junge Szene Wien
August 14 – September 22, 1991
July 12 – September 1, 1996
Though always controversial, the series Junge Szene Wien continued into the 1990s, providing a survey of current tendencies, trends, and artistic positions.

Rémy Zaugg
December 22, 1992 – January 24, 1993
Concept: Rémy Zaugg
Once again reviving the idea of the Gesamtkunstwerk, Rémy Zaugg transformed the entire building into a place of exhibition and used Gustav Klimt's *Beethoven Frieze* as an integral element of the exhibition. His own works were placed in exhibition spaces, while historical works were shown in areas not actually intended for exhibition, thus emphasizing spatial and temporal continuity.

Guillaume Bijl. Der Mensch überwindet Distanzen (Guillaume Bijl. Humans Overcome Distance)
December 16, 1993 – January 23, 1994
In a fictive, didactically oriented exhibition with objects from the storehouses of the Technisches Museum in Vienna, Guillaume Bijl temporarily transformed the exhibition space of the Secession into a museum using the theme of the development of forward motion. The visitor seemed to enter not an exhibition of contemporary art, but rather a space of museum-like presentation.

Erwin Wurm
March 23 – April 28, 1991
Ernst Caramelle
May 28 – July 4, 1993
Brigitte Kowanz
September 8 – October 17, 1993
Gerwald Rockenschaub
July 15 – August 21, 1994
Once a year for the first half of the 1990s, the Vienna Secession dedicated a solo exhibition to an Austrian artist of the middle generation as the first major presentation of his or her work.

Aura. Die Realität des Kunstwerks zwischen Autonomie, Reproduktion und Kontext (Aura. The Reality of the Work of Art Between Autonomy, Reproduction, and Context)
September 2 – October 16, 1994
Curator: Markus Brüderlin

The exhibition *Aura* used two essential tendencies in contemporary art – abstract painting and Appropriation Art – to examine the effectiveness of the work of art in the "age of mechanical reproduction" (Walter Benjamin). The theme's significance was intensified by its setting in the historic Secession, a building that "in its beginnings made use of the aesthetics of effect to invoke an aura" (Markus Brüderlin).

Roland Göschl
November 3 – December 11, 1994
In a further variation on the theme of the great Secessionist Raumgestaltungen, the Austrian artist's concept for the main hall of the Secession extended wall painting out into the exhibition space and onto the sculptural objects.

Dieter Roth
February 10 – March 19, 1995
For the Vienna Secession, Dieter Roth designed an installation extending over the entire exhibition space and incorporating found objects from everyday life— beverage cans, cigarrette butts, newspaper clippings, groceries in every stage of decomposition—sometimes arranged, sometimes laid down at random, but never established in any kind of final, permanent form. The 'sacred' space of the Secession thus seemed to have been temporarily transformed into a garbage dump —a counter-strategy to the aura of the place, but one that in the end was not entirely immune to that aura.

Heimo Zobernig
July 26 – August 27, 1995
Franz Graf
September 6 – October 8, 1995
Peter Kogler
October 20 – November 17, 1995
With installations by Heimo Zobernig, Franz Graf, and Peter Kogler, the Vienna Secession continued its series of presentations by contemporary Austrian artists in close succession.

Kurt Kren. tausendjahrkino (Kurt Kren. Thousand-Year Cinema)
January 26 – March 10, 1996
Concept: Loys Egg, Kurt Kren
The exhibition tausendjahrkino by the Austrian artist and avant-garde filmmaker Kurt Kren was the first to present the medium of film outside the institution of the cinema, thus once again employing an approach characteristic of the early Secession, namely the crossing of boundaries between different artistic genres.

Elke Krystufek. i am your mirror
January 31 – March 6, 1997
With a special exhibition architecture in the main hall, Elke Krystufek explored the difference between 'public' and 'private.' Entering the space, the viewer was first confronted by bare partition walls, on the other side of which were mounted photographic tableaux and self-portraits of the artist. The seemingly public nature of the medium of exhibition served to connect the interior space of architecture and the psychic space of the intimate and private.

Zoe Leonard
July 23 – September 14, 1997
Once again—whether consciously or unconsciously—the center of the exhibition was marked by a tree, the symbol and metaphor of the Vereinigung bildender Künstler Wiener Secession from its beginning.

FOUNDING MEMBERS OF THE VIENNA SECESSION

Alt Rudolf von (1812–1905)
Bacher Rudolf (1862–1945)
Bernatzik Wilhelm (1853–1906)
Böhm Adolf (1861–1927)
Delug Alois (1859–1930)
Engelhart Josef (1864–1941)
Falat Juljan (1853–1929)
Friedrich Otto (1862–1937)
Haenisch Alois (1866–1937)
Hellmer Edmund Ritter von (1850–1935)
Hölzel Adolf (1853–1934)
Hoffmann Josef (1870–1956)
Hynais Albert (1854–1925)
Jettel Eugen (1845–1901)
Klimt Gustav (1862–1918)
Knüpfer Benes (1848–1910)
König Friedrich (1857–1941)
Krämer J. Victor (1861–1949)
Kurzweil Max (1867–1916)
Lenz Maximilian (1860–1948)
Marold Ludwig (1865–1898)
Mayreder Julius (1860–1911)
Moll Carl (1861–1945)
Moser Koloman (1868–1918)
Mucha Alfons Maria (1860–1939)
Myrbach Felician Freiherr von (1853–1940)
Nowak Anton (1865–1932)
Olbrich Joseph Maria (1867–1908)
Ottenfeld Rudolf Ritter von (1856–1913)
Pirner Maximilian (1854–1924)
Poetzelberger Robert (1856–1930)
Roller Alfred (1864–1935)
Schwaiger Hans (1854–1912)
Sigmundt Ludwig (1860–1936)
Stöhr Ernst (1860–1917)
Strasser Arthur (1854–1927)
Tichy Hans (1861–1925)

PRESIDENTS OF THE VIENNA SECESSION FROM 1897 TO 1997

1897–1899	Gustav Klimt (1862–1918)
1899–1900	Josef Engelhart (1864–1941)
1900–1901	Carl Moll (1861–1945)
1901–1902	Alfred Roller (1864–1935)
1902–1903	Wilhelm Bernatzik (1853–1906)
1903–1904	Felician von Myrbach (1853–1940)
1904–1905	Rudolf Bacher (1862–1945)
1905–1906	Ferdinand Andri (1871–1956)
1906–1908	Franz Hohenberger (1867–1941)
1908–1909	Franz Nowak (1865–1932)
1909–1910	Franz Hohenberger (1867–1941)
1910–1911	Josef Engelhart (1864–1941)
1911–1912	Robert Örley (1876–1945)
1912–1914	Rudolf Bacher (1862–1945)
1914–1916	Ferdinand Schmutzer (1870–1928)
1917–1919	Richard Harlfinger (1873–1948)
1919–1922	Franz Messner (1873–1942)
1922–1926	Ludwig Christian Martin (1890–1961)
1926–1929	Ferdinand Kitt (1887–1961)
1929–1931	Othmar Schimkowitz (1864–1946)
1931–1936	Ludwig Christian Martin (1890–1967)
1936–1939	Alexander Popp (1891–1947)
1946–1947	Karl Stemolak (1875–1954)
1948–1949	Josef Hoffmann (1870–1956)
1950–1954	Albert Paris Gütersloh (1887–1973)
1955–1957	Paul Meissner (1907–1983)
1957–1960	Lois Pregartbauer (1899–1971)
1960–1965	Paul Meissner (1907–1983)
1965–1968	Walter Eckert (*1913)
1968–1972	Georg Eisler (*1928)
1972–1977	Paul Meissner (*1907–1983)
1977–1983	Hermann J. Painitz (*1938)
1983–1991	Edelbert Köb (*1942)
1991–1995	Adolf Krischanitz (*1946)
1995–	Werner Würtinger (*1941)

THE SOCIETY OF FRIENDS OF THE VIENNA SECESSION

was founded in 1986 in context of the renovation of the Secession building. Its membership is drawn from the business and art world. Membership dues of the Friends provide support for up to ten exhibitions annually. In addition, the Friends assist in the acquisition of sponsors, the cultivation of international contacts, and the financing of structural measures intended to insure the continuing independence of the Secession. Activities including lectures, gallery talks, fundraising dinners, and art excursions serve to enhance public relations for the exhibition program of the Vienna Secession and international contemporary art in general.

ABOUT THE AUTHORS

BRIGITTE FELDERER
Linguist and independent curator. Lives and works in Vienna.

GOTTFRIED FLIEDL
Museologist and art historian. Lives and works in Wolfpassing.

OTTO KAPFINGER
Architectural theorist and journalist. Lives and works in Vienna.

ELEONORA LOUIS
Art historian and independent curator. Lives and works in Vienna.

JAMES SHEDEL
Historian at Georgetown University, Washington, D.C. Lives and works there.

GENERAL INFORMATION

Exhibition space:
Main hall (600 m²), gallery (150 m²), graphic collection (52 m²),
Ver Sacrum room (49 m²)
The premises may be rented for programs, exhibitions, festivals, etc.
The Secession offers a wide range of educational programs with thematically
oriented tours of the building and the exhibitions. All exhibitions are accompanied
by publications, available along with selected literature, souvenirs, and gift items in
the shop of the Vienna Secession.

The café and shop in the Secession are open during business hours:
Tuesday – Saturday 10 a.m. – 6 p.m. / Sundays & holidays 10 a.m. – 4 p.m.
Guided tours: Sunday 11 a.m.

Wiener Secession, Friedrichstraße 12, 1010 Wien, Austria
Tel.: +43–1–587 53 07; Fax: +43–1–587 53 07–34
U–Bahn station: Karlsplatz (U1, U2, U4)

Internet: http://www.t0.or.at/secession
e–mail for the press: secession.pr@t0.or.at; e–mail for exhibitions: secession.ex@t0.or.at

Impressum

Editorial board: Vereinigung bildender Künstler Wiener Secession
Concept: Otto Kapfinger
Editor: Eleonora Louis
Assistant Editors: Nora Fischer, Bärbel Holaus, Isa Stech
Copy editors: Claudia Mazanek, Maria Platte
Translations: Melissa Thorson Hause
Visual concept: Heimo Zobernig
Graphic Design: Alexander Rendi

Production
Dr. Cantz'sche Druckerei, Ostfildern bei Stuttgart

Published by
Verlag Gerd Hatje, Senefelderstraße 12, 73760 Ostfildern-Ruit (Germany)
Tel. (711) 44 05 0; Fax (711) 4405 220
Distribution in the US
DAP, Distributed Art Publishers
155 Avenue of the Americas, Second Floor
New York, N.Y. 10013
T. (001) 212 - 627 19 99; F. (001) 212 - 627 84 94

ISBN 3-7757-0712-3 (Hardcover)
ISBN 3-900803-951 (Catalogue)
Printed in Germany

Cover illustration: Vienna Secession, front view (photo: Matthias Herrmann)